3-

The End of the Art World

ROBERT C. MORGAN

ALLWORTH PRESS
NEW YORK

School of
VISUAL ARTS

04 03 02 01 5 4 3 2

Published by Allworth Press
An imprint of Allworth Communications
10 East 23rd Street, New York, NY 10010

Copublished with the School of Visual Arts

Cover and book design by James Victore, New York, NY
Page composition by Sharp Des!gns, Lansing, MI
Cover photo © 1998 Thomas Schierlitz
Back cover photo © 1998 Bill Beckley
Author's photo, back flap © 1998 Anna Nenonen

ISBN: 1-58115-010-5
Library of Congress Catalog Card Number: 98-72760

AESTHETICS TODAY
Editorial Director: Bill Beckley

Sculpture in the Age of Doubt by Thomas McEvilley (May 1999)
The End of the Art World by Robert C. Morgan
Uncontrollable Beauty, edited by Bill Beckley with David Shapiro
The Laws of Fésole by John Ruskin
Lectures on Art by John Ruskin
Imaginary Portraits by Walter Pater

To Pierre Restany
with gratitude and affection

Contents

III. Artists

IV. Issues

List of Illustrations

Acknowledgments

Making a book is different than writing one. In order for the author's written text to become a published reality there are others who are essential in making it happen.

I am indebted to the artist Bill Beckley for his support in offering my initial manuscript of *The End of the Art World* to Allworth Press. Having long admired Beckley's work, I was further delighted to share in his knowledge of aesthetics and his theoretical interest in art criticism. I am grateful to Allworth's publisher Tad Crawford for his sincere interest and encouragement during the months of work on this book.

I also extend my gratitude to the superb editorial staff at Allworth Press, especially to the illuminating brilliance of Ted Gachot and Nyier Abdou, in overseeing the many details that have given *The End of the Art World* its coherence. Anne Hellman has been a welcome asset in writing accurate and incisive publicity releases and in pursuing the challenging task of promoting this book.

The generosity of Silas Rhodes, David Rhodes, and the School of Visual Arts in copublishing this book is something I regard as a special honor. Having been modestly involved with this institution for over a decade, I am deeply moved by their participation in this project.

I would like to thank my assistants, Cynthia Roberts, Leigh Winter, and, especially, Carla Gannis, who all participated in formulating the manuscript and in ferreting out the accompanying illustrations. I would like to acknowledge the professional expertise of Bill Bace, my editor at *Review,* who generously gave permission to reprint several of the recent essays.

I cannot ignore the many conversations I have had with friends and colleagues—too numerous to name—in contributing to my understanding of the role of criticism as having a place in today's atmosphere of cultural, economic, and social panic. They would have to include Ryzsard Wasko, Donald Kuspit, Arthur Danto, Hunyee Jung, Beom Moon, Michael Levin, Catalina Chevrin, Blanca Lloret, Oskar Yujnovsky, Alberto Serra, Martin Marcos, and, especially, Monice Glenz who instigated

the Spanish edition of *El Fin del Mundo del Arte* (translated by Rolando Costa Picazo) at the Centro Cultural Rojas of the University of Buenos Aires.

I would like to acknowledge the support of the Rochester Institute of Technology where I have had the pleasure of teaching for the past sixteen years. Most of all, I would like to extend a heartfelt thanks to my students. I am delighted and humbled by your questions, insights, and integrity. This is enough to make me believe that the end of the art world in this century will only spawn a more endurable awakening to art in the coming years.

R. C. M.

Art world, ivory tower, control tower,
art control, wheelers-dealers world
Art words, world, art critics, art critters
World of business-before-pleasure and vice versa
Living art, living-it-down world
Whorls, whirls, wholes, parts,
Painting is more than the scum of its pots
Can't you tell your impasto from a holy ground?
Holy smoke

Ad Reinhardt
Undated notes from Art As Art: The Selected Writings of Ad
Reinhardt, *ed. Barbara Rose (New York: Viking, 1975), 129.*

Former site of the Mary Boone Gallery, New York City. © 1998 Bill Beckley.

Foreword:
The Beginning of
the Art World

A new energy pervades art criticism today, simply, exuberantly, and profoundly expressed in the writings of Robert C. Morgan. Morgan declares an end not to art or painting, but to the provisos that surround art. A lonely voice in the eighties, he established a base for whatever might follow the postmodern era. Robert Morgan seems both prophetic to and compliant with a new accord.

The End of the Art World is a broadside on postmodern theory, which has predominated the later part of the twentieth century, and a critique of both the gallery system and art criticism itself. Morgan highlights the difference between the meaning of a work of art and its place in the art market. He writes with straightforward clarity toward a generosity that has always been inherent in art.

If the bombs over Hiroshima and Nagasaki precipitated a suspicion of progress, later, more trivial developments ushered in the postmodern era when, for instance, Cadillac tail fins, symbolizing progress through flight and space, first grew larger with each model year, then leveled out, and finally shrank. Along came postmodern architecture, which professed not a new style, but meaning through a conglomerate of already existent styles. Postmodernism in the plastic arts followed suit, declaring the impossibility of the new.

By the late eighties, however, a disenfranchisement developed in response to the often heavy-handed, sometimes puritanical philosophies that accompanied the postmodern rationale. Shouts of "NO MO PO MO" echoed in the halls of universities from Cambridge to California. But as John Barth reminded us in *The Floating Opera,* it is much less difficult to go from naïveté to cynicism than from cynicism to anything else. As the generation educated in the eighties matures, a collective desire simply to get on with it is apparent.

I first heard Morgan speak at a symposium on quality he moderated at the School of Visual Arts in the early nineties. Quality, by then, had been disparaged by postmodern enthusiasts as a means of propping up unwanted power structures. Unfortunately, this disposition gave a lot of artists an excuse for mediocrity. (I found it ironic when, on occasion, I did hear a good argument against quality.) Here Morgan clears

the air for a reconsideration of quality, not as the adherence to a rigid set of rules already in place, but as a way to understanding the possible criteria of art through the fluidity and clarity of the work itself.

Defining a new accord doesn't mean that everything is gonna be all right, or even that we would be content if it were. Anxiety contributes to the perception of time as we know it, and nirvana, when all forces are in perfect balance, is allied with immobility and death, particularly here in New York. But it is not so crazy to suggest that there are interests in the realm of aesthetics that are not necessarily political (though they might be). With the celebration of art as revelatory—and possibly spiritual—a different, more resonant kind of dissonance might arise.

Renewal, whether it be self-renewal or renewal of aesthetic norms, is a different sort of thing than modernism's notion of progress via technological advance. This renewal happens periodically in individuals and societies, and Morgan's criticism opens possibilities on either front. The Duchampian chess game—as interpreted by the marketplace—is over. The winner is irrelevant, and the queens, kings, knights, and pawns lay sprawled across the floor. In Morgan's terms, it's time "to rediscover the act of seeing," but in conjunction with thinking and feeling—to come back to art in a way that it might make a difference, "that it might actually benefit our lives."

Bill Beckley
New York City
August 1998

Introduction

Around 1992, I started moving away from the logical chain reaction to the vanguard developments of the late sixties and seventies, including the various reactions to those reactions, and began looking at art from a more personal point of view. I was less interested in the kind of art that had become a "discourse"—art that was presumably dependent on trendy ideas—and more involved with works by individual artists who expressed their views of structure and disjuncture through a heightened intuition and imagination. Concurrently, I became less engaged with spectacles that were being produced under the auspices of theory and administered by fashionable art centers, museums, galleries, magazines, art departments in American universities, and collectors in the Hamptons.

I began writing and lecturing more frequently and found myself questioning certain assumptions behind such once-fashionable terms as "multiculturalism" and "postmodernism." As a critical antidote I began using phrases like "institutionalized marginality" and "the post-Warholian nightmare," as if to suggest that art had somehow lost a sense of necessity and, in doing so, had forfeited any notion of the need for qualitative standards.

What had replaced these standards was a politicized rhetoric encased in a hardened academic language. It was not so much that I was rejecting the work of the conceptual artists that I had over the years worked so hard to champion in numerous essays, reviews, lectures, catalogs, and books. Rather, it was about expanding the parameters of art in order to make it more inclusive of forms that were being too easily dismissed. Yet it seemed at the time that if a critic became identified with conceptually oriented work, there was the immediate assumption that he or she had to be against what was called formally oriented art or, for that matter, art that conveyed a profound emotional content response through visual imagery.

By the nineties, the art world had become a matter of taking sides. If you were reading the "literature"—first, poststructuralism and deconstruction, and, more recently, the litany of books under the rubric of "visual culture"—then you were expected to think a certain way and to do a certain kind of work. The work usually dealt

with issues of "identity" framed in relation to an exegesis on "the body," "abjection," "alterity," or "subjectivity"—terms that have been more or less proselytized through various tomes on critical theory. On the other hand, if you were an artist exploring issues in abstract painting or working to reinvent a language of symbolism through interactive media or exploring content through new materials or asserting a position of intimacy as opposed to that of spectacle, you were considered out of the picture; that is, out of the *art world* picture.

This is to suggest that there has developed a distinction—an important and profound difference—between art as a significant creative mode of cultural expression and the kind of institutionalized marketing and publicity that exists in relation to it. The latter, though not clearly understood, is commonly referred to as the "art world." It is a microcosm that is generally understood as the social, economic, and political basis by which new art and emerging artists find support. It is also a world that reflects the cultural condition as a whole. This cultural condition is only tangentially related to art yet is overwhelmingly connected to the art world.

At one time, before the late seventies, the art world existed as a community of support; that is, artists were central to the art world. It was a community that was generally perceived to be outside the domain of the corporate mentality. In the eighties, the art world began to rapidly accelerate into a detached though intensely busy net-work; thus matching the software contingent with the times. With this acceleration of a business network came a proliferation of social and political concerns ranging from gay activism to multiethnicity to cultural feminism. While these concerns were necessary and important as timely vehicles for change within the culture, they were accompanied by an unfortunate fragmentation within the art world. In spite of the fact that a large majority of artists were fundamentally empathetic to these issues, there developed a profound mistrust—in extreme cases, paranoia—among the various constituents of the art world that culminated in what came to be known in the theoretical jargon of the nineties as "oppositionality."

However legitimate at the outset, these cultural issues were inevitably co-opted by the market. As the marketplace adopted a new line of slogans (ready-made promotion), criticism—that is, art criticism—was diminished and given the position of advocacy. The policy toward critical advocacy in the early nineties offered a twofold purpose: It slowly began to revive the art market by reviving the lost avant-garde (posing as "political art"). It further proclaimed an ideological piety—at the time called "political correctness," a rather ambiguous epithet passionately shared by both conser-vatives and liberals—a piety not so mysteriously removed from qualitative judgment.

As a "critic," you either agreed with the issues unequivocally and with the work of the artists who represented them—a type of corporate nonsensibility—or your position was viewed as modernist and therefore hopelessly out of touch. By offering a legitimate critical voice to this mindless advocacy, a critic might be given the over-determined label of "conservative"—a term that was bandied about after the highly politicized Whitney Biennial of 1993 to combat criticism that did not accept the premise of the show. In this sound-bite era, few readers will take the time to see the

difference or even to analyze the important gray areas that lay between conservatives and liberals. When the art world became politicized, as it did in the nineties, critical analysis no longer mattered. Only slogans were important, and slogans became the governing force in art as in big business.

At the present moment it is inconceivable that any realistic dialogue based on some form of internal critique could happen within the art world without the subtle intervention of publicity, management, and marketing strategies. Everything in art today is seen through the shroud of the market. By using the word "shroud," I am suggesting a type of religiosity, a piety about the market structure, an acquiescence to the sale of indulgences, which is uncomfortably close to what the art world has become. As the commonplace expression goes (at least in the television industry): you can't offend the advertisers.

Throughout the history of modernism, critics and artists have dealt with the end of art or even the end of criticism. I'm not going to repeat those claims or offer any new argument in relation to the end of art. If anything, I want to defend art, not as a philosophy, but as the material embodiment of an emotional structure within an era of globalization. What concerns me is the dissolution of art into a cyberspatial notion that exists on the same latitude as any other form of visual culture, whether it be a sitcom on TV, a Web site, a digital photograph, a multimedia display, a special-effects thriller, or a fashion show. This is less a conservative position than a radical reevaluation of the kind of sensory cognition that occurs through the intuitive, intellectual, and emotional components that become art. It is a position that embraces the intimacy of time and space—in contrast to the imposition of space over time as seen in countless gallery and museum spectacles.

Anyone who is aware of the progression of the art world as a social and economic force over the past three or four decades, either through lived experience or significant research, understands that art is now subjected to the same economic totalism as any other enterprise. Since the late seventies, art has become increasingly identified with its commodity status. Art and consequently artists have become increasingly acquiescent to publicity and media exposure. Just as the stock market depends to a large extent on media manipulation in order to keep investments afloat, so the art market depends on principle vehicles of exposure in order to keep the prices on a steady incline. In spite of what critics have to say, it is the exposure of the art that counts.

For example, if an artist who once showed promise is suddenly at a stalemate in terms of market activity, an influential dealer in the right position can work in the artist's behalf to regain the market. It does not matter whether the new work by that artist is significant or even good. What is important is that the dealer, like any responsible broker, ensures the status of the collectors' investments by maintaining the price structure. Just as the commodity market depends on trade magazines to give the inside story of what is happening with certain investments, the art world has magazines that function in a similar way. These kinds of strategies are, of course, well known by major collectors. This kind of art journalism is easily assimilated, if not assumed, in doing business.

Over and over again, trendy journals, dealers, collectors, curators, and critics at trendy symposia have cited the discussion of aesthetics in relation to works of art as irrelevant. In our overly pragmatic—and puritanical—society, there is virtually no thought of a synthesis between aesthetics and ideas. The critic is expected to represent one cause or the other. If an artist's work is fraught with intentions of one kind or another, then the work is not supposed to be understood in aesthetic terms. However erroneous this sound-bite mentality might appear, aesthetics generally refers to modernism, while ideas refer to postmodernism or beyond.

Therefore, if you do not agree with the significance of the ideas or the institutions that support them, you obviously do not "understand" the work. Ideas isolated from aesthetics engender a discursive response to art. The discourse becomes the institution, and the institution administers a consensual elitism bereft of any aesthetic criteria. Without such criteria, there is no critical judgment, only "mob rule." The mob wants their spectacles and their diversions. They want to be ruled by the mediated chain reaction of programmed "sensations." Is there any doubt that the Saatchi-sponsored *Sensation* exhibition (1998) has revived the art market in London?

One can see this happening time and again in relation to art foundations and museums that espouse a certain line, a specific modus operandi, that functions according to the bottom line—that is, the investments applied to the spectacle. In recent years, artists have become so conditioned to the presence of the art market as a governing force in what they do and in what they read that they may fail to see the degree to which they are pressured into believing that all the mediocre art put forth in elegant catalogues and expensive magazines must signify something important— something that is just beyond the reach of most artists who are struggling to find their own place within a fickle system where ruthless mayhem is shielded by concealed privilege. This is no different from the corporate world. There is the supreme illusion— a veritable real-life trompe l'oeil effect—that "art" is open to everybody. Just as industry needs a workforce, so the art world needs the projected illusions of artists.

To test the ground in this regard, it would be an interesting challenge to find a truly open-minded discussion within a significant institution where curators, critics, and artists of divergent points of view, who may fundamentally disagree on an issue related to the collection, discuss the aesthetic worth of an object or an exhibition.

Few artists want to say what they really feel lest it fall upon the wrong ears and ultimately damage their careers. Fear in the art world has become pervasive, so pervasive that aesthetic discussions have been utterly usurped by "information exchange" on the Web. These "chats" are concerned with such trivialities as the names of galleries that are closing or what directors from established galleries are starting their own galleries or who is moving to West Chelsea or the future of the "meat market" south of Fourteenth Street. This kind of talk has been so infectious that finally no one cares or wants to listen. The result is usually ending up at an after-opening party in some glitzy disco, sponsored by a prestigious gallery, where one sits with Perrier in hand, with music so deafening that no one can listen to anyone—a blessing that wards off the most ardent hustlers, the hangers-on, who become permanent fixtures at these affairs.

The post-Warholian nightmare is precisely this. Art has become irrelevant to

the art world except for the dinners, the parties, and the discos. It is one big, mindless bash where money talks and no one listens, and where even fewer see the art. Perhaps, in the sixties or seventies, Warhol could make such events into a scene and, in turn, enhance his publicity and ultimately his much deserved reputation. But Warhol was an original—and that was part of his allure, an attribute that even the critic Harold Rosenberg understood. But in the current atmosphere at the end of the nineties, at the finale to this century of modernism, the scene surrounding Warhol has become what it always was: a myth. This is something that Andy understood all along. The problem today is that few others seem to understand it.

The myth of the art world—and now, the end of the art world—is reenacted over and over again with the same dull beat, the same quasiritual, either out of inexperience, at best, or masochism, at worst. Human heads cast in blood, dependent on ultrarefrigeration, and sliced-up cows in cast Plexiglas, as recently shown both in London and New York, are fairly accurate signs of the times. But they are signs that belong to the semiotic structure of the social norm, signs that for the moment function in a kind of semiotic vacuum, a kind of hallucinogenic sanctuary, removed from the complexities and conflicts within a burgeoning globalization. Spectacles breed more spectacles, more diversions, and more tabloid news. The hyperreal spectacles in the current art world are like random channels on cable television: they offer the illusion that there is something significant for the spectator. The information is designed to titillate but not fulfill. There is no history, no memory. The ultimate diversion is the Internet, a hypnotic commercial ploy; that is, unless the viewer has the will or the intestinal fortitude to find precisely the information he or she needs. It is always easier to talk about porno paintings in a fashionable gallery or satyrs dancing painfully around a football field than to address the significance of serious painting or cinema. To deal with serious art requires a certain preparation of the mind, a relaxed synthesis whereby the mind comes into contact with the body, where there is a rejuvenation of seeing, and where thought is required to pull the act of seeing into the sensorium of feeling—to formulate ideas that are powerfully felt. It is time to understand the difference between what is symptomatic in such a mediated "culture" as ours and what is truly significant. The distinction is crucial in coming to terms with a new criterion in dealing with the art of the future; yet the signs are often deceiving.

On a more optimistic note, what I have tried to address is twofold: one, a point of view that offers an understanding of the intervention of corporate marketing into our understanding of art; and, two, examples of artists whom I believe exemplify an inner-directed approach to art. The inner-directed artist represents a position at odds with the commercially bent spectacle and the imposed economic fusion with the world of fashion. It is a position that is ultimately sympathetic to artists who perceive what they are doing, not as careerist attempts to find fame and fortune, but as attempts to seriously come to terms with their art.

The position offered here is not one of institutionalized marginality. It is not about the constraint of language or expression. Nor is it about the necessity to sell one's art. This is not a diatribe against economic support for artists. It is a plea to get in touch with serious art again and to offer support where it counts. The implication is

that artists are capable of succeeding according to their own terms by focusing attention on their concerns as artists. This is not to imply that artists should become diehard romantics hopelessly out of touch with the present realities of speed, information, and an accelerating market economy. Rather, artists should be challenged to accept and understand these hard-core social and economic realities in relation to their own existential positions in the world and in relation to their intentions in making art. It is a major challenge today for artists to focus on their work and avoid the *seduction* of the marketplace. Elegance and qualitative thinking in art will eventually be rewarded. The audience for art wants to feel intimacy in human expression in spite of all the indications that the spectacle has taken over. The art world is an abstract entity, an obsolete institution that needs to be transformed through the efforts of artists who maintain a purposeful disinterestedness in their careers without giving in to the mindless seductions that present themselves in every other gallery, magazine, and museum.

Artists with ability who produce significant work, and thereby make a contribution to our cultural lives, deserve to make a living. This requires, as Paul Klee observed in Dessau in 1926, an educated audience—an audience with the patience to come to terms with the art through intelligence and feeling. This is what will help to sustain art as a significant force in the next century. Collecting and supporting art requires more than arrogant strategies of investment; it requires a sensitive reception to new ideas. Chances are that these ideas are not endowed with cynicism and excess. They are not about spectacles that go and come like sports events or fashion shows. New ideas are within the province of art. Artists are still capable of producing them in the most astonishing and subtle ways. As one of these essays suggests, beauty may be what one discovers by paying close attention. The challenge is how to rediscover the act of seeing in this desperate age of speed and information, how to slow down and regain consciousness, and how to enter the world once again with an open mind and a new vision of what the future may hold with the prospect that it may actually benefit our lives. Artists have the power to redefine culture in their own terms—this is the crux of the matter in art today.

Robert C. Morgan
New York City
April 1998

I. Manifestoes

The End of the Art World

A colleague recently informed me that he had done some research and discovered no less than forty-three titles of books published in the past year dealing with "the end of" something or other. His conclusion was that indeed we are at the end of a millennium, and the publishing industry and the media are intent upon convincing us that this is the case—as if with all the barrage of information we might actually forget to notice.

As a matter of clarification, I am not talking about the end of art, but about the end of the art world—two very different issues. The implications of the former, I both dislike and distrust. The assertion of the latter, I believe, would be useful in thwarting the numerous media interventions, both political and economic, that are currently standing in the way of art. I would go so far as to say that these interventions of the marketplace into the work of artists stand in the way not only of discriminating what is significant in art from what is not, but also in the way of offering us a heightened sensory awareness of art as an expression of individual thought and feeling within a new global, and potentially intercultural, situation—a situation in which I have invested a considerable degree of optimism.

I am against the use of the term "visual culture" as applied to art, but believe it is a useful term in discussing other types of visual stimuli that perpetually bombard our senses from the hyperworld of media, fashion, television, commercial cinema, and all manner of material made available through the electronic Net and Web—in other words, the so-called digital world. I am against the notion of an amorphous posthistorical visual culture that neutralizes the significance of art, or art that neutralizes itself in order to conform to someone else's theory of what is now euphemistically called "the literature"—a term frequently deployed in academic departments where visual culture has come to replace, at least temporarily, a more thoughtfully expanded curriculum in art history.

The title of this essay admittedly has a certain sound-bite resonance, and, therefore, I am partially implicated in the kind of media activity currently being deployed in what is understood as "the art world." Nonetheless, to cite the method of the

3

great *photomonteur* and German iconoclast John Heartfield, the use of the media against itself can be effective as long as it does not go too far into cynicism.

A final introductory point I want to make is that this essay has no direct affinity with either Victor Burgin's very fine essay "The End of Art Theory" (1986) or with Arthur Danto's illuminating book *After the End of Art* (1997). I began working on this essay in 1994 when I was asked to write some brief remarks for an artists' journal published in New York. Gradually, over time, the ideas began to expand and develop into their current form.

I.

In recent years, various attempts to define the art world have become increasingly vague in connotation and problematic in relation to their social context. As advanced culture moves toward the end of the millennium, one could say that the cultural and economic requirements needed for emerging artists—and many mature artists—to effectively pursue their respective goals have become severely limited, if not altogether neglected, within the society. The absence of a consistent public or private support apparatus within the current artistic community could be read as a kind of fallout from the absurd marketing strategies of the eighties—a system bolstered, in part, by the overly self-conscious rhetoric of an Anglicized postmodernism that disclaimed stereotypes of the "struggling artist" as irrelevant in relation to the more ideological issues of art as commodity. As a result of this alienating mechanism, one could no longer assume that the community of artists and what was being defined as the art world—the mechanism by which artists are promoted and marketed—were identical.

In the eighties, the art world offered a form of social detachment to conceal the boredom of image repetition rampantly displayed in galleries, art bars, discos, and clubs. On one level, these images constituted a "real life" representation, signs appropriated from television soap operas, print media, and popular entertainment. On a mundane level, postmodernism in the eighties became a kind of manifesto for the art world—the resale marketing and investments, the social gatherings, dinners, and drugs. The art world of the eighties was all about cultural Reaganomics—supply side art—as if clients were infinitely available to buy gargantuan paintings and bits of detritus called "installations."

On a more academic level, postmodernism was a form of critical theory that challenged certain assumptions about modernism. One of the primary assumptions—somewhat ironical, in retrospect—was that modernism was "elitist" and that its elitism was shaped by notions of quality that were presumably based on aesthetic formalism. Yet, given the limited views about modernism being taught in American art schools throughout the seventies, it was no surprise that the generation of artists that evolved into prominence during the eighties was possessed by the overburdening desire to let go of its collectivist *nom du père* and relinquish the formalism of past decades. At this juncture, conceptual art became a code for anything that could be called an "idea" and

was fast becoming a radical presence in M.F.A. programs as an alternative to formalism.

At the beginning of the eighties, critical theory, whether French or German, became virtually synonymous with postmodernism. To engage in the so-called deconstruction of cultural signs became a fundamental issue in art. Experiencing a work of art was no longer about any degree of heightened emotional awareness. Art was no longer about transformation of one's idea of the world through feeling. In postmodern terms, art was, at best, a historicist exercise; at worst, a cultural delusion. Desire was considered inferior to information. Initially, critical theory was important as a method in coming to terms with the absent "aesthetics" of neo-expressionist painting. Gradually, it evolved into something else: an anti-canon to offset the canon of modernism and the "elitist" conventions of a patriarchal culture.

Advocates of postmodernism, weaned on the writings of Benjamin, Foucault, Derrida, Lacan, Barthes, Lyotard, and Baudrillard, began to declare intellectual warfare on "Eurocentric" art, suggesting that it was merely a representation of a much broader, yet concealed, history of Western colonialism and imperialist expansion. In such a climate, the term "aesthetics" was no longer useful. What replaced aesthetics— and, to some extent, criticism—was a form of applied theory, generally appropriated from philosophy, sociology, and psychoanalysis. For many of those who entered into the art world at the end of the seventies, it was evident that much of the theoretical rhetoric was already firmly established in other fields—namely, literature, cinema studies, and architecture.

By the mid-eighties, a popularized form of critical theory began appearing in various art magazines. Although commercially biased, the rhetoric suggested a reduction of options when it came to which artists the magazines considered acceptable for publication. Another result of this rhetoric was the introduction of the artist as a kind of rock star. Some artists, so inspired by this new model, began hiring assistants and press agents in order to fashion their image, to re-create themselves in order to appeal to "collectors" who demanded a new mystique. It was as if being an artist was largely a matter of successful publicity and promotion. Art magazines became important promotional vehicles for a new market-driven art world.

II.

Today, what is commonly called the art world is less a community of creative people than a detached network of subscribers whose existence depends on a set of precise taxonomical divisions. For various complex reasons, too many artists are becoming insecure about their role in society or their direction in becoming a significant cultural force. Instead of taking a position in response to the "instant effect" art of the nineties, artists are buying into the most nonthinking aspect of information culture, thus putting themselves in a position of competition with advertising and the most superficial entertainment media. This results in unnecessary pressures that are less beneficial than frustrating. This is not to imply that social and economic pressures cannot be real.

Rather, it is to suggest that when a self-imposed careerism becomes an obsessive goal, these pressures can become unnecessarily inhibiting in terms of how one functions as an artist. The result is a hardened cynical approach to art, an approach that extends beyond irony. To get at the opposite of cynicism, one must return to the origin of one's emotional strata to see what one is doing and why one is doing it. What is the purpose of one's art? Why be an artist? What is the motivation?

These are tough questions. I think they have always been tough questions, but, of course, the present always outweighs the past. We are all up against the present. And part of this alienated cyberspatial present—what postmodernism has avoided—is a failure to see the common basis underlying artistic intentionality. Advanced creative expression in this culture is not valued as part of society's normative structure. In fact, artists are seen as an idiosyncratic minority.

The splintering of factions within the community of artists at the current moment seems unnecessary and self-defeating. As society has moved from an industrial to a conceptual base, artists are caught within a period of high transition, a new phase of acculturation. In view of this transition, one might ask why so many exhibitions, symposia, panels, and articles have become fixated on the question of "otherness" when, in effect, the pursuit of art in itself has become society's "other." As for these separatist factions within the art world, it appears that the greater sector of our mediated global society does not particularly care. Regardless of the art world's perception, the ideological boundaries established within the current discourse are trivial, if not insignificant, among the vast majority of commercial technocrats and other workaday professionals. In this isolated context, artists might further ask: Where is the real community? And what kind of audience and support system is available?

I doubt that postmodernism has changed the way society perceives what artists do. What society understands about advanced art is the media's view of art. This was true with early modernism and it is true of postmodernism today. The populist view has no particular regard for either art or artists other than as a political rallying point. The French situationists made it clear in the sixties: society wants its spectacles as a diversion from the pain of capitalist exploitation, a diversion from the masochistic lifestyles of a programmed recessionary economy in the late twentieth century. Still, in spite of the media "consensus," it is necessary that artists proceed as if their art mattered, as if their social role offered society a spiritual infusion as opposed to a simulated careerism. If the artist's role seems illusory, it is still an essential one. Artists cannot sustain their work in a cultural vacuum driven only by fashion, cybertechnology, nostalgia, and cynicism.

I would say that today the more accurate use of the term "postmodernism" has less to do with a genre or style of art than with a condition of culture that affects the way we live in the world. This is not a new idea, merely one that got derailed largely for the benefit of utilizing rhetoric as a marketing strategy. It would seem more appropriate to let go of this rhetoric in order to claim a more practical application of the term "postmodernism" as a form of acknowledging the general conflict between cultural identity and the pressures to become, shall we say, transcultural. This conflict, which is by no means a simple one, implicates such variables as psychological distance,

fragmentation of belief, the suspension of opposing ideologies, and the control of specific economic interests.

One might also cite the perennial information glut as obscuring the trace of historical memory, including aesthetic signification, and displacing it with effects of surreal brutality and violence that cross over between domesticity and public life. These effects are contingent on the cultural variables of everyday life. They are not directly responsible for art, though indirectly they influence the content of art. Art strives to be qualitative through the artist's experience, but art cannot solve real-life problems. Yet, art defines itself in relation to these problems and, increasingly, in relation to their transcultural effects.

Historically, art has been able to sustain itself as a conduit of expression, even under the most difficult and intensely disturbing situations, even in the most underprivileged situations. The individual's struggle to make art under dire circumstances has been, in some cases, one of considerable significance that often lends itself directly to the content of the artist's work. On the other hand, one cannot ignore middle-class privilege as a reality for artists whose external world has proved more fortunate. The luxury of not having to worry about rent, food, and survival is another case. Yet, this does not—and should not—disqualify the significance of an artist's work. Art is a matter of finding the means to intuit meaning.

III.

Whether the struggle is an internal or an external one, there are important artists who are not being shown, promoted, or advertised in the delimited infrastructure of today's art world. There is a problem when art becomes an overtly market-driven enterprise, contingent upon mystique, as it has become since the eighties. To make art happen as a vital force within culture despite the rhetoric that supports this mystique through the sale of escapist spectacles, is to recognize that artists may still have a community in which to muster strength and mutual support. This community may be defined as one that maintains as its basis an open sense of internal critique. It is only though a sense of dialogue within the community that artists can hope to contribute a presence in relation to the cultural context that exists outside.

Over the years—since art has become "radicalized," or, rather, acquiescent to theory—some advocates of postmodernism have tried to diminish the separation between serious art and the conformist phenomenon of the wider market-driven art world, as if the need for any kind of real dialogue among artists and critics were insignificant. It is precisely the artist's dialogue that offers a spontaneous urgency and a necessary point of resistance to the conditioning processes inherent in an advanced capitalist world. If I understand the message of Joseph Beuys correctly, this is what he advocated in his "social sculpture." For Beuys, the puritanical isolation of the art world, based solely on materialism, was a negative force in culture. Instead, he incited the activation of what he called "power fields" within the society, and artists were the instigators.

I would argue that to be an artist in the most fundamental sense is ultimately a task of liberation. This is to suggest that to be an artist in the international sense is not simply about marketing one's logo, but is about maintaining a certain ethical relationship to art. It is about positioning oneself in opposition to the assumption that the information network carries its own "natural" momentum and will automatically improve life. It would seem that artists cannot escape the ethical responsibility to resist this omnipresent pressure, the wholesale seduction that the art world assumes in its desire for a revisionist informational environment. To be an artist— regardless of how one's success is measured—has always been a matter of intelligence, passion, constraint, shrewdness, and wit. This implies a position of resistance, but not one of denial. The power of art lies in its oblique angle to the accepted cultural norm. Artists define themselves as artists in terms of both their attraction and repulsion to this norm. The crucial issue here is in finding what sustains the necessity of one's liberation, because artists will move in relation to this necessity more than in the pursuit of ideas.

Art must be willing to resist what Barthes designated as "the fashion system" or it will gradually deconstruct itself under the guise of political slogans and social codes. In doing so, art will cease to exist as a cultural force of any remarkable consequence. Becoming an artist is a matter of priorities. Again, one must be willing to ask, What is the motivation for doing what one is doing? It is within the context of a community that these priorities can be tested and better understood. Liberation through art is both social and psychological. To this extent, art is a force that resists institutionalization. Art is a force close to life.

While the term "postmodern art" may have been useful in architectural theory in the late seventies, it does not fit seamlessly within a generalized discourse on the current situation in art. In fact, postmodern art does not exist. It is not a style because its very premise, being one of historicist appropriation, refutes style. As a prerequisite to modernism, the concept of style can no longer bear the weight of postmodernism. The only reason to discuss style in the nineties is to offer another marketing device to sell a politicized form of art. Put another way, the concept of style has often been used to sell derivative art that lacks insight, force, and qualitative significance. To clarify: we are not talking about an individual artist's historical orientation or approach to art-making; rather, we are talking about the imposition of a nuance by which to maneuver certain ideological and economic interests. It is a problem that could relate as much to formalist modernism as to neo-conceptualism. It is an overdetermined method that tries to deny its sources and, in doing so, merely becomes another marketing device—a metonym for advanced capital.

Postmodernism signifies repetition within the reification of objects. In a cultural climate fraught with cybertechnical gadgets, the current art world constitutes an abundance of signs caught within a tautological system of privileged referents. The same signs get repeated; thus, there is no forward motion. There is an illusion of motion. There are few cause-and-effect relationships of any consequence associated with artistic intent. This is one of the fundamental problems with regard to art made for the Internet. The experiential dimension is limited to the program, and the program is finite to the extent that the variables are only as good as the moment they were

determined. At this juncture, I would have to conclude that the vast majority of art on the Internet is merely another aspect of formalism that employs electronics instead of canvas.

This is not to discount the spectacular effects of visual culture as induced by interactive computer programs. The question being raised here is more about the lingering effect of these images. It would seem that the force of ideas in art has largely depended on what might be called the tactility of the image. The exceptions that I have seen are largely video installations where the interactive aspect of the work is truly an engagement with the immediate space in which one is situated; but this is a much larger, speculative issue than I can address here.

Just as images of the rock star Madonna have the apparent power to replace sex with the signs of sex, so art has been given a surrogate status in relation to theory. Put another way, art has come to play second fiddle to another level of rhetorical justification. The signs of art exist in a state of flotation—automatist signifiers within a noncontext of a burgeoning commercial cyberspace. The endgame is directed toward purchases that are made to vanish the very instant we dial the toll-free number. Instead of art, we are receiving the signs of art—signs that lead nowhere, signs without certainty.

Conclusion

One could argue that this paradigm describes the condition of society as it has come to frame corporate culture. In this sense, we could say that the postmodern condition exists, but not postmodern art. The packaging of art as "postmodernism" has been mistakenly understood as if it were another modernist style. Such maneuvers have contributed, in large part, to an overinformed and undereducated art audience. Postmodernists, of course, disclaim the modernist notion of the indelible trace of the artist's hand or mind as having any relevance to today's visual culture—again, another topic for another time.

Postmodern culture is the rule, the predictable spectacle, the cycle of entertainment and arousal—all aspects of predictability that artists must be willing to both accept and finally reject. Artists are both transformers and resistors, capable of recognizing themselves both as decentered and recentered subjects. Being an artist is a matter of trying to locate one's position in postmodern culture. It requires an inner-directed sense of reality, one that resists the loss of self-esteem. The artist's identity is contingent on a functional dialectical means, not a factionalized programming. The challenge for the artist is to rejuvenate the aura in art and thereby to rediscover the transmission of the creative impulse. In contrast to the more utopian aspects of modernism, artists today may become socially and politically involved not within an isolated and paranoid cultism, but with a community of artists willing to question the assumptions wrought by postmodern culture. Being an artist has the ethical dimension, in the Spinozan sense, of attending to specifics first and of avoiding the generalized moral imperatives of a puritan social taxonomy.

For the inner-directed artist, skepticism will come to replace cynicism in art. To be skeptical is to have a necessary aesthetic distance in relation to one's practice. To be cynical is a severe detachment in relation to one's experience with a work of art. In the latter case, art is negatively transformed into a system of politicized representations. Cynicism assumes privilege as the condition of art without ever confronting the effect of privilege in relation to content. This privilege often disguises itself through arrogance and projection and mindless, larger-than-life spectacles.

Dialogue between artists will become essential to the task of identifying the evolving possibilities for art in the future. Certainly, the Internet is one way of facilitating communication within a globalized context; yet artists should exercise caution. The digital dialogue is important if it allows experience to be articulated and if it further opens the door to a critical discussion on the qualitative standard in art. Quality in art can no longer be dismissed, and it can no longer be confused with privilege. It is a matter of a heightened sensory cognition, and it is for this reason that the notion of quality will persist. It will persist as an informed subjective idea. The experience of art cannot be proven, but it can be communicated. I would suggest that to be an artist today means, above all, to offer a purposeful and deeply intuitive resistance to the enormous influx of cultural programming that has become an assumed liability of the informational superhighway. This alone should be enough for artists to insist on an independent, yet interactive position in the era of a burgeoning globalization. Artists can still resist, and by resisting they can make the future possible through the determination of their own deeply personal creative efforts.

The Delta of
Modernism

A theory of art implies something different from a theory of art-making. In the first instance, we are dealing with a philosophical or aesthetic problem that is unavoidable in the study of objects produced in any culture. In the second, we are referring to theories constructed by artists to suit their own needs in accordance with the development of their work. Whereas the art historian is generally interested in the use of normative theory as an analytic tool, the artist is essentially involved with heuristic theory; that is, theory that develops in correspondence to the formalization of an image or idea.

In addition to art objects and events, heuristic theories have been expressed both systematically and indeterminately in sketches, diaries, notes, poems, lectures, diagrams, videotapes, films, and all matter of symposia. But before we explore the nature of heuristic theory as expressed within these various contexts, let us turn for a moment to normative theory—that is, the position of art historians and aestheticians—and consider the impact it has had upon developments in the art world three decades earlier.

The concept of modernism, as interpreted by Clement Greenberg, traces a linearity of development in Western art stemming from Manet's attention to the literalness of the picture plane through the post-painterly abstraction of the sixties.[1] Most of Greenberg's significant theories made their appearance just prior to the advent of American large-scale abstract painting.[2] The turning point in Greenberg's position as a normative theorist came in the middle sixties. This was the fulcrum between popular art and so-called high art, between kitsch and quality, and between significant theory and solipsism. It was also the beginning of what I have chosen to call "the delta of modernism," a point in the history of American art where the vanguard energies of artists began to divide, to subdivide, and eventually to branch off into a network of autonomous and uniquely individualistic concerns.

Whereas Greenberg followed in the aesthetic tradition set forth by Baumgarten and the philosophy of Kant, it was Harold Rosenberg who chose the polemic avenue of Diderot.[3] There are few relevant theories of art-making that are capable of

avoiding the terms proposed by either of these positions. Whereas Greenberg's historic-
ity oddly reversed itself and became yet another form of idealism, Rosenberg grounded
his criticism in a kind of Romantic existentialism, thus directing his attention to the
content of an artwork—both social and psychological—which he believed to be a
primary incentive. Whereas Greenberg took the role of a cultural theorist, Rosenberg
followed a topical-literary approach as a commentator not only upon the extrinsic
conditions that surrounded the production of art-making, but also upon the intrinsic
value of the work, the inward comment of the artist. A successful artwork, for Rosen-
berg, did not depend upon a social milieu to encourage its meaning; quality in art was,
in fact, separate from milieu. Good art sustained its own meaning within an aesthetic-
moral context as well as a social one.

Both Greenberg and Rosenberg have supported the notion of quality. For
Greenberg, quality meant taste founded on a rational style of self-critical reflexiveness, a
certain integrity to the medium and then some—that extra zest by which modernism
transcends its purely formal connotations. Yet, for Rosenberg, quality seemed deter-
mined through an object's propensity for literary interpretation; that is, what the image
could evoke in the imagination and how far this encounter could ascend the spirit of
the beholder. The notion of "quality" in either case—for either Greenberg or Rosen-
berg—had a strong emotional basis. Yet, Greenberg's further willingness to engage in
systematic discourse with art history eventually gave his inductive positivism an air of
prescription. It was this tendency toward prescription that found the most resistance
among younger artists who rejected the limitations of formal reductivism, a tendency
that characterized much of the art produced in the sixties.

The generation of artists that emerged out of the sixties and seventies held
a different set of expectations than those who emerged out of the forties and fifties.
Generally speaking, vanguard artists of the last twenty years have regarded theory
established in previous decades with resistance, suspicion, and, in some cases, vehe-
mence. These reactions to normative theory are often uninformed. In other cases,
however, the arguments are coherent. Even so, in recent years, the neglect of—shall we
say—a more humanistic approach to theory has found the art world in a state of utter
buoyancy, a kind of voluntary groundlessness, given a certain apprehension about any
brand of aesthetics as a criterion for critical evaluation.

The journalistic term "pluralism" that became associated with the art of the
seventies, gave some indication that the necessity for holding an aesthetically based set
of criteria was being challenged. A curious aspect to this phenomenon was that many
counterpositions by various critics and theorists soon became available to fill the gap.
The void left by the inability of Greenberg's modernism to sustain itself into the
late sixties and seventies dropped the ground out from under aesthetics. Without a
substantial normative theory to fall back upon, criticism became divided between the
journalists, on the one hand, and the serious critics, on the other, who aimed to replace
normative aesthetics with analytic philosophies and social scientism. Some of these
positions included varieties of structuralism, phenomenology, Marxism, feminism, and
semiotics.

A common problem among each of these secularizations of normative

aesthetics was how to translate their terminology into an operative critical vocabulary. Too often there was a tendency toward heavy-handedness in trying to apply these "theories" to specific works of art. It is no wonder that the conceptualists saw this as an opportunity to reinstill criticism within the context of the artwork itself, leaving the responsibility of criticism up to the artist. The problem with this position, however, is that the criticism is never really directed at the art, only at the culture that the artwork attempts to underscore.

It has since become apparent that a successful artwork is not guaranteed by facile accommodations of theory, particularly theory that is conceived on grounds other than aesthetic. Often the distance between theory and practice is so vast that any attempt at critical explication falsifies the purpose of the work itself. The extreme opposite, of course, would be a purely subjective account of an artwork that may have little or nothing to do with the artist's intention or even with the culture or subcultural context from which it evolved. But the focus of this essay is not to belabor criticism; rather, it is to address the problem of where theory has gone since the linearity of modernism began to form a delta, hence creating a new "post" era in the seventies.

The geologist James M. Coleman's book *Deltas: Processes of Deposition and Models for Exploration* (1976) defines a delta as follows:

> The term "delta" was first applied by the Greek historian Herodotus, approximately 450 B.C., to the triangular alluvial deposits at the mouth of the Nile River. In broader terms, deltas can be defined as those coastal deposits, both subaqueous and subaerial, derived from riverborne sediments. . . .[4]

My application and appropriation of Coleman's definition is for metaphorical purposes, thereby implying that rivers may refer to the chronology of time. A delta would imply the end of a particular concept of time as it relates to modern art. One may refer to the earth art and writings of the artist Robert Smithson as having some importance in first realizing the metaphorical relationship between art history and geological processes.[5] The linearity of artistic developments that has been identified in Western art since Manet indeed testifies to the acceleration of change that has occurred in our perceptions of the world, in our relationships to one another, and in our understanding of life itself. This veritable compression of time—that is, the shape of recent time—has, in fact, changed our very notion of history. The distillation of information, including historical facts and data, may be one indication that our concept of art as a historical linearity, arbitrarily divided—once into centuries, now into decades—is changing. There is an inherent contradiction posed in the notion of something still so relative to culture as "contemporary art history." Thus, the arbitrariness of recent modernism has pushed the history of art in front of art itself.

By the late sixties, we began to see various groups of artists talking about the idea of art bereft of a visual coherency; that is, without a necessary formal intent. For conceptual artists, to make art was a matter of regrouping data into some indeterminate signification. Yet, we cannot afford to overlook some of the ramifications implied by

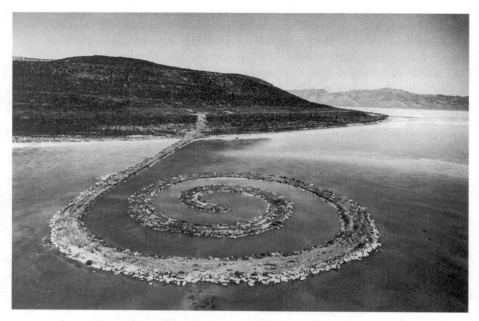

Robert Smithson, Spiral Jetty, *1970. Courtesy John Weber Gallery. Photo: Gianfranco Gorgoni.*

these proclamations as attempts to provide alternatives to existing modernist theory. The mediumistic paradigm was rejected as vanguard artists of the sixties began to look more in the direction of Wittgenstein's "language games" as a means for restructuring their theories about art-making. According to one conceptual artist, this reawakening of theory implied a shift from closed meanings in art to how art functions on a larger scale. That is, the implicit concerns of formalist art were rejected, then replaced by a more explicit concern for contextual awareness—namely, the relationship of art to the social structure. If an artwork is indeed a metaphor, dealing exclusively with aesthetic content, then how does it function once it leaves the artist's domain? What new meanings are attached to it? And whose value system does it come to represent? Along these lines, some artists became interested in the dialectical relationship of their work as an active agent within culture. A semblance of this claim was clearly advocated by Robert Smithson, an artist whose awareness of natural history was metaphorically entwined with that of culture. His own reconciliation of these two anthropologically discrete systems was to reify his thought processes into the geological strata of the earth whereupon the viewer/photographer might transcend any formal analysis in favor of a direct time-space encounter.

But the issue remains that in order for any form of art to work dialectically with those value systems already embedded within a culture, it must first have some acknowledgment of its receivership—in other words, an audience. If there are too few who understand the language of art, particularly the language of the avant-garde, then the game of conversation is bound toward monotony, an endgame cloistered by too

many constraints. To speak of the diaspora of styles, trends, labels, and techniques in existence a decade ago with any coherent chronology would be absurd, an exercise in splitting hairs, relevant only to a marketplace attempting to justify its wares. Recognizing this fact may further suggest the role of media fabrication in relation to contemporary art history. Much of what has passed for art history over the last decade is art journalism written in a normative style. Information alone does not make art history. What is required is authentic interpretation based on the research of facts and data. It is the critical voice that channels art objects and events into some future history. The type of pseudo-aesthetics to which we have grown accustomed has little relationship to historical methodology and almost nothing to do with the actual maneuvering of a dangerously extravagant marketplace.

In studying the formation of the delta three decades ago, one may recall such phenomena as body art, performance art, earth art, process art, conceptual art, photo art, narrative art, book art, and anti-art. To impose a linearity of sequence upon these developments, many of which have further branched out and intersected again, would be a misrepresentation of their real course of development. Rather than burdening these works with a chronology of recorded history—that is, through a diachronous course of temporal relationships—would it not be more accurate to reveal their synchronic features? They are not separate movements, after all, but relatively interrelated groupings—a fact about their origins that needs to be recognized. In most cases, particularly in New York, their differences are based on a clear awareness of other neighboring contingencies.

In the seventies, we began to hear the antecedent "post" applied to everything in art that had managed to sustain itself on the market for longer than two years. It is worth recalling that this well-worn antecedent was once applied to the term "impressionism" by Roger Fry in order to categorize what itinerant painters like van Gogh and Gauguin were trying to do. In recent years, the more prevalent nomenclature is that of "postmodernism"—a term that has created a good deal of ambiguity among critics. One source for the term "postmodernism" finds its etiology in a style of architecture that was conceived either as a reaction to Mies or as some fanciful variation upon the look of austerity in recent buildings. Soon, however, the term slid into the vocabulary of art critics, who tired of seeing everything as "pluralism." The generic connotation of pluralism became too vague and too generalized to be of much benefit or consolation. It signified little more than a market strategy, thus giving a broad eclecticism of styles a reasonable prospect for investment.

A more accurate term, in spite of its temporal and stylistic limitations, would be what critic Robert Pincus-Witten has called "postminimalism."[6] This tripartite analysis of vanguard art produced in New York and California from 1966 to 1976 manifests itself in three ways: (1) the pictorial/sculptural, (2) the epistemological, and (3) the ontological. This discrete branching off of minimalist tendencies is some indication of a delta being formed, that modernism as a linear development had run its course. My only quarrel with "postminimalism" is that reconciliations of aesthetic taste are too often measured in terms of antecedents rather than through intrinsic effect and implications. The critical urge to establish antecedents during these primary phases of

delta formation may be more conjecture than significant history. Issues of taste do not always correspond to statements of theory. Yet, what is commendable about Pincus-Witten's contribution is its potential as normative theory in an era of utter fragmentation and polarized belief regarding the function of art-making. Here appears to be a sincere and fundamental reassertion that vanguardism persists as a continuing and worthwhile endeavor, a true manifestation of thinking processes in an increasingly regimented society.

Still another "post" was given by Jack Burnham, a critic with a Duchampian bent. He referred to his writings as "essays on the meaning of post-formalist art."[7] Also, in the late seventies, a reputable art school advertised their program as "postconceptual" in emphasis—a term that has since gone stale in critical jargon. There are other schools that advertise "post-studio" programs. Both critics and cultural theorists regularly use the term "poststructuralism" in their writings, borrowing heavily from French theorists such as Derrida, Foucault, Lyotard, and Lacan.

In 1979, Douglas Davis ran a three-part series in the *Village Voice*, entitled "Post-Post Art."[8] If anything, the title remarked upon the absence of any coherent normative theory since modernism. An interesting point that did emerge from Davis's scattered sequence of quotes and commentaries was not so much about the current direction of art as about the assumed manner in which the art world and its public receive information; that is, the content of its delivery. Part of the issue relates to media strategies that deliver various permutations of images and text and the way this information always manages to stay just ahead of the latest development. This phenomenon, of course, is not only related to art messages. As shown in recent presidential elections, the media has the power to make a "post" phenomenon occur before the event itself has played out. The reality of information has come to usurp the reality of form. Anxiety keeps us afloat.

The concept of a "post art" has undoubtedly been around for some time. Certainly the fluxus artists of the early sixties were enamored by the possible annihilation of conventional art. They, of course, drew their inspiration from the dadaists. Perhaps one of the most effective gestures during the seventies to carry forth the idea of post art was not made by an American artist. Rather, it was made by two Russian artists who were geographically and ideologically removed from the cultural mainstream by which so much recent art has come to be known. Aleksandr Melamid and Vitali Komar found a reproduction of one of Andy Warhol's soup cans in a museum catalogue while they were working as an artist team in Moscow in the early seventies. They took the measurements of the canvas, scaled the image up to size, then painted it according to the color seen in the reproduction. The final step in the process was to ignite their painting of the Warhol, once it had been completed, with an acetylene torch. When the image had been sufficiently charred, they took the remaining remnants and mounted them on the surface of an unsized canvas and called it *Post Art No. 1*. Other pop art reproductions were soon to follow.

What I find interesting about Komar and Melamid's *Post Art* series is not the resolution of a formal problem in painting, because their work has very little to do with formal problem solving. (This, by the way, is a conscious attempt.) Instead, I am

16

interested in the way they took control of a media image that had already been signified within the context of contemporary art-making and designated as art history, as if it were being perceived two hundred years hence after some kind of natural erosion or man-made conflagration. Rather than trying to stay within the historical predictability of formal art procedures, they decided to jump outside the culture that had substantiated its present meaning and see it in instant retrospect. The art of Komar and Melamid is an art of satire. Their comment upon current art practices in American culture may be unpleasant, but it cannot simply be passed off as another form of linear progression. Their art attempts to stay outside the cultural parameters that support the meaning of art as a phenomenon that may require more questioning than we have as yet been willing to give.

My purpose here is not to go back to the questions being raised at the outset of the seventies about the future of art. It is, however, an attempt to come to terms with the repetitive and facile solutions that have been used to avoid the despair and "quiet desperation" currently seething in the art world. With the sophistication of advanced communications technology, via electronic sensors, laser beams, and satellites, the task of fabricating an instant linearity of historical facts and antecedents from an ever-increasing lexicon of recent art is neither the most humanistic approach to a basically human discourse nor is it appropriate as a methodology for the interpretation of data. This is to say that theory founded upon simultaneity, not linearity, would seem a more accurate response to the condition of art-making today. The mediumistic paradigm may certainly apply to a successful painting without intimating that the painting may also be a work of art. If the criterion for good painting is determined by how carefully and spirited the refinement of paint appears on canvas, then where does that leave sculpture? Is wood better than stone? Is steel better than bronze? Or, put another way, are freestanding forms superior to those on pedestals? This is to say, art can no longer be limited to "quality" based upon certain "rational" choices of medium or even approach. On the other hand, there is nothing mystical about formal clarity used in delivering a clearly sought feeling or idea.

In that I am advocating a heuristic approach to viewing current trends in art-making in contrast to the imposition of normative theory, my statements here might be heard as belonging to a polemic tradition of art criticism. It is, in fact, more conservative than polemic—related indirectly to a tradition of discourse set forth by others, such as Baudelaire and Ruskin. Nonetheless, my sympathies reside in the ever-present struggle to maintain an effective dialogue between art and culture. I do not regard the delta of modernism as a necessary conclusion or apogee of past achievements, beginning in the latter part of the nineteenth century, but I do view the present as a moment of confluence where what may appear to be objective time is actually comprised of numerous subjective rivulets that are taking shape in human consciousness. Consequently, I am seeking a renovation of heuristics from a critical as well as from a production vantage point by looking seriously at the present in hopes of preserving art through a forceful recognition of what is qualitative within an ever-developing transcultural world. The preserving of art in this sense only means that those special qualities of feeling and personal emancipation that are exempt in the

corporate media and in popular culture can still be found in art. Yet for art to perform this special function it needs to be understood as distinct from the art world and all the media and marketing strategies that encompass it. This determination will be made only if reasoned qualitative judgments are allowed to flourish independent of the commercial support structure that currently oppresses the editorial position of art magazines.

The Status of Kitsch

We long for this space, and the sensory overload that this discombobu-
lation provides, but we can't have it. It's all been circumscribed and
prepackaged and inscribed in the form of kitsch. So the idea was to mate
that primal need we have for kitsch packaging and the feelings them-
selves—somehow it's about a sense of loss. But we can reinvent ourselves
in kitsch, like a dog can get excited about going out for a walk on a chain.

Ashley Bickerton

When the late American critic Clement Greenberg wrote his famous essay
"Avant-Garde and Kitsch" for *Partisan Review* in 1939, there existed a radically differ-
ent context for dealing with issues of politics, ideology, and art—particularly among
New York intellectuals.[1] Greenberg understood the limitations of certain types of art
that ran contrary to his view of the avant-garde. He disliked what he saw as tasteless
forms of art that were susceptible to being appropriated by political and ideological
systems, such as in Stalinist Russia. When art was utilized in this way, it went through
a kind of negative transformation. According to Greenberg, the major threat to mod-
ernist art was the imposition of a debased standard of quality as evidenced in the
sensory numbing effects of mass production. Greenberg used the absence of this
standard as a determining factor in evaluating works of art. If a certain qualitative
presence was *felt,* then the work of art was deemed to have taste. If it did not possess
this quality, then it was either lowbrow art or "kitsch" to be consumed by the masses.

This is somewhat oversimplified, but one cannot help but acknowledge the
clear Marxist underpinnings of Greenberg's view of culture at that time.[2] In retrospect,
one might say that the problem of kitsch today is less an art problem than a cultural
delusion that has become a reality and is thus being evaluated as art. My argument is
that kitsch today is less aesthetic than cultural, and that the standard of quality used to
discuss and evaluate works of art in former decades have very little relevance when
applied to kitsch. In an interview presented thirty years later, Greenberg referred to pop

art as a "period manifestation" rather than serious art[3]—the implication being that like any visual effect belonging to mass culture, including media and advertising, pop art was perhaps more related to cultural anthropology than to aesthetics.

In the nineties, the context for viewing kitsch is considerably different than it was at midcentury. Today, kitsch is more sophisticated and more consciously cynical. It has become accepted and reified within its own system of production. It is one of several modes of discourse responsible for promoting the notion of cultural studies in American universities as a field distinct from that of aesthetics or, for that matter, art history. Rather than evaluate artists like Jeff Koons, Damien Hirst, Mariko Mori, and Matthew Barney, among numerous others, according to some predetermined art-related criterion, the argument currently presiding in the academy is to evaluate their respective careers in terms of "visual culture." Other artists might include Mike Kelley, Ashley Bickerton, and the recent Cindy Sherman, even though their positions appear more idea based than the others. The Puerto Rican artist Pepón Osorio would seem to use a kitsch approach in installation works, such as *Badge of Honor,* but in his case the kitsch is more of a subcultural ploy in order to get at a more personal and psycho-sociological statement. He is less detached than the others.

Contrary to their stated intentions or even the authoritative opinions stated in defense of their works, these artists appear less involved with instigating radical ideas about art than in revealing certain cultural effects in the vein of pop entertainment, rock music, the fashion industry, and Hollywood movies. These artists function as an extension of various media-effected post- and neoconceptual practices combined with a nostalgia for popular culture. In a recent visit to the Metropolitan Museum of Art, I spent some time studying late-nineteenth-century Salon painting. It is curious to compare such paintings as *Springtime* (1873) and *The Storm* (1880) by the young Salon artist Pierre-Auguste Cot with one of Koons's photo-paintings from the *Made in Heaven* series, or the work of Bouguereau with some of the later, more ironic photographs of Cindy Sherman. The relationship to kitsch seems undeniable in spite of the fact that the photographic medium has replaced oil painting. If one accepts the notion that this kind of art is simply part of the same "democratic" bricolage—as some art historians are willing to concede—then the problem is solved on the basis of what is titillating or alluring or interesting at any given moment. This is a noncriterion that allows the work to disappear as quickly as it comes on the proverbial screen. If one believes this to be the case, then art is no longer distinct from other commercially driven media.

The notion of visual culture is, in fact, a neutralizing position that offers no real incentive to explore the real significance of art on the level of experience. It makes no distinction between qualitative experience and the effects of media. It presumes that everything is on the Web and therefore can be analyzed on the level of social and ideological analysis. Therefore, when one talks about art and culture today, it does not have the same resonance it once did. Although the opposition between the two may appear vast, art and culture are discussed as virtually synonymous, as a single entity, within the hybrid of visual culture. This has created infinite confusion about the qualitative significance of works that exist outside the world of cyberculture.

Some artists and critics alike are willing to argue in relation to the vast separateness between art and culture today. But if we can drop the term "kitsch" as a negative assessment in relation to advanced art, the kind of work I am discussing here becomes "a period manifestation"—to use Greenberg's latter term—where judgments of aesthetic quality are simply beside the point. Since the sixties, the avant-garde has been invaded by kitsch to the extent that the avant-garde has been consumed. Kitsch has become a surrogate for the avant-garde. The opposition exists only when the focus of each is clear. What we have now is another kind of bifurcation, another structural problem where qualitative significance in art stands in opposition to visual culture. They are as far apart in the nineties as avant-garde was from kitsch in the forties.

At the conclusion of a lecture, "Conceptual Art and Postconceptualism," which I presented at the Contemporary Art Center (Zamek Ujazdowski) in Warsaw last June, someone in the audience asked if I would share some of my thoughts on the future of art. Though I risk being wrong in my predictions, I usually make it a point never to give the same answer more than once. Ultimately, one realizes that most of the ideas and judgments about highly visible art, whether emerging or established, have all been said before in one way or another. They have been stated in other similar situations. Once everyone agrees that a certain artist is important, the discussion becomes neutralized. The decision as to the future of art, like with any political or social institution in which power and economy are at stake, is a consensus that is reached by major art world institutions and their delegates.

I adhere to the position that any speculation on the future of art is necessarily dialectical. On one side is the aesthetic argument that calls for a stated set of criteria, and on the other is visual culture or the sociology of art.[4] I am convinced that while the two may appear synchronous, they rarely are. Often the assumption is made that because certain artists are talked about frequently and collected for a period of time they are automatically deemed important in the history of art. There is yet a further assumption that these artists are part of a discourse that sustains the existence of art amid the cold chaos of our globally fragmented, informational network. Anyone who understands the relationship of politics to the media is certainly capable of understanding the complicit mechanisms that govern the predictability of the art world.

Warhol's pop productivism argued against the class bias of kitsch as being lesser than formalist painting by suggesting that labels and signs from the assembly line would augment a neutralized context, thus breaking down the assignment of the "quality" object to a privileged class. While the actuality of such a situation is impossible, the scatological allure of kitsch—as inferred in the recent paintings of Ashley Bickerton—still persists as much within the domain of the wealthy as it exists as a way of life for the middle-class or lower middle-class majority. The new generation of kitsch artists—Koons, Barney, Hirst, etc.—seem to be responding to a social and economic situation that is based on the illusion that class differences have been eliminated through the proliferation of a new cybercultural environment. A comparison of the excessive domestic environments of Pepón Osorio with the commodified futuristic fetishes of Mariko Mori suggests less about the neutralization of class than the use of kitsch as a means to repress class differences.

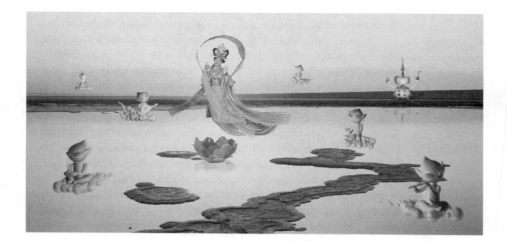

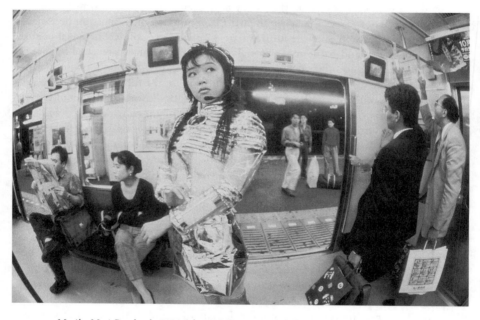

Mariko Mori, Pureland, *1998 (above);* Subway, *1994 (below). Courtesy of Deitch Projects.*

Today, kitsch is less a truth than a method that reflects the illusion of socio-economic homogeneity. Through a reification of kitsch, one may view these self-reflexive icons and logos, as in the case of Damien Hirst, as a kind of multinational (corporate) language that is fixed within a network of signs. This language of kitsch is less about real circulation than about the illusion of signs through their appearance and disappearance. Like all media, it turns on and off. It spins. It offers an allurement but remains essentially static. It has no experiential dimension. It is visual culture.

Kitsch is about status through the absence of status. It is also about stasis—an immobile system that is as likely to preclude entry into the realm of transcultural experience as it is to engage the viewer in confronting the illusions of democracy through a new language of virtual information exchange. Kitsch is essentially a project that appropriates the concern's cultural anthropology, only without the method. It is less about qualitative experience, as traditionally associated with art, and therefore removed from the burden of serious critical judgments. Ironically, the new kitsch represents the obverse side of cybernetics by filling the void that was left by the disappearance of artisanry as once expressed in the decorative arts.

Kitsch nullified the avant-garde by consciously averting the socioeconomic conditions that have given rise to it. Thus, kitsch has been conflated in relation to Debord's notion of the "spectacle" as a kind of deflection from the obvious. In the postmodern sense, the obvious is too painful and too overwhelming in its social and economic implications. Kitsch now performs in place of the avant-garde, but is in fact closer to its deterrent—the spectacle—and thus functions as any other form of diversion or "popular" entertainment. The issue of quality in the Greenbergian sense had to be deferred and disguised in the process. According to the new status of kitsch, the media and its endemic cynicism now take precedence over expressive content. The media fuels the artist's idea, which is later extended into a discourse.[5]

Given this condition within the temporality of media culture, would it not be more viable to try to locate the artist's temporal significance within the field of cultural anthropology or perhaps media communications? For critics and conceptual artists working on both sides of the Atlantic, such a shift of context is already the case. They don't need to be convinced. Yet, the consortium of art world delegates, including some gallerists, collectors, critics, and curators, are not necessarily in agreement. Many would like to retain the status of kitsch as more than a symptom of cultural loss and see it instead as an issue that concerns the history of art. Some will insist that kitsch is the superior art of today, thus conflating the paradigm of Greenberg's opposition into a complete irony by making any justification of quality, in fact, impossible.

This trajectory feeds on a certain repetition of art-making that is somehow indebted to the distanced creative lifestyle of Warhol. Since the sixties, the Warholian formula has been repeated many times over, always with minor variations. In theory, the idea that supports the work matters less than the effect of the idea, thereby refuting the popular delirium that Jeff Koons, for example, is a "conceptual" artist.[6] It is the effect that virtually defines kitsch—not in terms of significance, but as emotional titillation. The phenomenon is really no different from that of high-powered advertising as deployed on American television. In fact, there are those who would applaud the

Jeff Koons, Poppies, *1988. Courtesy of Deitch Projects.*

fact that art has finally followed suit and taken on the appearance and specularity of other forms of pop entertainment, arguing that it encourages a more democratic choice in terms of one's lifestyle. A well-known New York gallerist stated the case as follows: "Artists thirty years ago were still fighting a battle against bad bourgeoisie taste and degraded bourgeoisie attitudes. Now the attitude toward popular culture is completely different and art is very much a part of it. Young artists who I know don't consider Madonna to be the enemy. Madonna is just another form of creative expression."[7]

A question that is often raised is whether this kind of art can exist divorced from its market-driven apparatus. The answer, of course, is a complex one. Kitsch art can exist in two ways: either by subsuming the market so that it does not become an end in itself, thus allowing qualitative issues to come back into a discourse on culture—as, for example, in the gaudy video installations of Pepón Osorio; or it can exist as an end in itself as the sole determining agent for its market and without the intervention of a criterion—as with the fabricated spectacles of Damien Hirst. Of these two approaches, the latter has been the case for well over a decade, and there are few signs that it will suddenly shift gears or change its course.

But what interests me in recent years is that this cultural phenomenon has nearly usurped other forms of serious art. Kitsch, beginning with American pop art in the sixties, has become a primary marketing force.[8] There are few artists today, outside of kitsch, who can compete with its overwhelming allure and magnitude. It is curious to note that nearly three decades ago an early collector of pop art had this to say:

> Renoir? I hate him. Cézanne? Bedroom pictures. It's all the same. It's
> that time with the cubists and the abstract expressionists, all of them.
> Decoration. There's no satire, there's no today, there's no fun. That other
> art is for old ladies, all those people who go to auctions—it's nothing,
> it's dead. Pop is the art of today, and tomorrow, and all the future.
> These pictures are like IBM stock, don't forget that, and this is the time
> to buy, because pop is never going to die. I'm not planning to sell my
> IBM stock either.[9]

The seduction is a very real one, but so is the illusion of what it represents. Just as the cyborg in the virtual land of science fiction is perceived through a window of illusions, so the kitsch art of today is only further reified by the most advanced image-making media, including the fashion and film industries and high-tech rock music.

My prediction as to the future of art, offered on the basis of the question posed in Warsaw, was that the spectacle of kitsch would accelerate as the dominant art form well into the twenty-first century. This is not to say that kitsch is today's most significant art, only that it stirs the most conversation and gossip (which some will mistake for significance). Like it or not, the appeal of kitsch shows few signs of amelioration. The fuel for a growing interest in this cultural phenomenon will continue. The use of conceptual strategies in order to substantiate a discourse, essentially for the spectacle of a market, will have no particular interest either in ideas or in issues of quality. Kitsch artists will insist on filling the world with a neo-rococo aura as distinct

from art that offers the possibility of an intimate experience of pleasure-instigated insight.

Any prognosis for the future—including my own—will naturally meet with resistance. However, there is a positive aspect to this speculation. Kitsch is changing the way we look at our globalized culture. Through kitsch we may continue to examine the media that supports these spectacles, not merely as a "seduction," but as an apparatus that is presently off-balance in relation to human necessity. Put another way, kitsch has become the ploy whereby we are beginning to examine our culture of mediation with a renewed critical and dialectical perspective. In doing so, we might further change the way we look at kitsch. It might be viewed as an advance from the position of chaos and trepidation, rather than sublimated through the resignation of cynicism. Kitsch is the result of an overly mediated culture and is totally endemic to the current state of transition as we move toward globalization. This is evidenced on a daily basis through aleatory and indiscriminate image bombardment processed through the Internet and all related forms of print and electronic image generation. For the moment, kitsch has become the new avant-garde—the most logical reduction of our globalizing efforts.

This is exactly why it is important to view the work of these artists with some skepticism. It is a question of drawing the line between kitsch that offers a critique of corporate culture—indeed, a kind of hypereal metaculture—and kitsch that succumbs to the same effects as any other corporate image; that is, a form of immediately gratifying software. Without offering resistance to the conditioning effects of corporate culture, the status of kitsch remains in a holding pattern. It sells, but has no lasting impact beyond the titillation of the spectacle.

Signs in Flotation

I.

We have come to such a state in the criticism of art that it is no longer possible to avoid what has been written about art objects in the process of reinterpreting their meaning. In the 1980s, serious writing about art frequently occurred within a theoretical construct; criticism of art objects was often mitigated in favor of a quasi–social scientific method or the flaccid appropriation of terms from contingent fields of inquiry. Postmodernism reiterated the tone of the hieratic and thereby confused the role of the critic's experience with that of critical theory.

How the critic experienced a work of art often became secondary to the writing of criticism. Instead of reflecting on one's experience, criticism adopted a language previously reserved for the social sciences. Because there was no desire for aesthetics, in that the concept of desire had been evacuated from art only to be replaced by cynicism, it became increasingly difficult to find serious criticism in which reliable attention was being given to the object. As the eighties progressed from one revivalist position to another (i.e., neo-expressionism to neo-geo), the emotional distance in postmodern criticism began to thwart communication. Experience no longer had a language.

It was as if criticism could no longer invest in the signifying power of language. Instead, postmodernism's new function was to transform itself by appropriating the terms—less than the method—of critical theory. In so doing, it became increasingly necessary for critics to adapt a glossary of terms borrowed from linguistic philosophy, sociology, and psychoanalysis. These terms functioned according to a code that in itself was a hybrid located somewhere between academic rhetoric and art world jargon. As a result, any discussion of meaning in art was either displaced or exempted from postmodern criticism in order to suspend the concept of meaning as a series of signs in flotation, signs without referents.

Theory runs parallel to criticism just as criticism runs parallel to art. History

and culture are the continuum upon which these parallels ride. Art is not theory and theory is not criticism, although they borrow directly from one another. So, where are we left in terms of bringing experience back into critical writing? How does the critic climb out of the mire of recodings and manufactured signs that have mediated experience so often in the recent past?

When one talks about experience in coming into contact with an art object, there is an assumption that one is dealing with some sort of phenomenology. This phenomenological inquiry into the perception of content within a work of art is located within a temporality, a moment of discernment in which one recognizes something of value. One aspect of eighties postmodernism was an attempt to rationalize aesthetic value as coincident with economic value. In retrospect, it became difficult to accept these hugely inflated prices as having anything to do with the work's importance, historical or otherwise. I would defer to Duchamp's concept of the art coefficient where the viewer completes the work by attributing meaning to it, and, ultimately, the value of the work of art becomes a matter of consensus among viewers. The work of art achieves significance over a duration of time.

The experience of seeing and feeling something in relation to a work of art is indirectly connected to the viewer's system of values. One can theorize around the issue, but to avoid or to escape the value of art is not simply a matter of shifting away from quality toward a politically correct ideology. One's experience with a work of art does not necessarily change one's preconception of its value, whether one is aware of the artist's reputation or not aware of it at all.

On the other hand, if the critic's encounter with a work is truly experiential—that is, open to the possibility of changing intellectual or emotional perception—then it is conceivable that the value-referent may shift. The evaluation may become supportive or nonsupportive. This shift from experience toward evaluation can happen only arbitrarily within the realm of theory, where a work succeeds or fails based on one's preconceptions of its value. For any change to occur in the critic's understanding of a work, the experiential factor cannot be denied. This is not to deny that theory can be useful in articulating one's experience; it is only to suggest that experience should precede theory in the equation of how one addresses the work.

I would like to suggest that when one talks about criticism rather than critically talking about a specific work of art, one is operating as a metacritic, a position held by Professor David Ecker at New York University. Yet, there is an aspect of metacriticism that is equally important for the critic as well, and that is the acknowledgment of other critics' ideas and assessments. (This is quite different from citing the same five French poststructuralists or the leading exponents of the Frankfurt school in order to justify the authority of one's own position.) The writings of other critics are important to one's own experience with a work of art, and, in this sense, no critic can assume that he or she is isolated from what others are saying or have already said about an artist's work. Metacriticism, then, asserts the position that one's critical investigations and interpretations are, in part, responding to both an artist's work and to what other critics have said about it. This is what Roman Jacobson used to call "the aesthetic project."

II.

This is not to suggest that criticism should operate according to an immediate social consensus (which is unfortunately often the rule and not the exception, whether in the Enlightenment or in modernism). This is not what Duchamp had in mind when he spoke of consensus within the context of history; in other words, consensus was not a media sensation. On the contrary, any effective critical posture should function independently of this type of mediated consensus, even to the point of resisting it.

It is important to consider and to reflect on the writings of other critics, theorists, art historians, and artists, but it is not necessary to simply reiterate those writings in a new form because the language is familiar. The real work of the critic is to invent a language—a metalanguage, if you will—that reinvents qualitative significance in relation to the critic's experience with the art object. The current art world discourse—however authorative it may appear—cannot substitute for the subjectivity of one's direct experience with works of art.

The allusion here is, of course, to phenomenology. Whether the experience is direct or indirect, overt or implicit, whether it requires empathy or distancing, the critic cannot assume that this experiential—that is, subjective—intervention is not part of the picture. It is a crucial part of the experiential picture. It is in fact the contextual frame by which any worthwhile or viable form of criticism is able to function. Quite simply, experience of the work of art is the fundamental ingredient in one's critical response, the foundation for any authentic interpretation. It may include both linguistic analysis and phenomenological insight. This processing of both thought and feeling may occur without being a contradiction in coming to terms with a new work of art. Concomitantly, the critic's experience cannot avoid entering into the discourse already surrounding the art, and, thus, it must take into account any current social consensus about it, regardless of how superficial or how deep the analysis. This assimilation of the immediate social consensus—as, for example, when *Artforum* interviews the Whitney Biennial curator Klaus Kertess—cannot be avoided; and because it cannot be avoided, it is the social reality of art. The option for metacriticism is then to address this immediate social consensus in terms of a resistance, a necessary socio-aesthetic resistance.

To stand back, to distance oneself from one's own critical posture, is a necessary part of what metacritical criticism is about. Only in this way will it be possible for criticism to achieve the status of a discourse by functioning within an already existing, normative discourse. The term "discourse" began to evolve with the advent of postmodern theory in advanced art toward the end of the seventies. Today, the term "discourse" has become virtually synonymous with critical theory. It suggests a kind of aesthetic fixation, an ossification, a standard of codes and rules, not unlike the nineteenth-century French Salon. At this point in time, the discourse is the new canon, the antimodernist, or, better, the anti-canonical canon; in essence, the new authority over art.

The critic may have a significant experience with a work or allegedly not have any experience at all. At this juncture one has to concede that a critic's experience with a work of art, whether significant or insignificant, is not the same as establishing whether or not a particular work is qualitatively good according to a speculation upon its historical consensus. (It is conceivable that a critic could have a significant experience with a work that is blatantly inferior, both in concept and in execution. For example, one could be overtaken by the emotional content of a Kiefer or the politicized aura surrounding Mapplethorpe's S&M photographs at one moment only to discover years later that as works of art they were considerably less than one felt at the time. But this is a separate and complex issue that would need to be discussed in a future essay.)

One cannot assume that to experience a work of art one must already be within the normative discourse. If anything, the locating of oneself within the discourse comes after the fact of experience. The point is that experience cannot isolate itself from other critical writings—no matter how grounded or ungrounded these writings are in terms of a prevailing social consensus.

The critic's subjective a priori experience is the basic support by which theory is used to accommodate one's interpretative strategy in writing about a work of art. It cannot be the other way around. To be convincing, criticism must take a position. The taking of a position should not be confused with the facile notion of deciding whether a work is good or bad or whether an exhibition is a success or a failure—this is the kind of simplistic rhetoric that gets into the popular magazines and newspapers presumably devoted to culture. Taking a position is a matter of giving a socio-aesthetic analysis of the work of art based on a convincing experience with it.

Unless criticism is able to argue convincingly that a work of art is significant (or significantly bad), it is virtually worthless to pursue a discursive position. Without an implicit, experiential knowledge of art—that is, without coming to terms with art phenomenologically—there can be no effective discourse. Analysis of works of art in purely cultural terms—such as the commodity aspect of art or the semiotic construct of an image—may be appropriate in some rarefied conceptual works, but only as a method, not as a point of critical tension, not as a discourse. Semiotics is useful as a method, as is formalism or deconstruction, but these methodologies do not in themselves constitute a critical position. They are theoretical positions, which if used in relation to one's experience may function as useful instruments of interpretation. Otherwise, they offer inconclusive results. Without experience, there is no position. The alternative is academic jargon that is perpetually in search of its own justification.

III.

One might characterize the current politicized, market-driven art world as being overridden with a plethora of work that begs for the willful absence of experience on the part of critics. The implication is, of course, that criticism is superfluous to art. If a politicized statement is foregrounded as the primary issue—as is the case for some

current art practices—the work exists as a type of cultural anthropology. (Some artists now refer to themselves not as "artists," given the Eurocentric connotation of the term, but as "cultural workers"—thus giving them a noncapitalist status and a seemingly proper ego-neutralization.) The absence of criticism about such work is a kind of rebuke to what is perceived by the social consensus as the patriarchal white establishment. Yet, if this is the case, and if these observers believe that art should occur on some ground other than that of qualitative experience, it is still important that non-essentialist and nonpositivistic criticism be taken into account. For example, if diversity, fragmentation, and nonresolution really exist as prerequisite qualities for multiculturalism, then one might consider allowing these differences to enter into a forum—a forum of real art criticism—rather than being isolated into an "oppositionality" prepackaged and placed in commercialized venues.

American art criticism has suffered from a heap of strangely isolated venues in which few critics claim influence from other critics. Rather than challenge differing points of view in a public forum, critics proceed according to an isolated course—a course without a dialogue. Perhaps we can say that metacritical criticism requires that the experiential dialogue precede any realized discourse lest the discourse becomes its own course unaware of its meandering. In this sense, a dialogue is different than a discourse or, shall we say, a dialogue is to the critic's experience what the discourse is to a critic's instrumental use of theory. Yet, critical isolation is fundamentally a positivistic and often narcissistic approach to art that retains inflexible criteria. It is a revival of the former monolithic notion of a single criterion for all of art, a universalist approach to aesthetic quality. Such an approach is not credible in a highly eclectic, infinitely diverse, and conflicted atmosphere, such as the current situation.

What does "multiculturalism" really mean in the context of a situation such as that just described? How does it really function in the context of the New York art world? Very simply, multiculturalism has become a form of sloganeering conveniently used to justify museum exhibitions in need of federal funding and, of course, to sell objects in galleries that have chosen to appear fashionable or au courant. This is not to say that all work shown in museums and galleries under the aegis of multiculturalism is complicit with big business, but, unfortunately, too much of it has turned in that direction. For example, it is difficult to critically evaluate a Fred Wilson show after the 1992 extravaganza *Mining the Museum* at the Maryland Historical Society (cosponsored by the Museum of Contemporary Art in Baltimore). The appeal of this anthropologically oriented exhibition incited major funding organizations to jump on the bandwagon. Wilson's exhibition became a cause célèbre as if to suddenly reverse (or conceal) the guilt-ridden corporate benefactors of white America.

Overnight, Fred Wilson, a very capable installation artist represented by Metro Pictures in New York, became a symbolic archetype, a "conceptual artist" who has uncovered or "deconstructed" the hidden recesses that spell out white oppression within the institutional fabric of the Western museum world. Money from foundations and corporate sponsors began to flow in following rave reviews. From an alternative critical position, one might inquire into the motivation behind the sponsors and backers and purchasers of Wilson's work. In other words, what was at the source of this

exhibition's legitimacy? Was the show really significant as conceptual art, or was it merely symptomatic of a recent juncture in American social history? Was Wilson's work about the subordination of racial difference in the representation and installation of objects really about art, or was Wilson using art as a conceptual system in order to prove bigotry in the way history is interpreted?

If the latter is true, the lingering question becomes: Where is the line between cultural anthropology and art drawn? Perhaps Wilson's cultural distance offers a kind of pragmatic view of the Eurocentric concept of art and art history, a conceptual approach to art. This being the case, I would have to agree that the motive is a significant one, an incisive critique of museology that is connected to Haacke, Buren, Kosuth (and, I would add, Nancy Rubens), but not one representing a multicultural position decontextualized from the institution.

One could argue that Fred Wilson's installations are primarily symptomatic of a specific and important cultural transition rather than purposely significant as art. Unfortunately, Wilson's art could be seen as symptomatic in another way. It reflects a certain reactionary stance of the white social establishment—the guilt of corporate America—that turned its back on social programs during the eighties in order to accelerate Reaganomics and, later, the so-called Contract with America. Apart from the institutional critique of the museum, one could perceive Wilson's art as having a hidden subtext, namely, the psychosociological agenda that projects deconstruction into a spectacle and thus reflects the art market of the nineties.

There are countless examples of these subtexts happening throughout the art world of the nineties, the most exemplary being the infamous 1993 Whitney Biennial. In many ways, the response to the show offered the real spectacle. The diversity and rage directed toward this show from both ends of the political spectrum was far less predictable than the "curatorial" strategy behind the work being shown. The response seemed generally indicative of the social, political, and economic confusion that exists in the United States today. The attack of the aesthetically uninformed political right did not necessarily outweigh the attacks emanating from the aesthetically informed political left.

The conclusion one might draw is that the provocation struck a psycho-sociological nerve for reasons not unrelated to Fred Wilson's Baltimore exhibition. The sum total of the impact of the Whitney Biennial came across as the projection of an agenda, a manipulation of the viewer through a politicized subtext. What is curious, of course, is that this kind of manipulation happens on a daily basis through television and advertising and few people are willing or even interested in making a comment, let alone a critique. Somehow, art—or, shall we say, an institution that proclaims art—incites people's responses and makes them aggressively defiant. This is, perhaps, because art within the course of modernity has innately offered a point of resistance to commercial culture, no matter how utopian (the Bauhaus, constructivism) or how defiant (dada, expressionism) it may appear.

IV.

Art within the new multicultural environment offers itself as a dialectical point of resistance to the power of the media. It continues to proclaim its autonomy in spite of the ironically utopian postmodern dream that, in the new cyberspace age, art should enter more rapidly than ever before into the system of fashion—the digital codes of appearance and disappearance—which somehow it refuses to do.

In spite of the attempts of magazines like *Artforum* to make art look like fashion and to make fashion look like art, it is only the social context that overlaps at the edges—this being the crux of the new market economy, but not the crux of art itself. The attempts to promote the concept that spiritual or aesthetic value in art is always tied to money, even when those values are deconstructed by way of a slogan-eering ideology—multiculturalism, for example—emanates from the power of the marketplace. In essence, it is the power of investment that tries to keep art on a neutral stage with its pragmatic aegis to guard against the encroachment of spiritual value into the global terrain of speculation and exchange.

Just as Warhol once portrayed Mao Tse-tung in a shrine of huge portraits to show that even communism could be capitalized, the new era of multiculturalism has opened the door for a new era of manipulation in the marketplace. In such a climate, the role of the metacritic becomes all the more important in articulating the position of art by reinforcing its autonomy. Whereas criticism deals with the experience of the critic in relation to a work of art, metacriticism talks about criticism in relation to art. It is a socio-aesthetic polemic that perpetually challenges the normative status of the discourse as defined by the immediate social consensus. Thus, metacriticism is another form of intervention. Its relationship to multiculturalism is to open a forum between artists and criticism, between art and language, in order to prevent the loss of that special autonomy. It is this project that continues to challenge the assumptions and speculations of the international market that currently exists as a force beyond mere collecting. It is a force bent on normalizing art into a system of commodities with all the seductions of the fashion industry and the world of cyberspace.

Cyberspace. Here one day, gone the next. There is a difference between what is significant in a culture and what is symptomatic about a culture. The challenge for criticism and metacriticism alike is to focus on what constitutes this difference. The assumption here is that the emerging art critic for the twenty-first century will be willing to accept this dialectical role; that is, how to sustain art's relationship to an emerging multicultural environment without sacrificing qualitative standards in art. In this sense, both criticism and metacriticism should be directed toward improving the quality of art and, in so doing, offer a dialogue that ligitimates the significance of culture.

The Plight of
Art Criticism

It is not unreasonable to assume that most commercial art periodicals—whether they are published in New York, London, Paris, Berlin, or Tokyo—are somewhat compromised with regard to how they deal with criticism in today's art market. While not entirely obvious, editorial decisions are often made on the basis of whether or not a statement might endanger an advertising contract with a highly visible client—namely, a commercial gallery. Another more subtle reason is a certain equivocation in discerning new modes of inquiry that have entered into the language of criticism by way of postmodernism. While the art criticism that has emerged in relation to theory in recent years may have enlarged the way critics look at art, it has also confused the critical process. While some criticism has literally become an exegesis on cultural theory, other criticism has become reactionary to it.[1]

There are those who would argue that the emergence of postmodern theory has been beneficial to both criticism and the production of art. Advocates of feminism and multiculturalism have deployed theory as a method by which to intervene in the critical mainstream and thereby "deconstruct" certain assumptions about gender, race, and class found in the practice of art. The problem here is not so much the intervention of theory into the criticism as the current retrenchment of theory into a kind of anti-authoritarian canon. This new canon has become far more narrow than the subject of its attack—modernism. Certain presumptions about the failure of modernism have had editorial consequences in terms of what issues and which artists are being written about and how the language of these texts is being constructed.

In retrospect, one of the major problems with postmodern art criticism in the eighties was that the attention given to experience in relation to a work of art was nearly relinquished or usurped in favor of theory. How one experienced a work of art was either neglected or repressed in order to accommodate the "deconstruction" of the work's cultural infrastructure.[2]

This approach was more a philosophical inquiry or a sociological analysis than anything having to do with aesthetics. Consequently, the project of criticism, under the arbitration of postmodern theoretical claims, became increasingly more

distanced and severe and less subject to interpretative strategies. Take, for example, the following excerpt from an essay on the work of pop artist Andy Warhol by the art historian Benjamin Buchloh:

> We are not thinking primarily of the quotations of mass cultural imagery—after all they had been an acceptable convention if not founding condition of modernism since the mid-nineteenth century. Rather we are thinking of the way in which Warhol underlined at all times that the governing formal determination of his work was the distribution form of the commodity object and that the work obeyed the same principles that determine the objects of the cultural industry at large. Those principles (commodity status, advertisement campaign, fashion object) had been traditionally believed to be profoundly heteronomous to the strategies of negation and critical resistance upon which modernist artistic practice had insisted.[3]

The syntactical and semantic structure of Buchloh's argument is, of course, consistent with his choice of subject; that is, the criteria seem appropriate to Warhol's work, which, in itself, is quite severe and distanced. Stated differently, Buchloh's "distance" alleviates the burden of experience from the parameters of artistic intentionality. One may consider Buchloh as symptomatic of postmodern criticism in that the discursive method is essentially a cynical one.[4] Cynicism is not unrelated to a hyperrationality. Yet, one might also ask whether criticism in the more conventional sense, as a method to interpret and evaluate the significance of works of art, has anything to do with postmodernism or whether postmodernism has anything to do with it. Certainly, one can say that criticism may apply theory in the instrumental sense, but it can never *be* theory. My objection to the notion of a postmodern criticism is that it becomes theory by way of denial—the denial of the subject's experience as a preeminent concern in critical writing.

In contrast to the notion of cynical detachment, I would like to suggest that art criticism is a practice that runs parallel to the production of art objects, events, and installations. Some artists, of course, incorporate criticism or theory into the productive practices, but this can only have limited results. The effect or impact of such practices occurs within a temporal or topical situation, but from a longer historical glance, it is simply no more than that. (But then, who cares about a longer historical glance in postmodern criticality?) Although the practice of criticism maintains both style and method, it does not alleviate the articulation of experience through an intuitive grasp of the work's structure in coming to terms with the object, event, performance, or installation.

To recognize the significance of a work of art is ultimately related to how one experiences it. This is not simply a matter of giving an opinion or of distinguishing form in relation to content. It would seem that the necessary task of criticism is to find an appropriate language to address one's experience.[5] This requires both an epistemological and a cognitive process of seeing. Criticism is often most effective when it

occurs in the manner of art, as a kind of inspired moment where the language coalesces as essentially fluid and analytical, as an erotic rendezvous.[6]

Art journalists—that is, those who write about galleries and exhibitions on assignment—often resort to a style of descriptive phraseology that is presumed to legitimate their judgments about the work in question. In general, art journalism tends to fetishize the object, making it more of a spectacle than a truly significant work. In most cases, even in prestigious cultural magazines, art journalism consciously strives toward a format of politically mediated entertainment.[7] Judgments tend to become overdetermined and shallow through the use of casual jargon (to avoid the embarrassment of having no criteria); but one must also recognize that the history of modernism has largely emanated from this casual jargon, this ability to enunciate a position in terms that are reactionary.

One might consider the origins of such epithets as "fauvism," or, for that matter, the *New York Times* critic who, in 1913, declaimed Marcel Duchamp's *Nude Descending a Staircase* as "an explosion in a shingle factory."[8] Labels ranging from "abstract expressionism" to "neo-geo" have been the result of art journalism, the indulgence of a reactionary model whereby judgments are made hastily and trends are identified in relation to fashion as if they were concomitant with the advertising media. Yet, postmodernism did not refute this position, but accepted that this was the inevitability of a hyperbolized cultural bandwagon, a neutralized productivism that could usurp any premise or idea or image. Any object could be fetishized and thereby neutralized.

Mass production has made it possible to standardize any type of product— any object or image, any type of environment, including the psychological. Art production became another form of cultural production, regardless of the level of appearance. So, from the industry of objects, images, and the like, Duchamp discovered his readymades (1913–21), taken from the assembly line—detached objects with an aura of anonymity. Yet the reception of art became less palatable than that of mass culture. It could not compete with the popular demand for movies, magazines, and other forms of popular entertainment. Even so, for the so-called power elite, the world of art— primarily paintings and sculptures—was a fetish industry, a hoarding of artifacts of history. It is of no surprise that contemporary art eventually became a type of commodity, an investment, something that could be bartered or traded, a medium capable of engendering a profit.

Contemporary art in the postmodern age became a hybrid somewhere between fashion, investment, and status. To enter into collecting, one entered into a competition on a social level. In the eighties, critics were usurped by collectors who were made to feel that they were doing justice to the culture industry by supporting certain artists who, in turn, represented certain ideas about culture.[9]

The task of criticality is an instrumentality that involves and, to a certain extent, implicates, both history and theory. It is not a method that neutralizes everything within the vague notion of a "culture" as one kind of production. This is an unqualifiable notion. It is not unlikely that art objects are made as part of the culture industry, but then one has to view the context from which these objects are made, what

has provoked their making, and who is supporting the enterprise. One of the issues that Americans have only recently discovered is the fact that there is a sociology of art that runs concomitant to aesthetics. Sometimes the sociology of art and the aesthetics cease to be viewed as parallel and begin to converge as orthogonals. They reach the same vanishing point. In the eighties, this vanishing point became the overspeculation of the marketplace. It became virtually impossible to distinguish between the sociology of art and aesthetics.

Nonetheless, one cannot assume that this orthogonal convergence is always the case. Cynicism becomes evident when the two tendencies become inseparable, one from the other. They may intertwine, of course, but one cannot make an aesthetic decision based on the sociology of art, and vice versa. Yet, it is also acceptable to say that cynical art deserves a cynical response. When a work of art is premised on cynicism, it is unavoidable to address it in cynical terms. The mistake—even the temptation—is to assume that cynicism is a perennial condition in the interpretation and evaluation of art. It would further preclude any desire to interpret or evaluate objects other than on the most superficial level of critical inquiry—"superficial" here meaning the tendency to evade the experience of art in favor of a sociological analysis.

Occasionally, the absence of experiential signification in art reduces the aesthetic to ground zero. This move could be interpreted either positively or negatively. In the sixties, minimal art brought the production of art to ground zero in very positive terms. Conceptual art and earth art were further extensions of this newfound terrain. Ground zero was the re-formation of language in art, a new semiotics, and a new contextualization as to how to read art as an active agent within culture. Art was about a certain resistance to mass-produced culture—a premise seemingly different from that of the eighties in which mass-produced culture became the literal subject of art. The terms shifted again; hence, another set of criteria began to take shape. Ground zero was recontextualized to mean cultural anesthesia.

It was not that form was being reduced, but that culture was being diminished as an exercise in syntactics. The operational definition of culture in the eighties was entirely contingent on one primary referent—how the market seemed to perform at any given time. If certain artists' works were selling favorably, even virtually unknown artists, then the barometer at ground zero held steady. When, by the end of the decade, works by certain artists stopped selling, the harbinger went quickly into effect: the art world was in trouble. Ground zero was neither about formal reductivism, as it had been in the sixties, nor was it about cultural simplification toward a purely economic standard, as it had become in the eighties. At the outset of the nineties, the art world, as it had come to redefine itself in syntactical terms, was lost. Neither a revival of modernist abstraction nor a return to pluralism would suffice. The art world was in crisis.

At that moment of crisis, alternatives were being sought both in new empty spaces—enormous unadorned lofts in SoHo and West Chelsea—and in various alternative publications. In that criticism occurs through periodicals, and occasional lectures and panels, I would like to focus for a moment on the problem of writing criticism in such a climate with regard to its dissemination. Art magazines are dependent on adver-

tising, and advertising comes primarily from art galleries. Galleries want the publicity and therefore want to have their artists and exhibitions promoted through print. To paraphrase a statement by Stanley Ulanoff in his book *Advertising in America*, advertising is what you pay for; publicity is what you hope you get.[10]

I believe this distinction is appropriate to the problem being addressed here. The art magazines depend on revenue from the galleries, but the galleries want more than their names, artists, and exhibitions listed as ads. They also want to be reviewed, and they want their artists promoted. This is no secret. In essence, art magazines are becoming less and less about art criticism and more about advertising and publicity. As mentioned earlier, real critical analysis is not encouraged by the art magazines (with some exceptions) because readers generally do not like it, and these readers—namely the galleries that want promotion and visibility—are often the people who pay the bills, and so the cycle goes.

This may sound too omniscient, but it is rather a somewhat pragmatic system. In some sense, criticality proves nearly superfluous. (One can read "criticality" here as criticism that incorporates theory into its method of inquiry.) The point being that criticality is fine if it occurs within the scope of promoting certain artists that are being promoted by certain galleries that are, in turn, promoting the magazines.

To engage in criticality—that is, to use theory and history as a system in relation to one's own experience (not consensus) in addressing objects, events, and installations with an independent voice—has become a major challenge. Criticism can only be controversial if it avoids fashion, but when it takes a position outside the marginally acceptable or the accepted marginality that is understood but unspoken in the art world, it is unlikely that such a discourse will find its way into print—unless it is published in an academic journal.

Censorship is subtle in the art magazine industry, particularly in regard to controversial issues argued or investigated outside the delimitations of the gallery system. It occurs by way of overt syntactical shifts in editing or by way of deletion or clear exemption.[11] The argument that nothing could be so controversial as to be outside the purview of publication in the magazines is simply indefensible. Just as advertising slots on commercial television have implications for censorship in the programs that are being sponsored, so art magazines are subjected to certain pressures by the galleries that pay the bills.

To write criticism in an age of extreme diversity and cultural "crisis"—in the sense of how this is understood by American postmodernists—may be construed to mean that the critic must relinquish any original point of view in order to conform to those pressures engendered by a faltering economics. In such a situation, the acculturation process appears to shift toward a less substantial set of criteria. Perhaps it would be more accurate to say that the criteria are neglected in favor of a political support structure that implicates the necessity of keeping art magazines financially afloat.

In contrast to the "automaton" approach to criticism, where the institutional affiliations of the critic are made implicitly clear, one might accept a challenge by offering resistance to the pressures of consensus fomented by the marketplace that accepts certain artists who seem to be "hot." The alternative to accepting the hot artist

is to investigate experientially what it is that makes good art happen. Thus, it would seem that in order to preserve the meaning of art as a valid construct within one's culture—that presumably strives to accept the proliferation of diverse forms and visual ideas from many backgrounds (i.e., multiculturalism)—it would seem logical that criticism should resist the forces of a corporate internationalism. While these forces may appear abstractly removed from the creation of art, they make up the consensus that eventually appears authentic and is defined as "culture."[12]

It is here that the problem begins. By becoming separated from the authenticity of creative experience, art is given a simulationist status. One might interpret such a status to mean that objects are produced by means of the spectacle in order to keep the lack of credibility in art credible. In so doing, the absence of any tactile relationship to culture is suspended. The same nonsensibility that applies to advertising and commercial television makes any other aesthetic criterion seem irrelevant or indistinguishable from diurnal pop entertainment. As innocuous as it might seem, the divorce of the critical voice from the art media breeds a conformism that ultimately thwarts any desire to be original. Art is then replaced by a perpetual cynicism and held in check by the institutional affiliations of critics. At this stage, one might correctly cite "artwriting" as a substitute, or more generalized term, for what most art criticism has become.[13] The situation appears as follows: If authentic criticism is going to survive in such a milieu, inextricably conditioned by the marketplace, it will happen outside the predictable sources. The conventional sources are already too deeply invested and encoded. One can only hope, as emerging possibilities for criticism arise, whether in written or in spoken form, that some qualitative notion of art can be received. One may further hope that a growing audience will begin to pay attention to criticism and will be able to discern what sounds convincing not only in demeanor but in substance as well.

A Sign of Beauty

In memory of Michael Kirby (1931–1997)

> To feel beauty is a better thing than to understand how we come to feel it.
> *Santayana*

In our transglobal informational age, ridden with the denial of qualitative judgments as to the meaning of culture, there is the perennial problem of the senses. It is as if the omnipresent glut of information has distorted our means of sensory intake. The reception of data—scientific, economic, cultural, and political—has become so overabundant as to suggest infinity. New combinations of data appear with each fraction of a second, information to be perpetually recycled and reordered into new paradigms. In such a virtual environment—one that exists hypothetically on a global scale, barring certain unexplained economic and political constraints—there are gnawing questions: What to do with the senses? How to give validity to our sensory experience? How to acknowledge the rightness of the senses as a perceptual filter in determining quality in works of art?

The answers to these questions, of course, rely heavily on the subjective principle and on the confidence to assert qualitative judgments that exceed the rational constructions of the obvious. It is a type of intuition that is further dependent on the sublimation of a structural awareness of the language of form, and by knowing form to declare beauty as its effect—a point expressed by the philosopher Santayana. Before the concepts of form and beauty can be defined operatively in relation to one another, particularly in the current situation, there is the problem of sensory input as it defines our experience of works of art. This definition is contingent on foregrounding some acknowledgment, if not a resolution, of the mind-body function.

Sensory Input and the
Mind-Body Problem

There are a plethora of symptoms to suggest that we are living in a cultural moment that could be described as split between mind and body. As a globalized society, we have lost the apparent connection between the two hemispheres. Our perennial media glut shows little external evidence to suggest that mind and body are cooperative or that they, in fact, are neurologically dependent on one another. The notion of mind-body interdependency has, for the time being, been suspended. The consciousness of a sensory balance appears lost. The capacity for synaptic charges instigated by the mind to inform the body or hormonal secretions from the body to chemically inform the mind has been scientifically known for several years, yet somehow the implications of this research do not appear related to our current hypereal environment. Instead, we have come to exist in an antipodal culture in which obsessiveness of mind is positioned in relation to the fetishization of the body. (Is it any wonder that art and fashion have become virtually indistinguishable?)

Since Kuhn's *Structure of Scientific Revolutions* (1962), the physical and biological world has been viewed more or less in terms of a conceptual enterprise where every theory has a cause-and-effect relationship. The world is made from science, from rationality, from statistical memory. Theories are built upon theories. Metatheories try to account for the theoretical precepts of the past. Yet, the rush to theorize on the cultural level, as if culture were only a phenomenon relegated to the social sciences, may preclude more open frames of expression.

Culture, not science, is the repository of expressed human values. From a cultural point of view, the absence of a clear sense of intuition beyond the rational further precludes an accurate view of history. Without an accurate view of history, it is exceedingly difficult to gain an accurate view of culture in which qualitative significance plays a determining role. Without a clear dialectical understanding of historical time in relation to the cultural present, the role of sensory experience is considerably diminished.

Instead of sensory experience that is contingent upon the overlay of the synaptic mind-body function, we are left with the body as a fetish, as a primary focus of desire, as a scientific specimen depleted of historical and cultural significance. Within the rational confines of our postmodern condition, the body is given the status of commodity—a nonheroic mythic status, acquiescent to the commercial world of fashion. Where there is no evidence of qualitative significance, even on the most sublimated level, the role of beauty as a consequence of our sensory apparatus appears without force or authenticity. This loss signifies the repression of the subjective. In such cases, the body performs autonomously according to ritualized data, according to the input of software that makes it function. From a westernized cultural perspective, the concept of mind and body no longer operates as a conscious, unified organism. Instead,

they are treated as separate functions, as discrete entities, divided between the computer and the gymnasium.

An interesting attempt to find an overlay between mind and body can be found in the recent digital architecture of the collaborative team Arakawa and Madeleine Gins, whose work *Reversible Destiny* was shown at the Guggenheim SoHo during the summer of 1997. These fantastic and chaotic spaces, consisting of broken planes, curvilinear surfaces, distortions in scale, and displacements between inside and outside, appear virtually uninhabitable. Their architectural hypothesis intends to bring the mind into focus with the body, a concept shared earlier by the sculptor Robert Morris. The question that Arakawa and Gins propose is: To what extent can a revision of the concept of architectural space, through cybertechnology, restore sensory precognition?

What is significant about these cybergenerated projects, in spite of their totally fragmented impracticality, is how they represent the current cultural crisis to the extreme. Arakawa/Gins conceptually challenge the socioeconomic basis of our global "society" through ultra-amorphous deformalized architecture. They work like playgrounds for the intellect that are not entirely without sensory appeal. A clear example would be their only realized architectural project to date, situated in Yoro Park in Gifu, Japan. The irregular terrain of the space allows the irregular and asymmetrical forms to meet and fall apart in relation to one's ambulatory movements. The continuity of the habitat is subverted at every turn. One is left with a sense of utter displacement, caught within the delirium of an unrecognizable fragmentation.

The artists are ferreting out a means to bring architectural space in closer contact with the body through a kind of sensory play. The illusory aspect of the work relates to its computer programming. It functions as a digital system, yet has limited applications in terms of a tactile space or an actual mind-body involvement. The seduction of virtual time-space gives a convincing display of a virtual environment, but one that is highly self-conscious, reflecting a type of narcissistic indulgence. The architectural models, generated collectively by Arakawa and Gins, emphasize the fetishizing of the body through architecture. Yet, without a cohesive concept of mind-body interaction that can function in the practical world, there is only a pure aesthetics, a heightened sensory cognition, a fragmented utopia. There is little pragmatic application to the functional world. Beauty appears as an inverted romanticism, a lost horizon, a suspension of belief. On the other hand, this suspension of belief is consonant with the fragmentation of the present historical moment, a moment characterized as a period of high transition, or as Paul Virilio has articulated, a period infused with the pressures of speed.

Beauty as a Syntactical Sign

In the postmodern condition—a condition that some observers feel has already been usurped by an ever-expanding market economy and is therefore defunct—the question of beauty appears as a suspended entity, an imposed value system that is detached from

any recognition of form. This is consistent with the poststructural notion that signs are in the process of losing their signifying power and are becoming detached from their referents. Put another way, signs exist in a state of suspension or flotation. There can be no assumption with regard to their predetermined meaning, as made clear in the architectural projects of Arakawa/Gins. Here the signs of habitation are fragmented presumably in order to augment the sensory experience of the body. The absence of the referent suggests that destiny is no longer a factor in the mind-body function. Without destiny, the body is liberated from the constraints of form and gravity and, therefore, is capable of moving through time and space as a kind of autonomous sensorial entity.

The argument that a sign can function interdependently, yet divorced from its referent, is essentially a poststructural argument. It is also a highly contingent one. It is contingent on accepting the fragmentation of the sign as no longer requiring a specific syntactical operation. In contrast to these more complex signifiers that are dependent on some form of syntactical structure, commercial logos operate as fixed signs, virtually undaunted by their context. For example, Coca-Cola means the same in Atlanta as it does in Tokyo or Bombay or Buenos Aires. On the other hand, a concept as malleable and subjectively construed as beauty cannot exist as a fixed sign. Rather, beauty exists as a sign without a predetermined aspect.

Paradoxically, the concept of beauty may no longer be absolute as considered by Plato or Kant, but relative. This relativity, however, is contingent on the recognition of a form's conceptual understanding as much as on its aesthetic coherence. Yet its syntactical placement and contextual understanding are highly fragile. For example, a crushed car in a junkyard may not appear beautiful. However, when placed in an isolated context within a white gallery or museum, as in the César retrospective at the Jeu de Paume in Paris (summer 1997), the object is abstracted as material—compressed steel—and, for many observers, appears beautiful. One could make similar arguments in favor of Rauschenberg's *Bed* (1955), Tony Smith's steel cube, called *Die* (1962), or Warhol's *Campbell's Soup* (1962). Given the right context—namely the gallery or exhibition space, or what the critic Brian O'Doherty once called "the white cube"— these works become astonishingly beautiful.

Beauty Cannot Be Imposed

The formal argument for beauty need not rely on the absolute or on a single mono-lithic criterion. When it does, the work tends toward aesthetic formalism. This defi-nition of beauty is an exclusive one. To define beauty through the syntactical sign, it becomes necessary to rediscover the signifying power of the sign as existing between the formal and the conceptual. Without a formal basis, beauty can only exist as a surrogate form, as a fake. This is most often the condition of the commercial logo or any image that proliferates in reference to a product or ideology. Ultimately, such signs appropri-ate beauty as glamour, as signifiers of power, as conformist emblems, without any further structural or referential basis.

Yet, the structure of a sign that is understood as beautiful is one that is not

solely dependent on its ideological semantics, as is the case in commerce and in politics. While beauty appeals to the senses, it is not cosmetic; it is not a surface phenomenon. Beauty is not a phenomenon that can be imposed. It is neither a quotational spectacle as in the work of Robert Longo nor a spectacular quotation as in the work of Matthew Barney. Put another way: to use spectacle as art is one thing; to make art into a spectacle is something else.

One cannot intend or predetermine beauty to be the condition of a work of art before the work exists; rather, beauty becomes an encounter after the fact of the work—an aura that is received. Because beauty is not an absolute, but a syntactical sign, it exists as an a posteriori condition of aesthetic receivership, not as an a priori mode of determination. Beauty cannot be predestined. This is why works made with the intent of becoming commercial media cannot exist in the same context as art.

Beauty is fundamentally a sensory experience even if that experience is instigated through a conceptual form. It is possible to feel a coherent concept on a profound and intimate level whether or not the work exists in the form of an object. Though more difficult to obtain, conceptual art—due to its heightened degree of abstraction and its dependency on a thorough knowledge of art history, philosophy, and the processes of studio art—cannot be excluded from the effects of beauty. There can be beauty in conceptual art just as there is beauty in romanticism or neoclassicism. While the criteria may be different, according to specific methods or materials, the knowledge of the structure in art is consistent.

Beauty is an aesthetic issue, but not only that. Since the publication of Croce's *Aesthetic* at the beginning of the twentieth century (English translation, 1909), aesthetics has moved beyond "the science of beauty" as its sole concern. With Duchamp's fanciful, nearly insouciant *objets trouvés,* known as readymades (1913–21), not only art, but aesthetics was revolutionized. Beauty became a condition of syntax; that is, how the form is understood and acculturated within a given time and space.

In the sixties came the struggle between the old and the new, between aesthetic formalism (modernism) and conceptual art. The synthesis is still in the process: How to expand a definition of aesthetics beyond "the science of beauty"? How to include the social and natural sciences, psychoanalysis, and gender and ethnic diversity as flexible parameters in the reception of a work of art? The new aesthetic functions like a matrix, where ideas and images from various disciplines enter into art, yet art must somehow attend to its own method within the scope of this abundant information. What separates us from Croce's world a century ago is our heightened degree of self-consciousness. Referring again to the problem of the mind-body split, it is this obsession with the self that ironically precludes beauty as a self-begetting act.

Beauty is not glamour. Most of what the media has to offer us is glamour. Most of what the fashion world has to offer us is glamour. Most of what Hollywood has to offer us is glamour. Most of what the art world has to offer is glamour. Glamour, like the art world itself, is a highly fickle and commercially driven enterprise that contributes to what the late critic Lewis Mumford used to call "the humdrum." It appears and it disappears. What is "in" at one moment is suddenly "out" the next. It is about the persistence of longing. No one ever catches up. There is too much money at

Beom Moon, Slow, Same, #1400 *(above);* Slow, Same, # 5000 *(below). Courtesy of the artist.*

stake, too many investments. Glamour is about the external sign—the commercial logo—and has little to do with the inner-directed concerns of artists other than as subject matter for some expropriation of popular culture. Such examples can be found in works ranging from Man Ray to Ray Johnson, from Meret Oppenheim to Louise Bourgeois.

But the artist has to exist—to live—within a world that is mediated through glamour. The allure is constantly in the air. It is both omnipresent and omniscient. It carries the seduction of instant fame and success. It is the basis of the spectacle, and the spectacle is about the cycle of repetition, the lack that confounds passivity, the utter abeyance of the affectation of desire. Beauty functions on another level. It cannot be predetermined by strategies of investment or by the sublimation of advertising. Beauty adheres to a structure or meaning that somehow coalesces with the material reality of existence. Because beauty is recognized through form and intuition, it requires preparation, time, and focus. The seventeenth-century mathematician Blaise Pascal spoke of intuition as a quality that emerges when logic has exhausted its limits, provided that the mind is alert to that moment. In this way, beauty is an intuition with an affinity to the hypothesis of Pascal. It is an intuitive structure, a *recognition* of form, that, as Santayana asserts, is finally unprovable given its relationship to the senses.

Beauty is an act of grace, given neither to force or imposition. It is not an intent. It promises nothing.

Beauty is a felt concept, a structure known through coincidence, that exists as a condition of receivership. It remains elusive in relation to the artist's intent. Beauty functions differently than intent even though intent is the structural basis from which the artist's work proceeds. For example, Kurt Schwitters's early collages (*Merzbilden*) consist of torn scraps—discarded papers, posters, receipts, tickets, labels, etc.—as a dada gesture with the intent of upsetting middle-class standards of taste. Today we perceive these collages not as indeterminant detritus or "junk," but as something that revolutionized aesthetics in the twentieth century. Arguably, Schwitters's collages, commensurate with Duchamp's readymades, virtually redefine previous standards of beauty in twentieth-century modernism. Perhaps this is because these collages are not overdetermined; they simply proceed according to an intent.

Thus, beauty offers us something other than an intention. It offers us a sense of being connected to the world as mind is to body. In such moments, we come to understand beauty as a quality that goes beyond intention. In recalling a triptych by the contemporary Korean painter Beom Moon, beauty is less the condition of this abstract landscape than the effect that lingers long after the work has been seen. While experiencing art as a newly cognitive form, there is no contradiction in saying, "It is beautiful." For beauty—as it arrives through the language of form and concept—is still the crown of aesthetics. One might conclude, then, that beauty springs from the subjectivity of one's sensory cognition when spurred by an aesthetic catalyst. Whether material as form or immaterial as concept, beauty declares itself to be the case in spite of all that has been spoken or said about it. Whereas language is the condition by which the work is selected, resolved, or understood, beauty is the effect by which it is sensed, transmitted, and finally remembered.

II. *History*

The Boredom
of Cézanne

I remember some years ago, before attending graduate school in the seventies, going to the bookstore to pick up some books and seeing a sidewalk sale with reproductions by French impressionist painters. The reproductions were inexpensive but the quality was good, so I decided to buy two by Cézanne: one a watercolor of a still life with the famous Cupid statue and the other a reproduction of a painting from 1904 of Mont Sainte-Victoire.

I had visited the studio of Cézanne in Aix-en-Provence some years before that and recalled the excitement of looking out the window and seeing the famous view. This particular painting was, of course, one of the later versions of the famed mountain, painted within two years of the artist's death in 1906. In my opinion, it is one of his greatest paintings. It not only signals cubism but goes well beyond it, giving a sense of what would become known as "all-over painting" in the New York school of the fifties.

The reproduction of this 1904 version of *Mont Sainte-Victoire* occupied a place in my studio for more than a decade. It virtually symbolized the beginning of modernism. It represented a new idea about art and a new perception of reality in a most tactile way. I had not seen the actual painting for some years and had the pleasure of viewing it again at the Philadelphia Museum of Art two weeks before the touring retrospective *Cézanne* was scheduled to close. The gallery where it was hung was, of course, crowded, but through determination and intestinal fortitude I was able to establish a fixed point of observation for several minutes and view this amazing picture of Mont Sainte-Victoire, there amid the throngs.

What is it about this version of Cézanne's mountain that makes it so special and that takes it beyond all the formal arguments of modernism from early cubism, especially Braque, to Greenberg's argument about Pollock? It is not merely the formal mechanism. That would be too easy. There is a certain resonance about the work, a resonance that seems to have all but disappeared from painting in recent years. One can look at this painting with the discursive spectrum in mind established by Merleau-Ponty, on the one hand, and Erle Loran, on the other. In the former, Merleau-Ponty

argues in favor of the anxiety of the painter. Cézanne moved the paint throughout the canvas, working on all areas simultaneously, so that the definitive dabs of paint appear to have emanated from the artist's unconscious, as if he were struggling to obtain some form of certainty.

Loran, on the other hand, asserts that this unconscious dabbing of the paint is quite irrelevant. What really matters is the structural motif that the artist predetermined in relation to what he saw. Once the blueprint was in place, Cézanne simply painted according to the structural (geometric) parameters.

Meyer Schapiro understood Cézanne in more iconic terms—that the motif was a kind of erotic displacement where the painter was obsessed with the beauty of what he saw and wanted to obtain the certainty of his vision. Various positions on the theory and criticism of Cézanne have continued over the years—from Roger Fry to Sidney Geist, from Lionel Venturi to Clement Greenberg. It seems that every historian of modernism has taken a position with regard to what makes Cézanne a great painter.

What I would like to submit—at the risk of being misunderstood—is that what makes Cézanne a great painter is his boredom. Or rather, our boredom in relation to his disinterestedness. What grabs the viewer of a Cézanne painting is not the artist's astonishing sense of structure, as in Seurat, or his bold use of color, as in van Gogh, or his sense of shape, as in Gauguin, or even his acuity of perception, as in the late-period Monet. What comes across in Cézanne is his contribution to boredom—a concept of time, I would argue, that is essentially French. By playing off the insignificance of his other well-known motifs, such as his still lifes or his oddly Germanic bathers, especially in his late period, Cézanne repeats and repeats. These motifs go on endlessly. One can only conclude that he is less interested in the motif itself than in his own act of perception as it happens within the act of painting. The synaptic charge, as Merleau-Ponty observes, goes from eye to hand as Cézanne attempts to hold the certainty of his viewpoint. Consequently, the repetition of the motif becomes important in testing his ground, in testing his sense of certainty with regard to what he is seeing. How to make what he is seeing real? How to give it a sense of isolated reality—a reality that exists like another object or event only within the realm of the simulacra—the painting. This was the thing. This was the real object.

To get to the core of Cézanne, one might consider boredom as the condition by which his paintings are viewed. To get into the experience of boredom is to get to ground zero of one's perceptual consciousness; that is, to bracket everything that stands in the way of what one is seeing, then to build upon one's perceptions, to build slowly and tirelessly, to get inside the experience of boredom to the point where—as the late composer John Cage once said—boredom becomes interesting. With Cézanne's paintings, boredom does become interesting. But it requires an effort on the part of the viewer—the cynical postmodern viewer who is conditioned by the fast zip of the cathode-ray tube stuttering and blinking constantly in front of our visual field.

What appears necessary at this juncture in the history of art is a more focused comprehension of the media in order to demystify its important and its concomitant effects. Through this process of media demystification, one might learn how to look at painting again, particularly the kind of painting that Cézanne has to offer us.

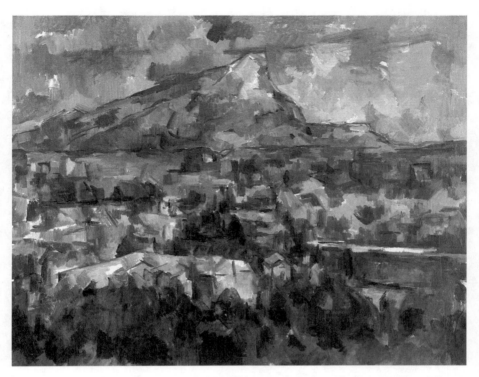

Paul Cézanne, Mont Sainte-Victoire, *1902–04. Philadelphia Museum of Art: The George W. Elkins Collection.*

It is neither Basquiat nor Schnabel nor Andy Warhol. Cézanne's work has nothing to do with any of the hype or the media that we have grown so accustomed to seeing since the eighties.

Looking at this painting of Mont Sainte-Victoire by Cézanne, to really come to terms with it, is to enter into the process of boredom and begin building one's personal experience with the work. In Zen, students or disciples, as the case may be, are asked to build "mountains of the mind." To look at Cézanne's mountain through this painting is to begin to build step-by-step an experience that is beyond all the hyperbole. It is an experience beyond what the media dictates. It is a level of understanding that exists on the most intimate level of vision. Real mountains are hard to get at. One has to view them carefully and begin climbing. Through boredom, one begins to takes the first step, then the second, then the third. Eventually, the experience of the mountain begins to happen. It begins to take hold. Suddenly, you may find yourself there.

The Enduring Art of the Sixties

Now that the sixties have become history, we can begin to look at the art objects from that decade as part of that history; that is, we can look at these works historically as survivors of a tumultuous period in late modernism. From a hermeneutic standpoint, we can begin to revive the meaning of their "text" as if it were the present, and as if the objects belonged to a living tradition. Truth to any text is a matter of interpretation. To interpret the sixties as a great period in American art seems accurate because we can see how that tradition has been played to the moment—a history that is still playing itself out.

The sixties were a decade of shifting and contradictory attitudes emanating from both art and life. As Robert Rauschenberg so sensibly put it (at a moment when he was moving aesthetically from the combines to the heraldic silkscreen paintings): "Painting relates to both art and life. Neither can be made. I try to act in the gap between the two."[1]

What Rauschenberg was telling us had a certain resonance. His statement moves beyond process into another realm of a "combined" pragmatic metaphysical vision, later seen in his *Persimmon* (1964). Any preconceived notion of art is an "overdetermination" and a travesty. The artist needed a tension between the sensation of an idea and the ability to constitute images in a fresh way, to give art the form of ecstatic resemblance. Hence, for Rauschenberg, the definition of art was far less important than the manner of its resemblance, the process by which the form evolved from one metaphoric meaning to another (an attitude with which the painter Jasper Johns also concurred). In other words, the creative process was primary, but it contained the tension and synthesis of the pragmatic and the metaphysical attributes of aesthetics. Rauschenberg was once questioned about whether or not he thought he was doing art. He replied with a typically coy answer:

> It has never bothered me a bit when people say that what I'm doing is
> not art. I don't think of myself as making art. I do what I do because I
> want to, because painting is the best way I've found to get along with

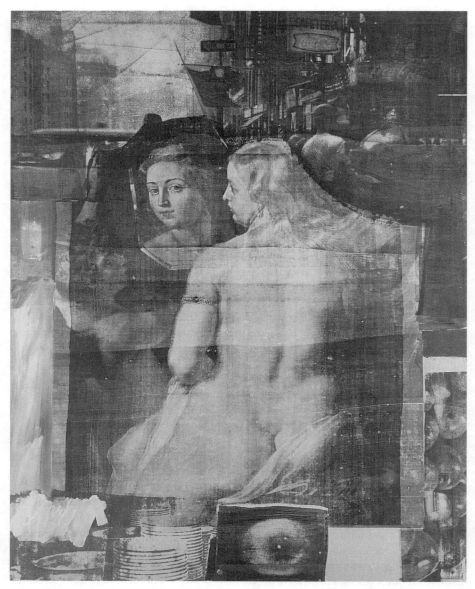

Robert Rauschenberg, Persimmon, *1964. © Robert Rauschenberg/Licensed by VAGA, New York, NY.*
Courtesy Leo Castelli Gallery. Photo: Rudolph Burkhardt.

myself. And it's always the moment of doing it that counts. When a painting is finished it's already something I've done, no longer something I'm doing, and it's not so interesting any more. I think I can keep on playing this game indefinitely. And it is a game—everything I do seems to have some of that in it.[2]

The notion of play is an essential ingredient of process, a notion also espoused by artists associated with the early "happenings," namely Allan Kaprow and Claes Oldenburg. Clearly, the notion of play, of participating in a game or working through a process, superseded the definition of art as a fixed, traditional concept. In many ways, the sixties represented a movement away from absolute form as an aesthetic dictum or posture to an emphasis on the transitory, on the notion that art could be a form of play, even though by the end of the decade the conceptualists had worked back into the realm of a more rigorous definition, almost as if a cycle had occurred. Nonetheless, from Rauschenberg to conceptual art, there was a common thread—and that thread lay somewhere in this gap between art and life, between nuance and cognition, between ecstatic form and formal documentation.

To fully comprehend the dilemma of the sixties—fraught as the decade was with contradictions and rapidly changing shifts in social and political temperaments— it is necessary to examine the context of these changes within the art world. How did the art world absorb such violent metamorphoses as the repressive fifties gave way to the explosive sixties? The art historian Irving Sandler points out that the unique sensibility of the sixties was less obvious since most critics interpreted "the new art" as merely a response or reaction to abstract expressionism.[3] Frank Stella's early blackstripe paintings, for example, were understood as hardened gesture, or a new form of geometric abstraction that was replacing the relational styles of gestural and chromatic painting that emerged in the late fifties and was particularly dominant among the second-generation abstract expressionists and the Washington Color school. In other words, the sixties was more than a simple change of styles. It was not so superficial. The contradictions, indeed, the warring factions upholding formalism and antiformalism, were profoundly at odds with one another.

It is generally agreed that Rauschenberg and Johns formed the bridge between the gestural attitudes of the abstract expressionists and the beginnings of pop art. For the most eminent critical champions who had defended the formal and philosophical premises of the old generation, such as Clement Greenberg and Harold Rosenberg, pop art was less than satisfactory as an evolutionary development. In fact, it was generally seen by these critics as a trivial response grounded in kitsch and supported by the media theories of Marshall McLuhan. For others, it was the awakening of a new consciousness, one in which secularism had come to replace metaphysics, where the mundane and the banal had come to replace the heroic and the sublime. Rosenberg invokes Andy Warhol's response to a question concerning whether one of his films was art: "Well, first of all, it was made by an artist, and, second, that would come out as art."[4]

Rosenberg makes the point that Warhol's statement, rather than defining art,

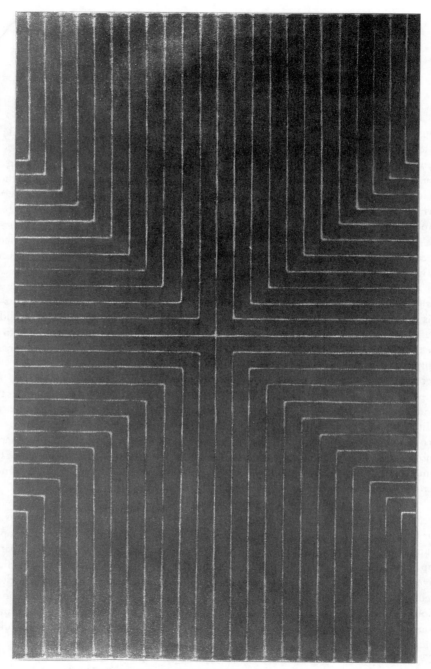

Frank Stella, Die Fahne Hoch, *1959. Whitney Museum of American Art.*
Photograph © 1998 Whitney Museum of American Art.

pushes audiences to the brink of what he called the "de-definition" of art. In questioning the criteria of the new art, Rosenberg explains:

> The nature of art has become uncertain. At least, it is ambiguous. No one can say with assurance what a work of art is—or, more important, what is not a work of art. Where an art object is still present, as in painting, it is what I have called an anxious object; it does not know whether it is a masterpiece or junk.[5]

On the other hand, for Greenberg, the criteria were not so much a question as was the quality of the art itself. The task of criticism was to maintain standards of taste at all costs and to resist the temptations of such period manifestations as pop art. For Greenberg, the traditions—hence, the criteria—used in determining the best art have a clear linearity: "Nothing could be further from the authentic art of our time than the idea of a rupture of continuity. Art is, among many other things, continuity."[6]

It is curious that most of the works of art in the selections from the Castelli and Sonnabend collections represent the antiformalist tendency that Greenberg firmly rejected after 1960, and the kind of avant-garde positioning that, for Rosenberg, had thrown the art world into crisis. Yet, as we look at these works today, the dilemma of the sixties does not seem as apparent as it may have even a decade ago. Somehow, the juxtaposition of a pop art drawing, such as Lichtenstein's *Ball of Twine* (1963), carries a certain elegance in relation to minimalist works by Donald Judd or Dan Flavin. And today, Johns's drawing of *Target With Four Faces* (1968) does not seem out of place in relation to Cy Twombly's *The Blue Room* (1957), though they are eleven years apart.

The latter comparison is worth noting. Johns has developed, over the years, an encyclopedic view of personal symbols—autobiographical symbols—that somehow manage to enter into a somewhat arcane stylistic vocabulary. Given his early evolution as a painter from a late abstract expressionist sensibility, it became evident that Johns valued the tactile response to the surface as much as the sign or sequence of signs represented. Johns, like Rauschenberg, stylistically placed himself somewhere between expressive gesture and sign.

The critic Max Kozloff boldly asserted upon viewing the first Johns retrospective, at the Jewish Museum in 1963, specifically in relation to the painter's use of numbers, letters, targets, maps, and flags, that conventional "subject matter" was missing from his work, and one could not easily differentiate "between the visual medium and the thing referred to."[7] Kozloff thus acknowledges in the early Johns a reduction of the visual sign to a trace of meaning that, although understood, ceases to function socially. This premise, on which the early work of Johns depends, corresponds to some degree with the readymades of Marcel Duchamp. In either case, the original meaning of the object is reduced to a functionless sign that, in turn, decontextualizes its potential for representation.

On the other hand, Twombly's graffiti-like marks on canvas in *The Blue Room* suggest absence by underscoring gestural marks rather than negating the abstract

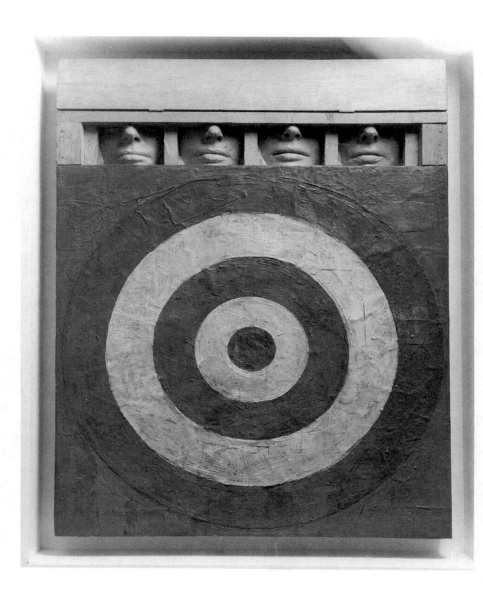

Jasper Johns, Target With Four Faces, *1955. © Jasper Johns/Licensed by VAGA, New York, NY. Courtesy Leo Castelli Gallery, Collection: The Museum of Modern Art, New York. Photo: Rudolph Burkhardt.*

surface. Twombly reduces and transforms the gesture itself into a trace in which the potential to represent is contingent upon feeling and upon a particular moment. Coincidentally, the repression of the sign, whether material or ethereal, becomes an issue in relation to the reading of the surface of the painting; that is, how meaning is construed by the sequence of marks constituting that surface.

Historically, the motif for a Johns drawing from 1968 is actually based on the well-known 1955 painting with the same title—the painting that art historian Leo Steinberg used in one of his illuminating essays to analyze his subjective response to the artist's first exhibition in New York:

> In *Target with Four Faces*, I became aware of an uncanny inversion of values. With mindless inhumanity or indifference, the organic and the inorganic had been leveled. A dismembered face, multiplied, blinded, repeats four times above the impersonal stare of a bull's-eye. Bull's-eye and blind faces—but juxtaposed as if by habit or accident, without any expressive intent.[8]

In this last phrase lies a key to Johns that has allowed the artist to distance himself from his encyclopedia over the years. Whereas with Twombly one may feel the impulse, the sensation, and the resonance of the marks as a special kind of scrawl, a primitive letter, that moves from the present into an inscrutable autobiography, with Johns the distancing effect is felt as the outset.

One can talk about the sixties in terms of the nonexpressive gesture. Irving Sandler, in fact, sees Johns along with Ad Reinhardt as forerunners of the "cool art" that eventually led to minimalism.[9] Artists such as Robert Morris, Mel Bochner, Barry Le Va, Dan Flavin, Donald Judd, Keith Sonnier, and John McCracken are all representative of this emerging sensibility in the sixties. The general issue among these artists was to discover a new space for art independent of the expressive gesture. Rather than expressivity, these artists were purposefully committed to the spatial effect of distancing. It is little wonder that minimal art appeared less as a manifestation of painting than as a pragmatic "distillation" of sculpture—a term adopted by the critic E. C. Goossen for this tendency. Ironically, Goossen's notion of distillation sounds similar to Greenberg's notion of "continuity" in Goossen's commentary on an exhibition at the Stable Gallery in 1966:

> An increasing number of artists are now working close to the core of the continuing process that is twentieth century art. That process . . . is one of distillation. As such, it has put more and more limitations on the mannerist and psychological escape routes available to anyone hoping to make a satisfactory work of art in our time.[10]

This notion could be no more apparent than in Donald Judd's *Untitled (Round Progression)*, Dan Flavin's *Monument for V. Tatlin*, and Robert Morris's *Nine Fiberglass Sleeves*. In each case, there is an emphasis on modularity, repetition, and

standardization. They function as artifacts of industry, yet removed from any assumption of utility; thus, they are implicitly related to Duchamp's readymades.

John McCracken represents a significant departure within the core style. His saturated, brilliant color, elegantly slim proportions, and lustrous finish evoke California hedonism rather than New York epistemology and struggle. For Judd, who wrote extensively in *Arts* magazine in the early sixties, including his important, definitive essay for the new movement, "Specific Objects" (1965),[11] the new sculpture was about "getting rid of the things that people used to think were essential to art."[12] Morris's nine-part modular sculpture confronts the viewer with a symmetrical group of identically fabricated irregular boxlike shapes suggestive of the gestalt relationship between inner and outer spaces in the process of forming a new configuration. The old "relational" idea of sculpture, particularly the anthropomorphic sculpture of the surrealist and early abstract expressionist period, was suddenly obsolete as a viable concept, especially in relation to Judd. One of the rich theoretical aspects of the sixties was the emergence of many contradictory impulses, which included the formalist argument and the disputed alternatives between the iconic gesture and the abstracted sign. The iconic gesture is directly represented in the blunt secularism of pop art, which first made its appearance in the United States in 1961. By the time of the *New Realists* exhibition at the Sidney Janis Gallery the following year, the major artists associated with pop art had been introduced in various New York galleries.[13] They included Andy Warhol, Roy Lichtenstein, Claes Oldenburg, James Rosenquist, and Tom Wesselmann. Another artist, Jim Dine, associated with Oldenburg in the earlier happenings, was also working in relation to a pop sensibility. From the outset, the nascent manifestations of pop art were given a controversial reception. Max Kozloff, for example, referred to these artist as "the new vulgarians."[14] The more euphemistic label "new realism" would eventually change to "pop art," presumably appropriated from the British critic Lawrence Alloway,[15] and thus avoiding confusion with the French nouveau realists— Arman, Yves Klein, Martial Raysse, Ben, Daniel Spoerri, César—who were introduced in Milan by Pierre Restany two years before the Sidney Janis show.

In retrospect, one can see that the initial receptions to pop art and later minimal art were controversial in the sense that they denied the tactile relationship to form and the rich painterly styles of the gestural abstract painters of the previous generation. The formal and aesthetic connections between the pop and minimal artists are curious and intriguing, even though the latter group generally repudiated the former. Whereas the representation and commercial sources of pop art were hypothetically opposed to artists such as Judd and Frank Stella, one can find certain connections and even resemblances between minimalist drawings and drawings by artists such as Lichtenstein, Warhol, and Oldenburg. These likenesses are not so much a matter of explicit subject matter or form, but can be compared to a kind of emblematic, even corporate, identity. For example, Stella's *Conway* or *Abra II*, both drawings on graph paper, are not so far distant from Oldenburg's *Typewriter Eraser* (1969) or even Robert Watts's neon signature of Picasso. Each work has as its signifier some connection to art as a form of production; that is, a production removed from the tactile uniqueness of gestural painting. From Hal Foster's revisionist perspective, the industrial connotations

of pop and minimal art endorse a similar kind of signification and status: the object functions as a sign of production in which there are permutations based on a shared, definitive prototype.[16] This does not suggest that the polygons of Stella, the modular structures of Judd, or the fluorescent light fixtures of Flavin can be lumped together as "variations on a theme." Rather, Foster implies a rationalist or even empiricist attitude to the object rather than its opposite.

In either case, pop and minimal art can be seen to promote another type of formalist model distinctly different from Greenberg's aesthetic formalism. The new formalism of the sixties, which at the time was actually perceived in terms of an antiformalism, seemed to follow the production-line model; but, unlike the earlier Russian formalists (Rodchenko and Mayakowsky), to which this new secularism or contra-Greenbergian formalism might be compared, pop and minimalism were decidedly more cynical and detached. Lacking the context of the October Revolution, despite the evident political fervor of the American Left, the antiformalist artists during the American sixties were more casual in their desire to purge themselves of the vestiges of late capitalism. In retrospect, pop and minimalism appear somewhat removed from the experience and social catharsis of political radicalism. It is curious that with the possible exceptions of James Rosenquist's monumental wrap-around painting *F-111* (1965), acquired recently by the Museum of Modern Art, there was almost a complete absence of explicit or even veiled political content in art. In spite of Benjamin Buchloh's arguments in favor of Warhol as a "political artist,"[17] pop and minimalism were generally moving on their own antiformalist tracks within an art world context. At the other extreme, Michael Fried argued that the new art's tendency to embrace a new theatricality was a pernicious sign, and he was speaking directly of minimalism.[18] For Fried, any attempt by art to transgress the limits of its own self-criticism was aesthetically untenable; therefore, the real time and real space of minimalism—its presence— was contrary to "the concepts of quality and value . . . within the individual arts."[19]

Fried's attack on minimalism or "literalist art," as he preferred to call it, only strengthened the forces building against Greenbergian formalism in the late sixties. Concurrently, toward the end of the decade, the common attitudes of social detachment and cynicism began to change, and the intervention of social and political concerns became more apparent, and pressing, with the formation of such artist-run organizations as the Art Worker Coalition and the Guerilla Art Action Group. By 1970, the spirit of antiformalism had enlarged its parameters to include issues outside the art world. This was largely inspired by the critic Lucy Lippard, an early champion of both pop and minimal art, who wrote incisively that "the interrelationship between art-politics (basically economics) and national or international politics makes artists unwilling to think about improving their own conditions as artists."[20] With the escalation of the war in Vietnam, the rise of attention given to civil rights, abortion issues, ecological issues, and feminism, the art world was suddenly faced with a radical new agenda that made the type of formalism associated with color field painting and lyrical abstraction seem out of touch with the present reality. Fried's positions, even buttressed by the theories of Greenberg, could not survive in such a climate.

Pop art was clearly the first evidence of a radical break from the appearance

of avant-garde art of the previous decades. Warhol's Campbell's soup cans (1965) offer an industrialized decorative counterpart to the emotionally charged gestures of the abstract expressionists or, for that matter, the rugged material entropy associated with the works of the post-happenings era, including the early paintings of Jim Dine, the crushed car sculptures of John Chamberlain, and the poignant plaster figurations of George Segal. Lippard makes the curious distinction between "clean" and "dirty" works of art to represent two sides of antiformalist tradition going back to some of the early dada objects.[21] What is decisive about Warhol's commercial packaging motifs, including his portraits of the famous art world personalities Leo Castelli and Ilena Sonnabend, is the manner of his production. Through industry and advertising, Warhol makes a "clean" break from the past, and therefore negates any accessible connection to dada or "anti-art." Another instructive comparison might be made if we take Richard Artschwager's *Swivel Chair* (1964) to represent the clean look, in that it deals with the refined simulation of fabricated, mass-production objects, while Claes Oldenburg's *Giant Ice Cream Cone* (1962) deals more with the anti-art tendency associated with early dada or with the spontaneous look of the happenings movement. Another example of the tidied-up look associated with the typical fifties American kitchen is represented in Tom Wesselmann's *Still Life with Radio* (1964). For a simulated, idealized but vernacular romantic vision, which nostalgically also represented the fifties, one could cite Roy Lichtenstein's *Eddie Diptych* (1962).

In the 1990 *High and Low* exhibition at the Museum of Modern Art in New York, Kirk Varnedoe and Adam Gopnik made an attempt to research the origins of pop art. One of their findings was that much of the material and imagery these artists used was borrowed from the decade before the sixties. In the catalogue, this notion is explained:

> By the 1960s, when high-level mass advertising had adopted many of
> the strategies and inflections of modern art and was operating at an
> extraordinary level of sophistication, artists had to dig deeper to find
> motifs and styles that would distance their work both from the romance
> of art and from the slick visual cleverness of contemporary ads. This is a
> partial explanation for the streak of nostalgia that permeates Pop, and
> that drew these artist to motifs dating back to the decade just past. . . .[22]

This sense of historical "distance" was one of the essential ingredients of pop art, and it contributed directly to its cynical content. It is curious that this effect of distancing by adopting the clean look in both pop and minimalism—in which Richard Artschwager played a preeminent role—would eventually refine itself to the point where the object itself seemed superfluous or, at most, subordinate to the "concept" that provoked its making. Hence, by 1966, a new phenomenon based on the "dematerialization of the art object" began to emerge in American art (with distinct counterparts in England and Europe): conceptual art.[23]

Many of the artists associated with this development—including Robert Morris, Mel Bochner, Bruce Nauman, Joseph Kosuth, and Barry Le Va—were earlier

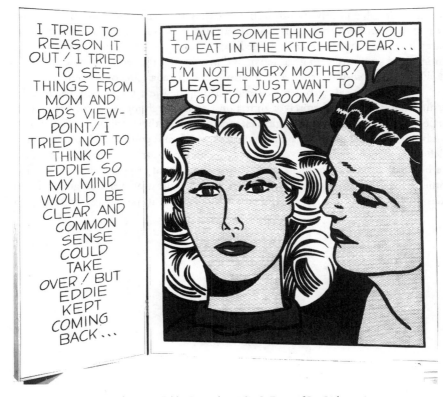

Roy Lichtenstein, Eddie Diptych, *1962. © Estate of Roy Lichtenstein.*
Courtesy Leo Castelli Gallery, New York. Photo: Eric Pollitzer.

considered minimalists or process artists or, in the case of Nauman, an "eccentric abstractionist" (later to be dubbed a "postminimalist").[24] Other major artists included Sol LeWitt, Robert Barry, Lawrence Weiner, Douglas Huebler, and John Baldessari. In essence, these artists were concerned primarily with the language of art as opposed to its visual form; or, put another way, they saw the "concept" as the irreducible if incorporeal substance upon which the material or documentary aspect of the work depended.[25] Many permutations of conceptual art developed between 1966 and 1972, some of which involved material form, but usually as a carefully considered consequence of the concept that supported it. Richard Serra's untitled rubber piece from 1968 is an example of a structural idea that has manifested its form according to gravity and physical space.

The scope of ideas, objects, and events that comprise the art world of the sixties now seems staggering, especially as we reinvestigate the theoretical terms upon which much of this work was determined. The antiformalist impulse was clearly the fundamental source inherent in these developments. There was abundant evidence on all sides of the breakdown of old categorical rhetoric by which formalist critics per-

ceived art through a positivist's prism. In the sixties, this type of formalism eroded as art came to mean more than "self-critical" painting and sculpture, and criticism began to stretch beyond Greenbergian and Friedian strictures. Artists were still producing paintings and sculpture with great fervor and insight, but the terms of these categories had changed, and with the changing of terms came the changing of content.

The political, turbulent sixties opened up new artistic possibilities, under pressure from the artists themselves, in response to new technologies, cultural attitudes, and personal lifestyles. The ideological factors implicit in their radical artistic innovations brought greater emphasis on the political, social, and cultural environment in which these works were seen. Even so, today we look back on the art of the sixties with a fresh perspective from another contextual viewpoint, and reappraise it in terms of another critical discourse. It is within this expanded context of ever-changing cultural values that the art of the sixties clarifies itself and achieves its enduring stature.

Antiformalist Art of the Seventies

After the eighties, it has become increasingly difficult to speak of an "anti" movement in recent American art. With postmodernism, there is the ironically staid assumption that polarities, such as those established at the outset of modernity, namely the repressive attributes of the Victorian pendulum, are largely, if not completely, out of sync with the mediated omniscience of our globalized heterogenous culture. That, in fact, is the issue of the eighties; or, perhaps, more than an issue, it is the decade's "problematic."

Is culture really losing its definition? And what do we mean by "culture," particularly as we approach it from an aesthetic framework? Postmodernism, as it came of age in the eighties, erroneously assumed that advanced culture—that is, culture wrought from the postindustrial "world"—had already homogenized the plurality of linguistic and behavioral effects attributed to various parts of the globe. In other words, everything was up for grabs, and whatever was "appropriated" by way of someone's historical memory could then situate itself within a new lexicon bent on irresolution and utter suspension of belief. At the risk of sounding too simplistic, this issue, or problematic, as the case may be, has tended to dissociate the facts of history from historical memory, in the sense that the latter, being an aspect of the eighties, tends toward a hyperaestheticization of global culture, thus making a global phenomenon out of pluralistic phenomena.

The writings of Edward Said were some of the first to address this phenomenon, along with the writings of French feminist thinkers, such as Irigaray, Cixous, and Kristeva, in a way that reminded us that difference deserved legitimacy and that the notion of an advanced culture (and thereby an advanced art) was not a seamless notion.

In the art world of the seventies, however, theory was not a popular issue. Pluralism, as it entered the journalistic portals of some art magazines and some counterculture tabloids, was quickly usurped as a marketing ploy. Once the Greenbergian hierarchy of the fifties and early sixties had become institutionalized, and in some institutions had become ossified, specifically among tenured male professors, it was time to relinquish certain assumptions about taste. In questioning the rules of formalism, which seemed indulgently wrapped around the notion of a late modernism, artists

of the seventies began to explore new terrain; that is, to enter into a new dialogue with content. The term "pluralism," due to its negative associations with a somewhat frivolous marketing appeal, was inadequate to express what happened at the end of the sixties. On the other hand, "antiformalism" was equally at fault. Whereas the former suggested that no criteria were available and therefore everything and anything was acceptable, the latter asserted an attack on the principles espoused by the American academy at the time. Indeed, each of these concepts carried some truth in spite of certain inadequacies that have become clearly apparent over the years. What appears most interesting regarding the phenomena of the seventies—and in this sense it is proper to speak in the plural rather than the singular—is the extreme diversity of tendencies that took off after formalism had, at least, temporarily, dug its own grave.

The cerebral concerns of minimal and conceptual art were, by 1970, starting to become mannered in their appearance—one might say "stylized" in that the work had convoluted, establishing various marks of artistic identity, thus falling into the same trap as modernism had fallen during the fifties and early sixties. The emergence of "pattern and decoration" in painting and sculpture came in the wake of early conceptualism and largely centered around the Holly Solomon Gallery. The history of this tendency is a little more indirect than the antiformalist concerns of other more reductive tendencies. One can see some relationship between the "post-painterly abstraction" (a Greenbergian notion), eclipsed by the term "color field painting" by the mid-sixties, and the development of something called "lyrical abstraction" in the early seventies. But what is remarkable is that many of the strongest exponents of "pattern and decoration" had almost no lineage with or connection to the formalist legacy of the preceding decade. This suggests that decorative painting not only carried a twist of irony but was as idealistic in its response to formalism as minimal and conceptual art had been to abstract expressionism.

One might say that the seventies was a saga largely told by individual artists eager to maintain a point of view divorced from any facile criteria or theory about art or culture. The expression of individual creative freedom in breaking the rules of a severe reductivist philosophy in art-making was starting to make sense. The rebellion was a persistent one. Each told his or her own story. Narrative was coming back into art. The stories and hybrid techniques forbidden by high modernism were suddenly let loose. At one extreme was the continuing advent of Neoplatonism run amok in the washes of concepts, body art, earth art, and performance of all kinds; at the other was another form of a stoic intrigue: the bridling of decorum through a revival of antiquity, but without stoic rules and bereft of conformity. Somewhere on the vast spectrum in between was the awakening of a feminist discourse, an ecological awareness, and a systemic regard for perception. All these tendencies came to the forefront as if the conventions of art-store material and traditional media had somehow been pushed aside. Some critics commented disdainfully on this strange reversal where concepts had suddenly usurped the presence of form. Put another way, the use of material had usurped the boundaries of objecthood. For example, in the installations of Ree Morton, where various shapes constructed in paper, canvas, and wood were placed directly on

the wall or suspended in relation to the wall, it was apparent that space was not a quantity to be assumed, but a qualitative mode of thinking in which materials could define themselves in terms of narrative structure. Indeed, it was Morton's ability to see beyond the confines of the object without rejecting the possibilities of material manipulation that revealed a powerful tentativeness within the cerebral posturing of that moment. It was the interval that held meaning, and within the interval there was the possibility of re-formation and reconstituting form as a perceptual field. Recognizing the temporality of all forms, Morton was instrumental in moving the lagging dogma of high modernism into another circumstance where content could assert itself as subjective distance. The antiformalist posture of that moment was quickly filled with a fresh decorative tempo. This was the moment before theory would reemerge in social terms. It was the moment that bridged one aspect of aesthetic theory with a more secularized involvement with systems of semiology and poststructural theory.

In challenging formalism, artists such as Judy Pfaff and Alan Shields began moving outside the unidirectionality given to the reductive enterprise. Shields brought painting onto the floor and gave it three-dimensional form as habitat or relic. Pfaff broke through the grid of cubism into another spatial arena, creating impossible manifestations of linear fluidity that defined the horizon between wall and floor. Pfaff's hybrid sculptural forms extend from the wall into the space with wire and steel armatures adorned with colorful bursting shapes. Shields's sculpture is also colorful, using suspended linear modules descending from the ceiling or pyramidal constructions rising up from the floor. In a different way, Gordon Matta-Clark began his investigations into planned buildings by tearing holes through walls and floors or breaking sections of buildings into discrete parts. Matta-Clark's anti-utopian vision dealt directly with the refuse of construction, thus focusing attention upon the temporal and sculptural aspects of neglected architectural spaces, and reinstilling within them a series of narratives that metaphorically captured the psychic dilemmas of our age. The violence attributed to Matta-Clark's vision was merely an obligatory response to the remnants of lost modernity. His was the important logical step where form could go after formalism failed to offer anything more than a solipsistic academy of utopian gestures and terrifying nuances heading backwards in time.

Yet, for other artists, such as Jennifer Bartlett, Mel Bochner, Sol LeWitt, and Barry Le Va, the system was the thing. Their aesthetic was more than a sensibility or a fashionable response to art as idea. Language was the essential feature of this work. Everything depended upon the structure of the operation or how the system played itself out. The grid was the essential component of structure, offering a uniform control over the configuration of the various systems deployed. LeWitt is significant in this regard. In many ways his work constitutes the bridge between minimal and conceptual art in the mid-sixties. LeWitt saw structure as a dualistic phenomenon: language and its visual concreteness. Both elements were necessary in order to describe the concept being put into operation. According to the critic Lucy Lippard, this operation was antithetical to the aesthetic formalism of the more consciously "expressive" artist.

LeWitt's approach is not "formalist": it is the reverse. The paradox originates in the two opposing stages of making art: conceiving it and executing it. In the first stage, the concept, or order, is pure; in the second, it is altered by the impurity of perception or disorder of "reality" that is affected and formed by accidental terms of conditions and experience.[1]

LeWitt's early drawings are excruciatingly precise. The most simple linear configuration is given to fastidious linguistic precision. In doing so, one is able to grasp the considerable tension that exists at the foundation of language and image.

Jennifer Bartlett's "grids," such as *CN 2022 #34,* involve the use of enamel and silkscreen on steel plates. The patterns are highly abstract, even agitated in their visual distribution; yet one detects a clarity of process—and from the process, there is order. While the linguistic aspect of Bartlett's work appears secondary to the mathematical randomness of the dots, there is a persistence about these modular arrangements that is intensely wrought. It is curious that Bartlett's work from the mid-seventies represents a hinge between the two extremes of the antiformalist position, a passage into poststructural narrative that eventually moves into her more recent paintings and installations.

Mel Bochner's stone pieces are also dependent upon the structure of the grid. They make use of a taped grid placed directly on the floor. Within the grid, Bochner places arrangements of small stones accompanied by simple equations as if illustrating a logical proposition. These primary elements describe the structuralist dichotomy between the natural and the cultural signifiers in both primitive and "advanced" cultures. With Bochner, there is the essential flare or reductivism presented in its most straightforward manner. Stones are used for counting and arranging, and for ordering. Stones are the elements of the system that the artist puts into operation. The architecture is a necessary structure, a material or physical structure, a point of resistance by which the stones intercede and play off the horizon of the floor and wall. Bochner's reductivism alleges a sense of the decorative without admitting it. One experiences the structure, the tension, and force of the natural elements; yet this tension may allude to another antiformalist situation. The philosopher Wittgenstein once said, "Form is the possibility of structure"[2]; that is, structure precedes form. Structure gives us certain parameters, but it resolves nothing. The discrepancy between the two is negligible as a concept but more accurate in its visual manifestation. The floor recedes into the wall, and form recedes back into structure. Resemblance and dissemblance echo one another. The tension is unavoidable, impossible to obviate or destroy. Stasis is built from kinesis; this is what Joyce described in the words of Stephen Dedalus:

> Desire urges us to possess, to go to something; loathing urges us to abandon, to go from something. These are kinetic emotions. The arts which excite them, pornographic or didactic, are therefore improper arts. The esthetic emotion . . . is therefore static. The mind is arrested and raised above desire and loathing.[3]

This stasis is also revealed in the drawings of Barry Le Va. His specific attention to space and his working of space incorporates overlays of architectural facets. These spatial overlays may then incite an awareness of his physical and mental processes. Space is conceptualized and made flat. The physical properties are attenuated in terms of linear angles that appear as hieroglyphic marks, as some forms of ancient language, some fundamental structure within memory. This suggests Noam Chomsky's theory of "innateness," that language is in fact a construct that is already present within the human mind. Through the testing of linguistic configurations and syntactical differences, these structures evolve as indirect correspondents. What is invisible emerges as visible. Le Va's installations are bound to the architecture in which they reside like a faceted analytic-cubist paradigm.

When more purely conceptual works, such as those by Lawrence Weiner, Robert Barry, and Douglas Huebler, are discussed, there is an immediate reference to language and the way in which it operates. With Weiner, the phrases maintain a syntactical and metaphorical connection to physical space. They are painted or placed directly on the wall. In a series of drawings called *A Reasonable Assumption,* the permutations of a diagrammatic space reveal a certain dialectical association. For Weiner, words are ineluctably tied to their dematerialized construct. Weiner draws configurations of abstract geometric elements in relation to words as if to set up a logical paradigm between space, objects, and their linguistic context. In Robert Barry's work—which consists of lists of words on paper or slide projections of words in dark space—physical space is neither here nor there. Language exists in suspension of its syntax. Barry's generalized significance of the words offers an expanded possibility, a concept without a frame. Even in his more recent paintings and wall pieces there is a sense that the words and phrases are constantly moving outside the domain of their syntactical place. Their linguistic habitat is completely arbitrary. What matters is their association and their connection to human experience, not their predetermination.

Douglas Huebler was perhaps the least emblematic of the conceptualists working actively during the seventies. Huebler's works are nearly impossible to decipher without their accompanying statements. By observing a relationship of points and lines that Huebler has affixed to paper or the wall, the viewer is invited to read a statement that influences one's perception of what one is seeing. Though reductive, the arrangement of points and lines takes on a metaphysical relationship to the viewer's sense of time and space. For Huebler, the work only exists by way of reconstituting the various components that the artist has made available to the viewer. These might include photographs, maps, drawings, sketches, paintings, legal documents—any of which is accompanied by a descriptive statement, usually presented by the artist on a sheet of typing paper. This approach to art once inspired the following analogy by the late critic Harold Rosenberg:

> Art communicated through documents is a development to the extremes
> of the Action-painting idea that a painting ought to be considered as a
> record of the artist's creative processes rather than as a physical object. It
> is the event of the doing, not the thing done, that is the "work."[4]

Robert Kushner, Bicentennial Salute *from* The Persian Line: Part II, *1976. Courtesy DC Moore Gallery, New York.*

It is curious that Robert Kushner's work, considered a seminal proliferator of the decorative movement, had an indirect relationship to action painting as well. In one respect, Kushner's orientation toward art and art-making could not be further removed from Huebler and the conceptualists. In another way, Kushner's involvement with the gesture, with body movement, with costumed concealment and revelation, suggests that the activity of form or the process that begets form is highly descriptive of a conceptual action. Just as Allan Kaprow once described the work of Pollock in terms of choreography, movement, and gesture, one can see this sensibility arising in Kushner's oeuvre, particularly in the period of the mid-seventies. *Biarritz* takes its form from a ceremonial robe, a garment worn by a participant in a ceremony or in some ancient ritualized presence. Kushner expresses this idea in his choreographic work *Persian Line, Part II* performed at the Holly Solomon Gallery the following year.

While Kim MacConnel's work also contains a careful modulation of decorative form and content, one might also cite a semiotics of political involvement. At first, MacConnel's work carried a cynical aspect to it, a certain defiance in its stance against formalism. As his approach to patterned ornamentation developed into the seventies, it became more ideological, specifically in its allusion to arts and crafts. The history of the Arts and Crafts movement in England in the mid-nineteenth century was a history of defiance against the standardization of aesthetics as epitomized through industry and a rising class consciousness. With MacConnel's *Untitled (Collection Applied Design),* there is a homologous attempt to address the concern of decoration as floral patterning—a

Kim MacConnel, Arabesque, *installation view, 1978. Courtesy Holly Solomon Gallery, New York City.*

textile-design concept that does not fit the prototypical model for manufacturing (as in the case of Haring or Scharf), but rather assumes the action-gesture as integral to the process. Pattern, for MacConnel, is not an automatic concept, but an evolving one. It is not about the punctuation of disco music, but the rhythmic variations of a repetitive module juxtaposed in vertical registers. In this sense, to produce a pattern is a political action when it is placed in tension with the manufacturing industry and challenges the standardized means of production.

The concept of patterning, or pattern painting, was also practiced by such feminist-oriented artists such as Miriam Schapiro and Joyce Kozloff. In either case, the role of the artist was seen as a means of production in order to provoke or incite another political referent. Whereas MacConnel's patterning used a form of designer mimicry, within the gestures of action painting, to offset the industrial prototype, Schapiro and Kozloff—not to mention the ceramic interiors of Cynthia Carlson— were more specifically directed toward the content of woman's issues. The fact that decoration tended to be regarded by some art historians as a "lesser art" was a concept that needed some deconstruction by the way of practice. Patterning was one way in which content could come back into the reductivism and ultraformalist absence of art-making.

This is to assert that the split between patterning as a means of production and conceptualism as a means of dictating the position of art as idea could never meet on equal ground at the time these divergent works were being produced. For the

Valerie Jaudon, Canton, *1979. © Valerie Jaudon/Licensed by VAGA, New York, NY.*
Courtesy of Sidney Janis Gallery.

decorative artists, conceptualism had gone too far in removing itself from the plasticity of form. Something had been lost that needed to be regained.

Valerie Jaudon's manneristic geometric configurations are not far removed from the influence of Islamic design. Her large square paintings, such as *Canton* (1979), resemble the implied infinity seen within the great mosques of Islam, such as the one at Córdoba. With Jaudon, there is a literalness and a supreme directness in the mapping of the arcs, curves, and angles; yet there is not the dependence upon linguistic interpretation or correlation that is used by Sol LeWitt. One might refer to Jaudon's paintings as mannered because they extend the rigorous specifications of LeWitt, Le Va, Bochner, and Bartlett (early) in terms of an explicit opticality. *Canton* is more a perceptual experience than a conceptual one.

This sense of illusions through literalness was often the result in works

produced by artists who were associated with site-specific sculpture. After the earth works of the late seventies, there was a tendency among some sculptors to deal with sensory qualities in relation to the perception of given spaces. In the work of Elyn Zimmerman, this phenomenon became apparent in a series of installations made primarily in southern California.

At the Baxter Art Gallery of the California Institute of Technology in Pasadena, Zimmerman altered the perception of the space by manipulating the orthogonals on the floor in their perspectival relationship to the viewer. She then proceeded to set up two mirrors that would exactly reflect two shapes of light; one trapezoid and one parallelogram. Zimmerman became interested in how the viewer's relationship to the space acts as a specific reference toward gathering visual information about the space. The experience may become both cognitive and psychological. To come to terms with the space, the viewer is asked to enter into it, thus becoming part of a gestalt. The gallery, at this juncture, ceases to operate as a container for works of art and instead operates as an entire pictorial field. Pictoriality no longer exists as a quality detached from one's sensory mode of being. In this sense, one could presumably get no further from the concepts promulgated by decorative art.

Yet, on another level, there are some startling similarities. Just as the Austrian secession could include works as radically different as the Steiner House of Adolf Loos and the decorative panels of Gustav Klimt, so one might presume that Zimmerman's perceptual environments may have been, in the mid-seventies, as challenging to the formalist program of the sixties as ornamentalism was to color field painting. The limits of reductivist space were being opened up and maximalized. Regardless of how naive these pictorial experiments may have been, there was a new topology of content coming back into advanced art.

This sense of the naive could provoke a considerable breadth of content. For example, one might regard Vito Acconci and Thomas Lanigan-Schmidt as approaching art through a kind of purposeful naïveté, but in different ways. Acconci's *Trappings* (1971) documents a somewhat hermetic activity—an androgynous affair reminiscent of Duchamp, yet onanistic in a way that carries the intensity of an Egon Schiele. The activity involved the artist who sat undressed in a closet while "dressing-up" his genitals. The psychoanalytic implications of this activity may appear anal retentive, yet what is illuminating about Acconci's piece—in this era before postmodernism with all its theoretical baggage—is precisely its boldness and naïveté. Acconci's work is truly cognitive, even heuristic. Something can be learned in the process of observing and discussing it. Thought and emotion function on the level of language, a structural paradigm removed from the vestiges of normative social behavior.

With Lanigan-Schmidt, the religious icon is not so much attacked as it is embellished beyond reason and beyond any consideration of its proper significance. Lanigan-Schmidt operated as a true iconoclast. In many ways, his ornamental structures parallel Acconci's investigations into a subjective discourse on the body. Lanigan-Schmidt's corporeality is bound to the icon, and the icon is the signifier that is closest to any system of representation. The gaudy gold and extravagant pinks and purples, studded with cheap jewels and toys, are the perfect antidote for the frozen signs of

Thomas Lanigan-Schmidt, The Infant of Prague as a Personification of Liberation Theology, *1986–87.*
Courtesy Holly Solomon Gallery, New York City.

formalism. With Lanigan-Schmidt, the portals of the postmodern epoch are set ajar only to reveal the glittering phantasms of a purloined culture where icons abound and signification begins to stutter.

What becomes evident in examining the works of these artists, who initially may appear at opposite ends of the aesthetic/political spectrum, is how proximate they are in their defiance of a strict formalist code. In this sense, decorative art and painting are perhaps not so far removed from conceptual art as has often been presumed.

Eccentric Abstraction
and Postminimalism

To come to terms with the tendency known as eccentric abstraction in recent American art, it is helpful to clarify its generating impulse as it emerged in the sixties and then fed into the postminimalist sensibility of the seventies. Upon confronting the pervasive dominance of minimal art in the mid-sixties, the critic Lucy Lippard became interested in an alternative possibility for sculpture—one that might "soften" the hard-edge reductivism and fabricated appearance of those cubic and cylindrical modules. In the summer of 1966, she was asked by the director of the Fischbach Gallery in New York to curate an exhibition based on the content of an article she was writing at the time for *Art International*.[1] Entitled "Eccentric Abstraction," Lippard's article focused on a group of mostly younger, though unrelated, sculptors who were less involved with academic formalism and more concentrated on a play with materials and experimental form, often citing antecedents in the work of the surrealists. The exhibition actually preceded the publication of the article by one month, opening in late September and extending through October 1966.

Although heavily involved with minimal art at the time, Lippard felt that something was missing from the severe parameters being described in most of these artists' works. While she initially comprehended the importance of minimalism as a radical departure from the kind of sculptural sensibilities represented by David Smith, Ibram Lassaw, David Hare, and others associated with the abstract expressionist aesthetic, she felt that this radicality had reached an extreme by the mid-sixties. There were signs of another type of sculpture emerging out of the literalness and modularity claimed by artists such as Robert Morris, Carl André, Donald Judd, Dan Flavin, and Sol LeWitt.

In retrospect, her show at the Fischbach Gallery proved significant not only because of the idea of a countertendency that, in effect, extended the principles of minimalism into biomorphic form, but also because of the artists whom she selected. They included Bruce Nauman, Keith Sonnier, Eva Hesse, Frank Lincoln Viner, Alice Adams, Don Potts, and Gary Kuehn. Lippard also included the work of Louise Bourgeois, who was older than the others yet whose reputation was largely unknown by artists associated with this evolving tendency in American sculpture. Still, in spite of

Lippard's insight in selecting these artists—some of whom were being shown seriously for the first time—one cannot deny the impact of Donald Judd's essay "Specific Objects," which had appeared in *Arts Yearbook* 8 (1965).[2] It was Judd who suggested that the "new work" was three-dimensional, yet painterly in its appearance through the use of "all sorts of materials and colors." Of the illustrations used to accompany Judd's article, a work of his (dated 1963) was the most literal in its reduction.

Lippard's criteria for her show (and essay) seemed much more "specific" than even Judd's. In a recent interview, she recalled, "I had some strange criteria—I don't know exactly what they were—but I was looking for things that were both modular and had some minimal sense of structure and armature, but that broke that armature, flopped out of it in a vaguely erotic way. . . ."[3]

In making a curatorial statement about eccentric abstraction as having some opposition to the more prevailing tendency of minimalism, Lippard appropriated some indirect references to the kind of structural norm that artists such as Judd and Morris advocated in their break from the relational sculpture of the past. All eight artists seemed to espouse a type of modularity, repetition, and/or refinement of a formal idea about sculpture. But the absence of a rigid geometry or sameness of materials was also pronounced.

Rather than conventional materials and surfaces, these artists were into casting, using plastics, vinyl, polyester resins, and rubber. Their works had a more layered, organic appearance largely due to the way the materials behaved and the way the shapes could be formed. In some cases—namely, Don Potts—the work had a more industrial, prefabricated look, yet still retained an organically refined structure on the surface. The happenings artist Allan Kaprow, whose implicit influence on eccentric abstraction was noted by Lippard, recently claimed that "the minimalist objects were not user-friendly, whereas the eccentric objects were. . . . You don't want to go hug a cube."

Eva Hesse's work has been recognized as defying the rigid principles of geometry, even though the geometric construct is clearly evident in her work. (This is perhaps partially attributable to her early exposure to the teaching of Josef Albers at Yale.) There is an attempt in Hesse's work to secure a type of playful interaction between her shapes and materials as they relate to modular surfaces. This is apparent in her *Metronomic Irregularity I* (1966), in which cotton-covered wire extends between two vertical rectangular panels that are painted and covered with sculptmetal. A more complicated version of this idea, involving three panels, was installed for the *Eccentric Abstraction* show.

In another vertical, three-panel piece by Hesse, also from 1966, there are three squares constructed out of various media. Two interior spirals are placed between the three panels, thus maintaining a visual tension between the curves of the spirals and their divisions between the square edges. Though fully geometric in origin, the process orientation in Hesse's work—which is evident throughout her short career, even in her last works from 1970—defies any sense of an imposed order. Rather, one might say, that her sense of order is an organic one. The simple shapes appear heavily endowed with feeling. They are unconstrained and fully energetic.

There is a humorous dimension in Hesse's work that is difficult to articulate,

Eva Hesse, Eighter from Decatur, *1965. Courtesy Robert Miller Gallery, New York. Photo: Allan Finkelman.*

Louise Bourgeois, Avenza Revisited II, *1968–69. © Louise Bourgeois/Licensed by VAGA, New York, NY. Courtesy of the artist. Photo: Peter Bellamy.*

but it is a quality that emerges from an acute visual sensibility—a quality that would appear anathema to minimalism. In two earlier works from 1965, humor accompanies a circular motif used in *Eighter from Decatur* and a linear motif in another untitled piece using eight wooden dowels. In *Eighter from Decatur*—the title referring to a game of dice—there is a unique hybrid that is both pictorial and sculptural. It is optical in a Duchampian way, suggesting a game of some type—a playful exercise in perception. It is a work that precipitates her developing vocabulary of form in the next few years.

In view of Eva Hesse's work and the works of others associated with Lippard's exhibition in 1966, it is important not to confine the term "eccentric abstraction" only to those eight artists. Rather, Lippard's term has proven to have a more generic aspect to it, one that carries applications to the work of many artists who were also coming into their formative periods around this time. Perhaps one can refer to the term as identifying a tendency more than a style. It is a tendency that has antecedents in neo-dada and in nouveau realisme. It is also a tendency that stretches between American minimalism and arte povera. Lippard's reflections, in her essay, upon the surrealist underpinnings, are important in this respect; and to come to terms with its meaning, one cannot avoid the role of Louise Bourgeois's work, even though it was removed from the other artists' generational attitudes.

First of all, Bourgeois's aesthetic did not emerge from minimalism, but from a personalized attitude toward surrealism. Consequently, the orientation of her work was less concerned with problems of structure and armature and more given to issues of psychological content. Her work is both literal and metaphorical. Form projects meaning and meaning projects a condition being both within the self and within the world. One might read this work as an expression of a woman's sexual identity, a pulsating, vibrant energy, that connects with universal archetypes, projecting from the unconscious into the world of mystery that is always on the surface of things, and our feeling about things.

One of Bourgeois's best-known works, *The Blind Leading the Blind*—a work with a strong sense of modularity, repetition, and formal refinement (various aspects of form related to minimalism)—was conceived in one of its five variations nearly two decades before Lippard invented the term "eccentric abstraction." Yet, this approach to form is only one side of Bourgeois's art. *Lair* (1962) is quite the opposite and represents another tendency, another impulse, where the shapes implode upon one another and thereby cohere as a self-contained, organic unit. This is also true of *Spiral* (1960), a series of concentric rings formed in plaster.

Recent works, such as *Eyeball* (1987) and *Henriette* (1985), seem to continue a Freudian legacy in the most subjective terms, creating controversy through personal application as a vision is transformed into an appendage or body part, and given an anecdotal memory. Bourgeois is an abstractionist dealing with content. The forms are visceral ones, not at all intellectual. Her art functions at the most extreme edge of those reductive strategies automatically linked to the postminimal aesthetic of the seventies. In the case of Bourgeois, her aspirations toward metaphor and fecundity as a mental construct based on the corporeality of vision easily part ways with those postminimal artists who may have at one time secured their roots in eccentric abstraction.

Still, it is necessary to see the connection between these aspirations toward psychological content and the belated formalist desires of the postminimalists. For it was during the decade of the seventies that metaphor again surfaced as appropriate to the art-making process and became linked to the new narrative structures and dissemblances of artists whose former allegiances to literal time and space were incited to shift one way or another away from a literal position into a more accessible, memory-ridden presence of continuity with the environment, both interior and exterior.

The term "postminimalism" must be credited to the critic Robert Pincus-Witten. It was not a belabored term. According to Pincus-Witten, the term "postminimalism" came as a kind of journalistic enunciation in which to describe "open and unstable modes, forms not only beautiful in themselves despite their unfamiliarity—beautiful on the level of unmediated sensation—but forms that also called into question the stabilized appearance of the day's abstraction."[4] In this series of phrases, Pincus-Witten defined a somewhat generic spectrum that would stretch from the biomorphic sensualism in work of Louise Bourgeois to the hard-edge concreteness of Richard Serra. At the same time, the term must somehow account for the "anti-form" tendencies of the late sixties—the scatter pieces of Barry Le Va, Carl André, Robert Morris, and Serra—and the process orientation of sculptors like Eva Hesse or the emerging California artist Bruce Nauman.

Nauman, who had graduated from the University of California at Davis, where he had come into contact with the "funk art" group, used materials such as fiberglass, latex, neon tubing, bronze casting, felt, wax, iron, and cardboard as extensions of his own body. For Nauman, these extensions were basically literal in concept. In *From Hand to Mouth* (1967), he cast the space between his mouth and right hand in resin as if to literalize the commonplace expression. Concerned with his existential reality within the studio space, Nauman wanted his materials to encapsulate his corporeality or to document an impression of a specific physical activity.

Nauman's presence in the *Eccentric Abstraction* show was a crucial, if not a pivotal one. His reductive and sparse use of materials gave considerable attention to the space that encompassed his forms. This is to suggest that the works by earlier minimalists, such as Morris, Flavin, André, LeWitt, and Judd, were also concerned with the phenomenological aspects of reality, but their intentions were more focused upon presenting an epistemological standard that would somehow challenge all preceding concepts of perceptual reality in relation to art objects.

Nauman's search for a psychic identity or ontology came by way of the corporeal and the physical.[5] One's sense of physical reality was contingent upon knowing what was between the body and other things. Examples would include many of the works from 1967, including *Device for a Left Armpit* and *Six Inches of My Knee Extended to Six Feet*. These works came after the earlier fiberglass and latex pieces that were being made at the time of the exhibition in New York. Nonetheless, they most accurately assimilated the phenomenological ideas of the self—the perceptual body—into a work of art. *Six Inches of My Knee Extended to Six Feet* is a literal realization of the title in which Nauman stretches the latex from the actual size of the cast to the height of his body. This issue—as discussed by the French philosopher Merleau-Ponty in his

Bruce Nauman, From Hand to Mouth, *1967. Hirshhorn Museum and Sculpture Garden, Smithsonian Institution. Photo: Lee Stalsworth.*

writings on Cézanne—may be seen as both a perceptual and a physical issue; it reveals the basis upon which Nauman's earlier works achieve significance.

The reductive component, as shown in minimalism, was clearly apparent in Nauman's works from the beginning as was his concern for spatial definition. Nauman's departure from minimalism was only a partial one in that he personalized many of the perceptual ideas related to the gestalt field—as did, for example, Robert Morris. Nauman's body operated as a vital component, a happening within a given space. He was further interested in the kind of anthropomorphic metaphor that could be transmitted from the biomechanics of the body and thus become its own sculptural form. This linguistic operation was entirely dependent on both the physical activity of the body and the material process with which the mind was engaged while in the studio.

Although there has been a strong conceptual basis in Nauman's abstract interpretations of space, one cannot designate his approach as "post-studio" either in its intention or manifestation. Even in his most recent video works and neon "signs," which represent people assaulting one another or being assaulted in various ways, the sculptural presence of the interactive or kinetic light-forms suggests a similar type of physical gesture that could have been conceived reductively within the intimacy of the studio. What is eccentric about these newer pieces is perhaps less related to the abstract biomorphic concerns that Nauman used in his work over twenty years ago and more concrete in its relationship to the psychic forces generated from the kinds of social repressions indicative of the eighties. Even so, the extended vocabulary of Nauman's sense of physicality and perceptual involvement with time and space still resides in these effasive public signs. Their intimacy within publicity give them a special quality that is both idiosyncratic and alive.

When Lippard conceived the term "eccentric abstraction" as a response to tendencies that she had observed coming from a wide assortment of influences and places, she was essentially doing research for her essay. When she was asked to curate the show, Lippard decided to excerpt a section of the essay and publish it as a broadside on vinyl (in keeping with the "new" materials aspect of the works she was showing). Following an introductory quotation from Champfleury—"Only the ugly is attractive"—Lippard began her essay with the following declaration:

> The rigors of structural art would seem to preclude entirely any aberrations toward the exotic. Yet in the last three years, an extensive group of artists on both East and West Coasts, largely unknown to each other, have evolved a nonsculptural style that has a good deal in common with the primary structure as well as, surprisingly, with aspects of surrealism. The makers of what I am calling, for semantic convenience, eccentric abstraction, refuse to eschew imagination and the extension of sensuous experience while they also refuse to sacrifice the solid formal basis demanded of the best in current non-objective art.[6]

In retrospect, Lippard felt that she may have made too much of the surrealist affinities with the work about which she chose to write. Nonetheless, her articulation of

the issues confronting these artists at the time—most of whom were under thirty—seemed accurate insofar as their search for a new basis of content was very pronounced. Artists, like Hesse, Nauman, Sonnier, and others, were directing their energies toward a more organic or biomorphic quality inherent within the primariness of formal reductivism. In that minimalism had more or less regimented the look of sculpture in New York by the mid-sixties, it was important to find new channels of consciousness that could be expressed directly through new prefab materials.[7]

In a more recent exhibition mounted in 1985 at the Blum-Helman Gallery in SoHo, called *American Eccentric Abstraction, 1965–1972,* there was an attempt to reinvestigate the work of some of these artists, including many of whom were later associated with postminimalism. For Joseph Helman, the curator of this later exhibition, the crux of the issue was related to how Judd had defined literal space in his 1965 essay "Specific Objects." Helman became interested in the problem of literalism, which he believes originated in the late forties with artists such as Kelly, Cage, and Cunningham. *American Eccentric Abstraction* was an attempt to show how younger artists were reacting to what Helman calls "the supergraphic images of the early sixties."[8]

The eccentric abstractionists were showing their dissatisfaction with purely "mechanistic, factory-made objects" and needed to express more intimate concerns through sculptural form. Whereas Lippard's original exhibition viewed surrealism as lending a primary feature to these works, Helman's retrospective paid more attention to ideas of process, temporality, and meditation. One of the major differences between Lippard's and Helman's views of eccentric abstraction centers around the place of Louise Bourgeois. Helman does not see Bourgeois as connected to the sensibility or the generational concerns that inspired the tendency of eccentric abstraction. He believes there were other social, political, and formal aesthetic factors that persuaded these artists in favor of a more organic or process view of art.

For Lippard, the art of Louise Bourgeois performed a major role in the development of eccentric abstraction—a role that was more implicit than direct, more ideological than formal. The fact that Bourgeois was a mature woman artist in 1966, producing what Lippard sensed as feminine forms and shapes that further suggested a feminist position in art-making, only intensified the artist's importance. For Lippard, the missing ingredient in minimalism was the feminine sensory expression, and it was this quality that she found in Bourgeois's sculpture.

It should be emphasized that Helman's retrospective version of eccentric abstraction in 1985 could not have easily avoided the reinterpretation of many of the original artists' ideas as expressed in Robert Pincus-Witten's highly influential book *Postminimalism,* originally published in 1977. The fact that some of these artists had advanced to a more mature level of artistic thinking in relation to their careers suggested the need for such an interpretation. What began in the mid-sixties as "eccentric" eventually became established as postminimalism ten years later. The most obvious examples would be Eva Hesse, Bruce Nauman, Keith Sonnier, and Louise Bourgeois, who all became established art world figures by the time Pincus-Witten coined the new term. It is also curious, but consistent, that Helman's exhibition included works by Nauman, Hesse, and Sonnier, but left out Bourgeois. He added works by artists such as

John Duff, Richard Serra, Richard Tuttle, Robert Smithson, Barry Le Va, and Alan Saret. Many of these sculptors were also included in Pincus-Witten's book and therefore could be dubbed "postminimal" as well.

Even so, Helman's curatorial selection clearly parted ways with the kind of organic surrealism that informed Lippard's original choices by favoring the emergence of content as a consequence of the work's process orientation. In either case, regardless of how the content of eccentric abstraction was generated, it has become increasingly apparent that the tendency which evoked these issues in the mid-sixties should not be viewed as belonging to an exclusive group of artists with a particular mind-set. Indeed, there were several artists—many of whom would become well known in the seventies—whose work was in a formative stage at the time. In addition to those previously mentioned, one might include Mel Bochner, Neil Jenney, Lynda Benglis, Joel Shapiro, Rosemarie Castoro, and Jackie Ferrara, among others.

The apparent arbitrariness of some of the early "scatter pieces" by André and Le Va could be viewed as an extension of the eccentric abstractionist point of view as well. Yet, in other ways, they were still very much connected to a formalist philosophy that was tied to minimalism. Whether they were achieved through random placement or by way of predetermined calculations as in the work of Barry Le Va, they were still basically concerned with form or at least a formal approach to making art. Although Mel Bochner's earlier work may have been too "conceptual" to fit the criteria used in Lippard's show, there is little doubt concerning its relationship to Pincus-Witten's criteria for postminimalism.[9]

An interesting comparison can be made between a Bochner corner piece from 1972 entitled *Triangular and Square Numbers,* in which sets of pebbles are placed in a serial alignment to form triangles and squares at either edge of a corner, and a more recent two-panel painting called *Domain* (1987), which appears more gestural and expressionistic due to its tight sequence of marks and its abrupt color scheme. Viewed from a corner perspective, the 1972 piece functions as a hybrid between minimalism and conceptualism in much the same way that Sol LeWitt's work does, yet the "natural" material offers a disjuncture to the fabricated appearance used in minimal art and the presentness of the seriation defies the purely ideational mode. In *Domain,* Bochner formalism exceeds itself by verging on expressionism where random placement and predetermined calculation seem to collide in a Wagnerian struggle in search of ontological significance.

Keith Sonnier, an artist who was included in the original exhibition at Fischbach, has made another interesting transition by moving from his earlier static pieces in wood, cheesecloth, and epoxy to more extravagant technological works in neon, glass, mirror, and aluminum or, in some cases, steel I-beams. Sonnier's earlier "eccentric" work held forth with a certain modesty in which the materials offered a formal transition between the wall and the floor. Whereas Sonnier claims an interest in sensory awareness in these works—a tactile involvement in space—the more recent neon works, such as *BA-O-BA* (1972–88), which incorporate neon tubes with wood, metal, and other media, extend that tactility into a constructive vocabulary. Sonnier manages to obtain a considerable freedom in his placement of the various components

so that one is not expected to discover compositional wholeness. In *BA-O-BA*, which was recently shown at the Barbara Gladstone Gallery in New York, the neon and its reflective components are not necessarily containable, but they are seen more as parts functioning openly in relation to architectural space or, in some cases, like David Smith's *Cubi* series, are most effectively presented in relation to nature.

Sonnier's increasingly technological sculpture functions iconically in much the same way that his earlier pieces from the late sixties functioned. They hold definite presence in relation to the space. They read either as signs abstracted from popular culture, as *Slot-Slash* (1987), or as forms with which one interacts in terms of one's own corporeality.

Metaphors of the body were very close to the origins of eccentric abstraction. This quality, as it is effected by an attention to materiality and process, is evident in the works of John Duff and Alan Saret.

Closeness to nature informs the work of John Duff as well. Duff grew up in southern California near the beaches in an environment most conducive to the sensory impact of nature. He moved to New York in 1968 and became friends with Neil Jenney, Robert Lobe, and Gary Stephan, who were all living and working in a building on Jefferson Street. In his early *Tie Piece* from 1969, Duff gathered several men's neckties of various pattern and colors, mostly bought at inexpensive thrift shops, and had them sewn together. As the length of the assemblage grew, the series of neckties began to assume a shape. Duff then constructed an armature that would allow the ties to project from the wall in their natural saddle shape. The morphological references to the body and to the paradoxical order of nature's chaos serve as metaphors in this classic piece, which was later exhibited in 1985 at the *American Eccentric Abstraction* show.[10]

Alan Saret's sculpture depends upon a kind of dematerialized awareness of form. Constructed out of a mesh of stainless-steel wire, *Font Vora* is not a containable form; rather, it has a certain elegant diffusion, a quality of lightness that is elusive and abstract. Saret's wire-mesh constructions appear on one level as amorphous, but they are, in fact, carefully constructed three-dimensional compositions.

Another artist, Richard Tuttle, had also maintained a quality of simplicity and refinement in his severely reduced constructions, often using wood and cloth in a manner that appears deceptively casual or even accidental. In reaction to the hard-edge cubes of the minimalists, Tuttle wanted to make art where the materials were simple and direct, not weighty. He wanted the shape of the form to be indecisive, yet central in its impact upon the surrounding spatial architecture. In his recent work, a certain baroque quality has transformed this elegant simplicity into a narrative structure that celebrates another kind of secular vision. The process is still present in the work, and yet it is subsumed by the dramatic positioning of the wood and cloth. The feeling of baroque ecstasy? Perhaps. Or maybe another more timely statement: an attempt to locate the meaning of sculpture somewhere in that tenuous zone between the literalness of space and the imagination of forms. It would seem that the evolution from eccentric abstraction in the sixties into postminimalism in the seventies was precisely about this struggle. It was the struggle with the process of the work that ultimately defined the work and gave it the stature that it holds today.

American Sculpture and the Search for a Referent

> Propositions cannot represent logical form: it is mirrored in them.
> What finds its reflection in language, language cannot represent.
> What expresses *itself* in language, we cannot express by means of language.
> Propositions *show* the logical form of reality.
> They display it.
>
> *Ludwig Wittgenstein*, Tractatus Logico-Philosphicus *(4.121)*

In the eighties, the issues of representation and multiplicity came to overshadow the concerns of visual formalism so prevalent during the preceding two decades. This is not to imply that representation is not contained within the lexicon of the formal apparatus; and, indeed, multiplicity of form is clearly a condition of minimal art. It's just that the referents have shifted from a concentration upon the linearity of focus propounded by minimal and postminimal sculptors to a more open dialectical concern for the determinacy of image-making as a network of signs depleted of linear significance.

In an attempt to refocus attention upon the project of visual formalism—where it left off in the late 1970s before its co-optation by neo-expressionism and concomitant ventures into poststructuralism and related forms of critical theory—in 1987, the Albright-Knox Art Gallery in Buffalo mounted an exhibition entitled *Structure to Resemblance: Work by Eight American Sculptors*. The exhibition included a selective profile of recent sculpture by Lynda Benglis, John Chamberlain, Joel Fisher, Nancy Graves, Martin Puryear, Judith Shea, James Surls, and Robert Therrien. The rationale behind the show's elusive title was to suggest something of a transition between the rigid epistemology of form that dominated American sculpture for most of the sixties and seventies—its explicit reductivist tendency—and the more subjectively and culturally translatable references that implicitly return to the problems of representation and symbolic content once again.

Thus, *Structure to Resemblance* is about momentum in a nearly dramaturgical

sense, a certain direction that visual formalism appears doggedly bent on going. More than confining itself to repetition and experimentation for its own sake (the premise, in fact, whereby visual formalism became formal*ist* art in the more derogatory vein), the eight sculptors selected for this showing give a convincing argument in favor of the re-formation of content through a rigorous attentiveness to formal processes. In the majority of these new works, the commitment to formalism heralds forth with a certain defiance—an invincibility and inscrutability that is free of academic restraints, yet utterly clear as to its convictions and presence.

John Chamberlain, who is cited in the catalogue as "the patriarch of the exhibition," revives a personal flair for symbolic content found in the earliest abstract expressionist painting and sculpture in his most recent crushed steel and painted works. Although his sculpture has maintained the rawness of gesture associated with de Kooning, for example, it has also been associated with pop art, which, of course, includes the automobile in all its manifestations. In addition, Chamberlain's awareness of formal placement as a primary criterion for sculpture has connections with minimal art. This latter connection, however, is more in theory than it is in fact. Chamberlain has never advocated "primary forms"—a term used in the late sixties—as a method of approach in his own work.[1] He never believed, for example, that sculpture could be fabricated according to specification, and disagreed rather vehemently with artists who employed this method at the time. The alternative was to make his desires apparent as a way of signifying the freedom of the direct process to allow the form to evolve sponta-neously.

The group of Chamberlain sculptures included at the Albright-Knox exhibi-tion was selected from work completed over the three previous years. *Gangster of Love* and *Crowded Hearts* are two works that give testimony to an acutely defined romantic impulse. The emphasis given to these compressed wads of steel, consisting of chrome fenders and automobile body parts, is essentially formal. The application of color in a quasi-graffiti style, the formal attenuation of shape, and the subtle compositional effects contribute to a dynamic equilibrium that moves from the literal processes associated with visual formalism into a quest for autobiographical metaphor. The tactile involvement, both physically and optically, has always been explicit in Chamberlain's sculpture; the volume in the shapes has always appeared as a container for emotional content. Yet, *Gangster of Love* maintains its formal presence despite all else. Rather than a single monocular point of view, as in many of the earlier relief pieces, *Gangster of Love* incites the logic of primordial vision by acknowledging form as presence through the ritual of contemplatory movement. It virtually signifies a desire for the poetical inter-lude amidst the counterstrife of desire that resides outside art's ideal position.

The figurative in sculpture is often considered in contrast to the reductive methods and focus upon materials used by the minimalists. Yet, as curator Michael Auping quotes the sculptor Robert Morris in the exhibition catalogue, "The specific art object of the sixties is not so much a metaphor as it is an existence parallel to it. It shares the perceptual response we have towards figures." In retrospect, it is difficult to read Morris's statement apart from the visual formalism that is so evident in his own work from that period, work that intends a certain built-in choreographic aesthetic as,

for example, in his *I-Box* (1963), where a hinged door in the formation of the letter *I* opens to reveal a photograph of the nude Morris standing in a frontal view.

This figurative presence might apply in a postminimal sense to the sculpture of Robert Therrien. Given Therrien's apparent yearning for metaphor and stated convolution, the perceptual parallel discussed by Morris is much less literal here and more open to interpretation, yet the ratiocination found in Therrien's untitled works of the eighties hardly surpasses the initial stages of visual formalism in which the balance and tension of the constituent elements is declared immutable, if not void. In the better work, this void comes close to the kind of vision Samuel Beckett describes through the character Vladimir in *Waiting for Godot*:

> All I know is that the hours are long, under these conditions, and constrain us to beguile them with proceedings which—how shall I say— which may at first sight seem reasonable, until they become a habit. You may say it is to prevent our reason from foundering. No doubt. But has it not long been straying in the night without end of these abysmal depths? That's what I sometimes wonder.[2]

As with Beckett's character, much of Therrien's untitled work concentrates upon the suggestion of narrative through its absence, the sign without a referent, as if to establish some site of recognition that allows reason to operate in the void or, in Beckett's words, "in the night without end of these abysmal depths." Therrien's highly reductive work from 1986 of two rectilinear blocks with a tilted wooden bowl placed askew at the top elicits some essential spatial dislocation, as if the form were a pivot between early constructivism and postminimal romanticism. The action is without origin, offering only the bleakest clue to sustenance that might prevent "our reason from foundering."

A similar paradigm is operative in the recent sculpture of Joel Fisher, as, for example, in his *Study for "Tree."* Fisher's elusiveness is built upon the principles of fusion between "sense and non-sense" (a phenomenological distinction made by Merleau-Ponty) or between figure and object, organ and fetish.

In *Study for "Tree"*—a cast biomorphic form—it is difficult not to see its morphological connection to the Winged Victory (Nike) of Samothrace (c. 190 B.C.) as pointed out in the catalogue essay.[3] This rather obvious fact of association is apparent as a cultural sign; yet there is the indisputable and irreconcilable connection with natural organic forms as well, half botanical and half birdlike, a section of fungus or even tropical fruit. This irreconcilable disparity alludes to the possibility of resolution in spite of the artist's conceptual agility with the forms. What remains is a kind of mutation full of grace and potential for repetition, an organic prototype ready for the assembly line yet somehow precluded from joining the ranks of the commonplace. As with the Catalan Miró, Fisher's work seethes with ambiguity and deftness, with nature and "the natural." In contrast to Miró, the irreconcilable force of the elements makes for a distancing that gives its passion a cynical edge.

With the exception of Eva Hesse, most of the offshoots of minimalism were

hard-edged and epistemological in their orientation toward form. Hesse used the modularity of repetition and cubic structure but gave the formal units a process orientation suggestive of organic growth. It is curious that much of the sculpture at the Albright-Knox carried an attitude of organic "resemblance" more than epistemological rigor.

Judith Shea's torsos, constructed of various hard and soft materials, are preeminently organic and further suggestive of multiplicity and interminable romantic longing. *Abstraction and Empathy* (1985) is a bronze and steel floor sculpture made to represent the buttocks and upper thighs of a human model resting in a partially supine position. The object is hollow in that one can peer through the thighs and the waist, thus leaving only an abbreviated trace of human recognition. The nostalgic component is nearly classical. This fragment of a person has been carefully worked so as to abstract the form without dehumanizing its appearance. The languorous position of *Abstraction and Empathy* appears in considerable contrast to an earlier iron work called *Jack* (1983), which reveals the same parts of the body but in a more industrial, rigidly defined manner. In either case, the reductive philosophy of the sixties—the visual formalism that American sculptures seemed bent on achieving—is never forsaken; the liberties taken to instill metaphorical meaning and value are only a pretense toward narrative.

Appropriation of nature sounds like an oxymoron, yet the borrowing of a cultural sign to produce another kind of image—a simulacrum—was common fare in the eighties. For James Surls, the alteration of natural forms, such as tree branches, plays an internal role in determining the construction of his work. In *Struck Broke* (1987), oak and hickory branches comprise the basic appearance of the work's structure. Suspended from the ceiling of the gallery, *Struck Broke* is placed on a diagonal axis, giving the piece a calligraphic presence. Surls is committed to drawing as a thinking process, and often his sculpture may be understood in direct reference to his drawing, as an evolutionary, three-dimensional manifestation.

Differing from Shea's inherent classicism and Fisher's elegant decoys of artful productivism, Surls's approach to sculpture is humorous, lyrical, and primitive. In *Me, Three, Nine and the Flower Bird, III* (1986), the shape of a mandala is echoed in the swirling position of redwood fragments on a steel armature. The play of light against these multiple elements has an expressionist effect as the shadows intensify the aggregate form, giving it a hallucinogenic quality. This is sculpture from the Great Plains more than from a congested urban environment. It breathes openly, yet carries a sinister appearance as well. Surls extends the raw material of the prairie into a contemporary sign—an oxymoron of opposing shapes, conflicting shapes where nature and culture collide.

The amorphous shapes present in the sculptural reliefs of Lynda Benglis imply immense force and torsion. The forms are not entirely the result of process in that deliberate "aesthetic" decisions have been made to alter—add or subtract from— the way they appear on the wall, contradicting the work's fluidity with a curious stasis. The pleated metallic sheets strive for rhythmic punctuation as ensembles of baroque cloth waving in the celestial breeze of an arcadia. In *Pictor,* Benglis has achieved her most remarkable fitting of diverse folds—using bronze wire, zinc, and aluminum—by

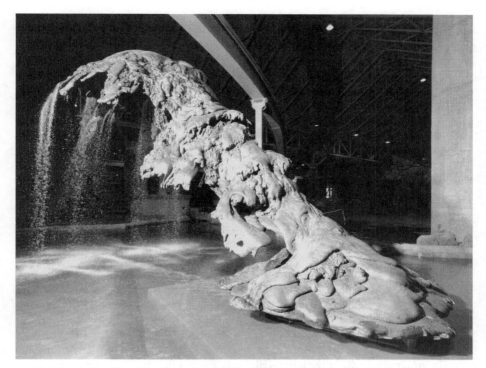

Lynda Benglis, The Wave (The Wave of the World), *1983–84. Art: © Lynda Benglis/Licensed by VAGA, New York, NY. Photo: Peter Bellamy.*

suggesting an animal presence or figure while keeping the piece fully within the realm of abstract thought.

There is a certain decorative impulse in the sculpture of Benglis in spite of its obvious subversiveness. There is no contradiction. Historically, as evidenced in Pre-Raphaelite painting, there is a connection between the two. It is this subversive quality that disengages the categorical definition of the work from its aesthetic tradition. In *Corona Austrina* (1986), the variation of paint, patina, and gold leaf lend a considerable richness and dimensionality to the work that is not unrelated to the surfaces displayed in Chamberlain's work.

Although completely distinct in style and approach, sculptors Nancy Graves and Martin Puryear emerge as the two artists who most effectively define the boundaries of the curatorial intention by revealing a spectrum of three-dimensional narrative in a fully abstract sense. Both Graves and Puryear maneuver their discretely articulated structures in response to a metaphorical play of signifiers as if such encounter were in contention for some linguistic parallel. The title of the show, *Structure to Resemblance,* defines a tendency in American sculpture in terms of representing a transition or an emergence from a strictly visual formalism to a more playful system of signs in which

formal thinking is also made to appear primitive, secular, metaphysical, even transcendent.

In the *Tractatus,* Wittgenstein makes a clear distinction: "propositions" can display "the logical form of reality" and yet "cannot represent logical form."[4] Here the philosopher is speaking in terms of language—what it can do and what it cannot do. In other words, language cannot represent reality (which is inherently too complex), but it can display reality according to its own means. Thus, any configuration of language stated in the form of a proposition cannot represent more than what is already contained within it.

The visual formalism of the 1960s, as it came to be defined through the writings of theorist/critics such as Clement Greenberg, Rosalind Krauss, and Michael Fried, corresponds to Wittgenstein's notion that language can represent nothing more than what is reflected within the mirror of its representation. (This is precisely why Greenberg was so concerned about the problem of "literary" content in works of visual art.) The most subtle distinction, however, is to determine when language expresses itself, so as to avoid the use of language to represent what has already been expressed. This, of course, has been the persistent bane of philosophical aesthetics in recent years: the problem of redefining artistic intentionality as if it were somehow equal to the reality of art itself. (This is why aestheticians have such anxiety in dealing with conceptual art.)

The visual formalism in Graves's work, such as *Tarot* (1984), has its own language. The job of the critic, then, is to determine if the language of the form succeeds in expressing itself. In the curatorial thesis, there is the chance that the structure as defined in Graves's selection and resolution of component parts may *resemble* something else; that is, the structure of *Tarot* may achieve metaphorical significance, yet this form of signification will never depart the premises stated in the resolution of the form, which *is* the language of art. Resemblance is only resemblance; it cannot transcend the limitations of language.

Nancy Graves's *Tarot* engages diversity into unity. From an aesthetic point of view, this is one of the principles of classicism; that is, refinement and restraint are proportionate to balance and harmony. What Graves seems to be testing in her *Tarot* is the extent to which vertical linearity begins to appear radical. The forms are composed from different signs and shapes, some natural, some cultural, but nothing is repeated. The disjunctive resonances are essential to the continuum of how the work reads visually.

Tarot is as much about its medium (material) as it is about the sense of illusion that it creates. The abstract presence of the form pulls the eye upward. But in addition to this abstract directionality, there is an implied narrative, an act of magic, a spurious sense of balance that gives *Tarot* a special meaning. For disjuncture to function in the formal sense of abstraction, it requires a synchronistic or indexical set of relationships—in fact, a cognizance of the equivocation between abstraction and representation, between language and what is expressed by means of language.

Martin Puryear's sculptural forms are perhaps the most elusive in the show. Works such as *Mus* (1984) and *Vault* (1984) carry a density and an oblique sense of

enclosure. In each work there is the suggestion that the sculptural object either has or has had some functional or ritual use. Made of wire and painted wood, *Mus* is carefully crafted using techniques of basketry; yet one would not be likely to mistake the object for craft. As with Benglis, Surls, and Chamberlain, there is a persistent awareness about how the object is made; the process and the delicacy of the work require careful scrutiny. An untitled piece from 1985 hangs on the wall in the shape of the hull of a fishing boat. But the shape clearly could not function as a boat. Its symmetry is tilted, and the construction of wire mesh make it entirely unseaworthy. However, one cannot dispel the association or the "resemblance" in spite of the mystery of the form.

As with Graves, Puryear's sculpture has a language of its own. The condition of its mysterious and inscrutable presence is largely a result of its impossibility. One cannot define or easily "represent" what Puryear's language expresses. It is like seeing Duchamp's readymade of a bottle-drying rack, which has been removed both in time and culture from the present day. The object *becomes* art not because it is represented. This readymade from 1914 does not have to be represented to be art: it simply has to be presented in a context apart from its original definition, which was initially given according to use.

In *Endgame* (1985), a section of pine appears to have been steam-bent into an irregular circular form, then painted. The open section of the circle suggests the *enso,* a sign made by Zen monks to inspire contemplation. There is also the reference to the Beckett play of the same title in which the four strangely anonymous characters express the finitude of language through bizarre actions and abbreviated speech.[5] The direction in Puryear's *Endgame* is circular; the form winds in upon itself. Its language is perfectly contained, yet openly suggestive. Its structure is clear, yet its implications are wide. The narrative is not entirely a literary one but an incitation toward metaphorical meaning. The metaphor leaps from the synapse of the open section of the ring to confirm the spatial dimension to which the virtual form resides. Form and space intertwine as inseparable nuances of being and substance. Optically perceived, Puryear's sculpture suggests a statement about survival, as do Beckett's plays. One does not illustrate the other. Sculpture and narrative operate on parallel tracks as affinities, each contained within their own respective systems of discourse, constantly reiterating the possibilities of the other. There is scarcely a sculpture by Puryear that does not fill the synaptic space of its absence with the fullness of its presence; in this sense, the resemblance becomes a statement of faith about the direction of the sign. In *Endgame,* that direction is toward the referent of being in order "to prevent our reason from foundering."[6]

Art Outside
the Museum

The museum spreads its surfaces everywhere and becomes an untitled
collection of generalizations that immobilize the eye.
Robert Smithson, "Some Void Thoughts on Museums"

One may think of modernism as having an overwhelming scope that
virtually encapsulates the gamut of visual styles available to the human imagination.
Whether veering toward concrete abstraction, figurative expressionism, political art,
performance, or dematerialized objects, the philosophy of modernism—from its
inception—has been a reverberating sequence of visual statements that have attempted
to transmit, and, in some cases, to reify some sense of reality in the twentieth century.
Modernism represents a reality determined to confront the illusions of the past.
Through a series of chain reactions and often simultaneous equivocations, beginning
with Cézanne and the cubists, modernism has set out to dispel the illusion of the
picture plane and its subject matter and, as Moholy-Nagy once proclaimed, to move
into a new "space-time."[1] By introducing various forms of art that insisted on another
criterion, a new critical language for modernism had to evolve in order for these new
forms to be accepted and understood.

One could say that there is a kind of schism—a conflict, in fact—that is
fundamental to the project of modernism. What does it mean, for example, to have
divergent artists and movements at the beginning of the century espousing the ideals of
a machine aesthetic, and concomitantly to have another group equally impassioned in
their rebellion against the machine? Or what does it mean to have one group of artists
that is interested in prolonging the legacy of an aesthetic institution—guardians of the
tradition of oil painting, for example—and others who think only in relation to the
camera or the performance and are out in the streets distributing pamphlets against
conventional institutions of culture?

The answers to these questions are not only aesthetic, they are also sociologi-
cal, political, and economic; in fact, the answers require a clear recognition of many

complex factors in Western society's struggle to evolve from an agrarian to an industrial economy, from a closed to an open democratic structure, and from a premodern toward a modernist sensibility. One might argue that the basis of this struggle—at least from the perspective of the artist—began as a profound and deeply felt spiritual crisis, a yearning for a better world, and, in some cases, a neurosis in being unable to attain it. The burgeoning of modernism incited a crisis that most directly effected the changing role of the artist as the visionary (or tormented) subject of a rapidly evolving social drama. Whether recognized or not, artists have irrevocably changed the course of life in the twentieth century. This is less an aesthetic evaluation than a cultural observation. Given the remarkable formal and conceptual breakthroughs during the first quarter of this century, who can deny that this has not been the case?

In essence, the struggle of modernism for the artist was the struggle to be modern, even if one existed outside those formidable institutions of the new industrial society—whether political, economic, social, or aesthetic. The drama of this struggle and this conflict among early twentieth-century artists cannot be overplayed. It was a drama founded on conflict right from the beginning, a drama that has still not terminated, even as the industrial age has been presumably succeeded by the age of information. The rules of industry and its relationship to the institutions of art—museums, academies, publishers, galleries—still provide the momentum for our understanding of culture. One might speculate that the only real difference between the institutions at the outset of the century and those in recent years is that now they function with a more "professional" aura, a certain detachment that is more market-driven and more overtly cynical.

In writing on the activities of artists outside the museum in the twentieth century—or, shall we say, artists who have defied the conventional institutions of modernist art—there are several models or paradigms available. Not all artists who rebelled against modernity had the same reason for doing so. Some did it for personal reasons or reasons that were forced upon them by historical, psychological, or social circumstances. The dada artists, living in Zurich in 1916, were a mixture of refugees and draft dodgers who projected their guilt and frustration over the tragic circumstances of the war by rebelling against "bourgeois intellectualism." In their exhibitions and performances at the Cabaret Voltaire, they were hoping to reinvent the meaning of art by inciting absurd and outrageous actions in a deliberate and intentional way, thus diverting themselves from the chaos and destruction surrounding them. Their emphasis on irrationality, nature, and chance opened up a new discourse on art far removed from the guardians of the institution. On the other hand, the Russian avant-garde (futurists, formalists, suprematists, constructivists, productivists) was experiencing a different historical reality.

In contrast to the Zurich dadaists, the Russian avant-garde had a different motivation in attempting to realize a different kind of work more given to a utopian dream. Yet, in their pragmatic quest to discover a means for artistic survival, they wanted to express a spirit of optimism—even though optimism had little basis for justification. Malevich and Popova, for example, were working within a system that had

failed to accommodate them, both socially and economically, after the fall of the provisional government and the return of Lenin (from Zurich).

Yet, beyond the personal and social reasons, one might investigate the phenomenon of the modernist avant-garde art in another way: by using paradigms of a more theoretical nature; that is, by using paradigms that reflect the conflicting interests that are so endemic to the modernist discourse. In entering such a discourse, one might begin with the assumption that modernism became an institution not only through the embrace of a machine aesthetic, but also by the desire to escape it. By escaping the desire for utopia through art, one might enter into another realm of desire more directly associated with iconoclasm. This characterized what might be understood as the fundamental split in modernist aesthetics.

The escape from the institutions of culture—namely, the museum that sanctions art for historical and ideological purposes—through the avant-garde activities of the belle epoque in late-nineteenth-century France and the perpetuation of this conflict throughout this century has been one of the major defining principles in modernism. From a psychoanalytic view, one might say that the Freudian impulse to move beyond or outside the authority of the father, or, in this case, the institution, has possessed avant-garde artists of divergent stature in the history of modernism, ranging from Picasso to Duchamp. The resurfacing of the Oedipal drive as having its own subtextual legacy—including the various theoretical attempts to disprove it—as a motivating force within the course of modernism has been spelled out on numerous occasions in poststructuralist literature over the past two decades.[2] Still, one cannot assume that this conflict is the sole motivating factor in the evolving structure of art as it relates to problems of modernism.

Rather than laminating theories borrowed from the social sciences in relation to the evolution of the modernist avant-garde, would it not be more to the point to examine actual events outside the museum and to infer from these events a set of paradigms that are indicative of this discourse? To begin with empirical observation is certainly not a new strategy in the application of modernist theory, yet it is a strategy that has been derailed in recent years, particularly in the United States, given the extraordinary seduction of marginal issues related to semiotic theory and the claims of ideology that have been given to them.[3]

The remarks that follow in this essay are less oriented toward overt ideological claims and more toward paradigms based on actual events that happened during the course of the modernist avant-garde. Three paradigms have been chosen that characterize this divergent history. They serve as general categories and as indicators of related objects, events, and installations that have influenced modernism from outside the institution, primarily the institution of the art museum. Although separately conceived, these paradigms tend to overlap and reverberate against one another.

From History to Performance:
Simulation and the Media

From a poststructuralist perspective, it may be difficult to reconstruct the historical context in which non–object-oriented artworks have occurred in past decades. One reason for this difficulty is the current assumption that the electronic media is pervasive, that in the age of the Internet anything can be obtained from anywhere at any time. While our logic tells us this was not always the case, the ability to reconstruct a sense of temporality in relation to a specific event—as, for example, a performance that occurred in a foreign place within another cultural context at another point in history—may often elude us. Non–object-oriented artworks are based on some form of temporality, even if the work is a conceptual document or a language piece, such as a statement by Lawrence Weiner or a definition by Joseph Kosuth. In such cases, language is the medium by which the idea is signified and transmitted from one person to another, from sender to receiver.

The event in early modernism that typifies this paradigm would be the performance in Petrograd on November 7, 1920, in honor of the third anniversary of the October Revolution, in which the storming of the Winter Palace was virtually reconstructed and reenacted in every detail.[4] This colossal-scale extravaganza, directed by Nikolai Yevreinov with the assistance of three theater directors, included nearly 2,700 participants. Among them were soldiers, circus artists, ballet dancers, and a five-hundred-piece orchestra and chorus. Inspired by agitprop theater and a demonstration organized two years earlier by the Russian futurist Nathan Altman, this massive undertaking was the kind of spectacle that would only occur today if major broadcast corporations were on the site backed by major advertising. Instead of television footage, the only remaining documentation of this event are a few grainy photographs and some sketches and diagrams used to coordinate the production.

The larger point related to *The Storming of the Winter Palace* (as it was titled) is the desire to replicate the original political upheaval in exact detail as a simulated event—in fact, as a performance. Even without the advanced technology of television and computers, the desire to make a spectacle that would accurately simulate the "real" event suggests one of the critical attributes of the modernist avant-garde: that the reproduction of the original was in fact a replacement of the historical actuality.[5] The performance of *The Storming of the Winter Palace* in 1920, three years after the original, constituted yet another historical staging, a theatrical doubling that would be labeled "art." Not only would the performance become "art," it would also come to represent the historical event as if the event were secondary to the experience of the performance itself.

During the dada revival of the late fifties and sixties in New York, the avant-garde composer John Cage would revive the issue in another context by ignoring history in favor of structural improvisation and chance operations.[6] Allan Kaprow, who had attended classes given by Cage at the New School for Social Research, further

meaning, n. 1, = that which exists in the mind (e.g. yes, that is my —, *mihi vero sic placet, sic hoc mihi videtur;* see INTENTION, WISH, OPINION; 2, see PURPOSE, AIM; 3, = signification, *significatio* (of a word), *vis* (= force of an expression), *sententia* (= the idea which the person speaking attaches to a certain word), *notio* (= original idea of a word; see IDEA), *intellectus, -ūs* (how a word is to be understood, post Aug. t.t., Quint.); it is necessary to fix the — of the verb "to be in want of," *illud excutiendum est, quid sit* CARERE; to give a — to a word, *verbo vim, sententiam, notionem sub(j)icĕre;* well- —, see BENEVOLENT.

Joseph Kosuth, Titled (Art as Idea as Idea), [meaning], *1967. Courtesy of the Menil Collection, Houston.*

expressed ambivalent feelings about historical references as they might relate to performance—in his case, the happenings: "And the past? Those heroic men who also gave their lives to amuse themselves? What of them? I suppose to be a revolutionary, one must know and hate-love the past deeply." Kaprow goes on to say that "The only general use the past has for me is to point out what no longer has to be done. The past cannot and does not want to be embalmed. I think that it can only be kept living in artists who appear to be spitting in its face."[7]

 At the crux of the neo-dada in the early sixties was the fluxus movement. Under the somewhat authoritarian leadership of an eccentric Lithuanian artist named George Maciunas, those associated with fluxus generally preferred the ephemeral over the permanent, the concept over the form, and the event over the object.[8] They pre-

ferred absurdity and wit to the seriousness given to expressionist painting or to the more fashionable emergence of pop art.

Fluxus was, in one sense, antihistorical. It tried to exist without a referent. Dick Higgins, Alison Knowles, Yoko Ono, Al Hansen, and Ben Patterson would perform mini-happenings, often involving music and poetry. In contrast to the happenings of Kaprow, the fluxus performances tended to refute the large-scale spectacle in favor of Artaud's more hermetic style of unmediated experience. Yet there was a certain elegance in all of this, a certain refusal to conform to what the museum wanted as official art or what the history of art seemed to dictate as the next logical step in the progressive linearity of modernism.

In retrospect, it is possible to consider fluxus as the last art movement within the modernist period that could truly be defined as avant-garde. It was elegant but not entirely cynical. It was spirited but not spiritual. It was defiant of the system—whether in art or politics. In this way, fluxus captured the heightened ecstatic flavor of the sixties when revolution was in the air, and it did not matter whether the event was history or simulation, whether it was "real" or "art." For artists associated with fluxus, as designated by Maciunas, revolution and anarchy represented the ideal state of affairs; and it is perhaps because of this cultural support structure during the sixties in America that fluxus could not sustain itself as a significant force beyond that period.[9] It was limited by its own contextualization—namely, the revolutionary spirit and openness of the sixties. It surfaced as a grand echo of a socio-aesthetic ideal, and it existed for the moment within the context of a performance—a context that would soon be transformed into something else.

Art as a Free Agent: Conceptual Art and Duchamp's Readymades

When Henry Flynt wrote his important underground essay "Concept Art" in 1961 (published in 1963), it was not clear exactly where his speculations would go.[10] At the time, Flynt was connected with avant-garde musicians such as La Monte Young and with intermedia artists such as Walter De Maria and Robert Morris, who were then working primarily in performance and choreography. The opening lines of Flynt's important (though underrated) essay read: "Concept art is first of all an art of which the material is concepts, as the material, e.g., of music is sound. Since concepts are closely bound up with language, concept art is a kind of art of which the material is language."[11]

While this version of concept art appears close to what Sol LeWitt would eventually call conceptual art six years later, it was not exactly the same. In a "correspondence" with Andrea Miller-Keller (1981–83), LeWitt stated: "his [Flynt's] idea of it [concept art] was Duchampian-Fluxus. Mine tended to have more to do with the way artists do their work, and to redirect the emphasis to idea rather than effect."[12]

In retrospect, LeWitt's comment must be taken in the context of his associa-

tion with minimal art—a term with which he never agreed. Nevertheless, the passage from fluxus to conceptual art is not so simple. While there were some similarities between the two, the spirit and method of fluxus—as advocated by the movement's self-appointed leader George Maciunas—was quite distinctive from that of conceptual art.

Although Flynt has disavowed any connection with fluxus in recent years so as to retain rights to his linguistic breakthrough in art, it is also difficult to see Flynt as divorced from the general scope of neo-dada activities in the late fifties and early sixties in New York.[13] This was the era of the happenings and environments, the era of the assemblage and junk sculpture, the era of the beat generation, jazz and poetry readings, the underground rebellion against the status quo of the American way of life.

In contrast, LeWitt's concerns as expressed in "Paragraphs on Conceptual Art" (1967) were coming from a totally different perspective.[14] His perspective had more to do with reductivism, sequence, and seriation. LeWitt was interested in approaching the formalist position from a radically different angle. Rather than diversity within unity, LeWitt was in search of the idea in art that allowed art to function as a machine.[15]

It was a much more distant attitude about art, an attitude about reserve in the art-making process as opposed to shifting the ground of art completely into the realm of mathematical speculation as Flynt seemed intent upon doing. Nevertheless, Flynt's intuition about art as language was ultimately correct in spite of the direction the market took at the end of the sixties. To change the predominance of aesthetic formalism in American art, as advocated by the critic Clement Greenberg, it was necessary to find another strategy—a strategy that would allow the transformation of art through language.

This transformation would not have been possible without the advances made several decades earlier by Marcel Duchamp, particularly in relation to his readymades. After completing a group of cubist-inspired paintings in 1912, including his famous *Nude Descending a Staircase,* Duchamp began work on a new project. His research at the Bibliothèque Sainte-Genevieve in Paris, between 1913 and 1915, would eventually lead to his work on the Large Glass, otherwise known as *The Bride Stripped Bare by Her Bachelors, Even* (1915–23). It was also during these intervening years that he developed his theory of the readymade.

The first example, in 1913, was a common bicycle wheel that he turned upside down and fastened to the top of a kitchen stool. The following year he found a galvanized bottle-drying rack in Paris near Hôtel de Ville, which he took back to his studio, then signed and dated it. His use of the term "readymade" was not determined, however, until he came to New York in 1915 and bought a snow shovel in which he added the phrase "In Advance of a Broken Arm" along with his signature and the date. Several decades later, in a talk given at the Museum of Modern Art in New York on October 19, 1961, Duchamp stated: "A point which I want very much to establish is that the choice of these "readymades" was never dictated by aesthetic delectation. This choice was based on a reaction of visual indifference with at the same time a total absence of good and bad taste . . . in fact a complete anesthesia."[16]

One cannot ignore or deny the industrial context of the readymade. It functioned as a sign or series of signs related directly to mass-produced items taken from Ford's assembly line. Duchamp's point was that the Bride of industry has—at least, temporarily—taken over art. What was important was not the handcrafted object but the simulated object that was selected on the basis of some unknown quantity, what the poet and critic Octavio Paz once saw as an erotic "rendezvous"[17]—that is, a chance encounter, a concept that owes a certain debt to the protosurrealism of the writer Isidore Ducasse (Lautremont).

Duchamp's readymades signified a shifting linguistic structure in art, but they were never intended by the artist to be art in the strict sense. For Duchamp, the concept of the readymade was the work of art, not the readymade object itself. It was the signifying power of the readymade that was important in shifting the emphasis of art from the object to ideas. In suggesting that art could exist as an idea, the readymades gave art a secondary power: to further provoke ideas within a "nonretinal" system, within a context that did not seem to be art, but one that could become art through thought expressed as language.

Whether an early wall drawing by LeWitt, an installation by Rebecca Horn, or an "investigation" by Joseph Kosuth, it is the signifying power of the readymades that influenced the development of conceptual art in the late sixties and early seventies. Fueled by Wittgenstein's *Tractatus* (1921), and the final black paintings of Ad Reinhardt, the readymades represented art as a sign by replacing formalist aesthetics with a new linguistic structure.[18] It was this new linguistic structure that moved art from its preeminent objecthood—paintings and sculptures predestined for the museum—to a more open and dematerialized existence outside the museum. By the end of the sixties, art had become a free agent removed from its past relic-container and, thus, destined to define itself outside the confines of the institution.

Beyond Utopia: Earth Art and the New Social Order

At the end of this century we are being confronted with the ideals of the past. Just as we cannot ignore the past, we cannot ignore the ideals that were a part of that history. As mentioned earlier, the utopian aspect of modernism was an important part of the conflict that made this history what it was. In recent years, there have been countless "deconstructive" analyses that tried to prove the instability of utopia, the impossibility and exclusionary effects of utopia; but to what avail? What is the real purpose of trying to defeat the premises of modernist utopias?

Now that we are deadlocked in a cult of information, inculcated with metatheories and cynicism, overwrought with the pressures of the mundane, it may be advantageous to suggest that utopia, in spite of its apparent naïveté, still holds something of value. Perhaps the approach to utopia in the second half of this century has been less about solutions and ideological impositions and more directed toward the full

spectrum of our structural fragmentation. The earth art of the late sixties (Smithson, Heizer, Oppenheim, De Maria) was one sign of this phenomenon. The site-specific installations, both indoor and outdoor, that followed in the seventies (Turrell, Irwin, Aycock, Miss, Fleischner, Holt) was a continuance of this new subjective utopia—a vision that encompassed both the intimate and transcendental aspirations of individual artists.

A clear example of this transcendental feeling was expressed by the artist Robert Smithson in an essay written on his work *The Spiral Jetty* (1970):

> The water functioned as a vast thermal mirror. From that position the
> flaming reflection suggested the ion source of collapsed matter. All
> sense of energy acceleration expired into a rippling stillness of reflected
> heat. . . . I was slipping out of myself again, dissolving into a unicellular
> beginning, trying to locate the nucleus at the end of the spiral. All that
> blood stirring makes one aware of protoplasmic solutions. . . .[19]

The search for the sublime within space-time has always been connected with utopia as evidenced in the transcendental communities established in America during the late nineteenth century or among the so-called hippies a century later. The concept of a new social order is always related to the desire for individual subjective enlightenment. During the twenties in Europe, this was the case among artists at the Bauhaus and de Stijl. This was also true among the futurists, the constructivists, and, in an ironic way, among the dadaists and surrealists as well. Despite the influences of abstract expressionism and minimalism, one could argue that the earth artists were also possessed by a strong influence from the dadaists and surrealists. On the other hand, one could understand the utopian concerns of Schwitters in the construction of his *Merzbau* and the sublime spirituality in the marine landscapes of Tanguy.

From another point of view, one cannot disregard the importance of Joseph Beuys as a utopian thinker. His concept of "social sculpture" is essential in understanding the extended possibilities of utopian thinking as we move from the twentieth to the twenty-first century. Beuys's theories are very tactile in that they emanate directly from his function as an artist. He spans the width of both individual freedom and social necessity, the desire for a sublime relationship to nature while, at the same time, embracing the need to change the work, to shift the ground of irrelevant institutions and recall the fundamental necessities of the social body.[20]

Without Beuys as an artist/performer/theorist, the extended idea of a subjective utopia would not have been revived and interpreted as a bridge to the next century. His involvement with art actions outside the institution and his redefinition of the institution based on his extraordinary metaphor of the "honey pump" offers a signal of hope that artists still have a role in society that is both sensory and conceptual and that art is an epistemological and a socially responsible endeavor, despite the enormous market-driven pressures to find fame and fortune in the halls of the museum. What Beuys's teaching suggests, in contrast to that of John Cage, is that the denial of the ego is less healthy and less beneficial than the rechanneling of the ego as a source of energy.

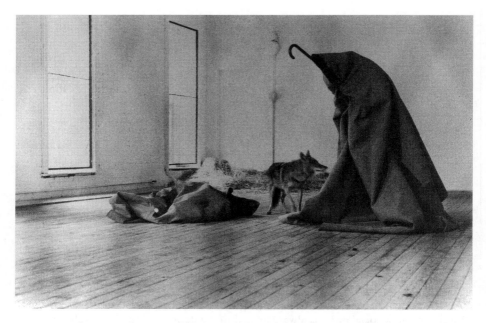

Joseph Beuys, I Like America and America Likes Me, *1974. Rene Block Gallery, New York.*
Photo © 1974 Caroline Tisdall. Courtesy Ronald Feldman Fine Arts, New York.

In a world where energy depletion has become a major issue, artists must confront and repair the separation of mind and body that has been precipitated through media, fashion, and advertising. This seduction and concomitant ego-dissolution has become the basis for conformity in the age of the virtual institution, an age where the insights of artists would seem not to belong.

It is conceivable that this situation will change again in the near future; and when the change occurs, it will come most likely as a result of museums recognizing the need to deal realistically with changing social and economic realities, including those realities that artists have to confront in the everyday world outside the purview of the institution. To be truly effective, these changes may have to confront the entire legacy of modernist art through new forms of critical intervention, outside the current market-driven system, including the various metalanguages that have developed as a result of an accelerating transcultural world.

III. Artists

Nancy Grossman: *Opus Volcanus*

Under the skin the body is an overheated factory.
 Antonin Artaud, "Van Gogh: The Man Suicided by Society"

The challenge in confronting the art of Nancy Grossman is an internal one. To see one of her ferocious life-size heads, bound in black leather, zippered up, with protruding features and gnarled teeth, all exquisitely carved and crafted, or to see one of her recent *Black Lavascapes* made of twisted leather with slices of cut rubber and metallic parts, is to feel an inner sense of being that goes far beyond the mundane world of external events. Grossman is engaged in the pursuit of her own inner-directed motif, her own concept of the human condition that pulls us back to a sobriety of another emotional reality.

The label that is often attached to her work is "expressionism."[1] But what does this mean in the case of Grossman? Is her work merely an expression of something unknown to the world of rational ideas? Is it trying to communicate an inner drive, a passion, that exceeds how we basically feel toward one another? One cannot deny these issues as possessing a certain content that impacts our attention. There is an undeniable obsession that resides within her work—an obsessiveness that is at the core of much of the great art of the past, from Caravaggio to Goya to Kahlo. As Grossman explains, "You have to be obsessed enough with what you are obsessed with."[2]

Yet there is another side to her work, an obverse tendency that is more pragmatic. Grossman's attitude toward sculpture is directed toward the process—the process of how she works and how she thinks in relation to her materials. It is not based on a desire to mystify the viewer, to instill fear or insult, or to give some hopeless, disparaging view of the future of humankind. In fact, her intentions are quite the opposite. She is unassuming both in her work and in her desire to make art. This is the primary issue. Grossman has never been a careerist in the trendy, market-driven sense of the word. Whether collage, relief, assemblage, or mixed-media sculpture, she has made it clear that her work is always about a process. In her own words, "The material-

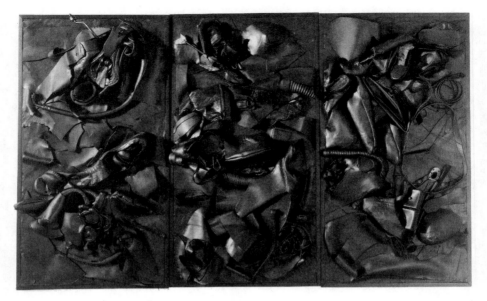

Nancy Grossman, Opus Volcanus, *1994. © Nancy Grossman/Licensed by VAGA, New York, NY.*
Photo: Larry Lamay.

ity of the end result is worth the process." She understands the necessity of "plodding along," as he puts it, in order to make her materials function more physically in their goal toward visual representation.

Despite her high regard for technique and process, Grossman does not deny the psychological, physical, and existential realities that may emanate from her work. In her typically provocative way, Grossman states, "The longer you live, the more the earth gets you. You fall under the spell of gravity." This comment is not only related to her recent collage works, such as the *Volcano Series* (1993), or her sculptural reliefs, such as *Opus Volcanus* (1994), but to her self-perception of her own physicality and the limitations she has recently learned to accept.

At the end of 1995, a serious physical impairment inflicted her left hand that crippled her ability to work for over a year. Grossman discovered that the cartilage of her first metacarpal bone was completely worn away. This traumatized her hand movements to the extent that she virtually lost control of the necessary reflexes she needed to perform the detailed functions required by her work. After years of repetitive and highly concentrated movement related to precision carving, Grossman was forced to take a hiatus from her activity and have her hand surgically rebuilt. After several operations, she has gradually regained movement, but not with the same facility to which she had been accustomed. This accounts for why Grossman has not been able to carve wood in recent years and why she has turned instead to making works more related to collage and assemblage. Ironically, this is where her career began in the early

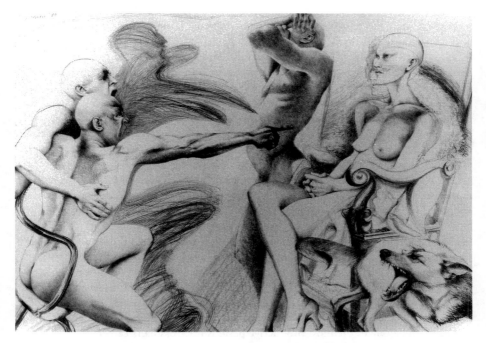

Nancy Grossman, Five Figures, *1984. © Nancy Grossman/Licensed by VAGA, New York, NY.*
Collection: The Arkansas Art Center. Photo: Bill Jacobson.

sixties—a time when the neo-dada spirit of assemblage and happenings occupied much
of the attention of the art world.

In 1965, Grossman was awarded a Guggenheim Fellowship—three years
before she conceived of her well-known "heads." One might argue that Grossman is a
kind of pictorialist who eventually made her way into sculpture. She had studied with
the German emigrant artist Richard Lindner at Pratt Institute in the late fifties. It was
here that she grew to understand the importance of figuration in her art and also came
to terms with her need to develop a personal vocabulary of forms.[3] Lindner, who was
considered eccentric by some of his New York artist colleagues, impressed upon his
students the importance of drawing. Through Lindner, Grossman came to believe in
her extraordinary capability as a draughtswoman. Despite the disturbing content of
many of her works, both in two and three dimensions, most critics still cannot argue
with the formal quality of her line.

One glance at a drawing such as *Five Figures* (1984) makes the bold and
remarkable character of the artist's ability abundantly evident. In this large-scale work,
made entirely with charcoal and graphite, Grossman delivers a feminist-inspired alle-
gory of betrayal and guilt. The force of her line, the accuracy of her figurative render-
ings, and the placement of the light and dark shapes within the compositional space
represent a disturbing personal confession, the content of which is conceivably related

to her upbringing as one of several children living on a farm in a rural upstate New York community during the late forties.[4]

Still, in spite of her personal travails, Grossman continued to believe in herself. She recognized at the outset that any artist who has sustaining value must develop a personal language of form, one that can be applied with a diversity of syntax within a chosen field of investigation. Also, under Lindner she came to understand the importance of the line not only as a drawing instrument, but also as the foundation of formal composition. She was fortunate to discover in Lindner an artist "dedicated to his own integrity." This integrity became a basic component in her search for her own artistry; it was a lesson that Grossman never forgot.

One might say that integrity has been the cornerstone in Grossman's career as she has moved from painting to collage, between assemblage and relief sculpture, and, finally, by 1968, to the heads. Her first important exhibition was at the Cordier and Ekstrom Gallery in 1969 and consisted mainly of the rancorous-looking carved heads wrapped in black leather. Although the gallery owner was diffident about handling the work at the beginning—perhaps because it was transported to him in two large shopping bags—he eventually agreed to show it. There is little doubt that Mr. Ekstrom had some difficulties with the straightforward content in Grossman's work.[5] Reportedly, he was visibly shaking as he looked through the drawings. Yet, in spite of his initial hesitancy, the artist's association with the gallery continued for twelve years and came to be one of the most productive periods in Grossman's career.

It is curious that by far the greater portion of the artist's subjects has been male. The heads and drawings of bound male figures take on a mythological significance, a ritualized aspect as if they emerged from some dark night of the soul into the presence of stark daylight. In a recent essay on "beauty," the artist Jeremy Gilbert-Rolfe cites the German philosopher Winckelmann as proposing that the ideal male should be represented as possessing some traces of the feminine.[6] If these qualities are not present, the representation of the male lends itself to "an aggressive display of . . . brute physical violence" and thus appears "ludicrous or repulsive." With some exceptions, it is curious to note how many of Grossman's collage paintings of male figures appear feminine in their grace and vulnerability, yet how the more visible leather-strapped heads, such as *T.Y.U.L.* (1970), have just the opposite effect.[7] By appearing removed from their femininity, these severed heads assert an inner violence and a hell-bent absurdity as they confront the world in their aggressive masquerade.

Grossman's vision is not far from that of the French surrealist poet and playwright Antonin Artaud. Grossman shares with Artaud the knowledge of an inarticulate space between the masculine and the feminine, between the rational mind that represses desire and the desire of the body to release itself to the forces of an unmediated experience.[8] When Grossman's heads appear in the light of day, constrained by darkness and bondage, one is compelled to reflect on the profound split between mind and body. Who are these creatures? From what world did they emerge? What is the nature of our civilized environment that imposes such a hiatus between the rational and irrational expressions of the human mind? Where is the closure between them? They suggest a kind of schizophrenic condition, a division between two states of being;

but Grossman's heads rarely give us a simplistic cause-and-effect relationship. The conflict is both greater and more subtle than their accountability through language. They imply the lost need, at least on a conscious level, for ritual in our society, in our brave new (digital) world. It was as if our culture had gone too far in the direction of the rational, to the zero degree of overdetermination, and had left the human race as a species of sublimated creatures wandering in the purgatorial chasm between torment and lucidity.

A few months before her disability, Grossman completed a large-scale, three-color etching, entitled *Apollo the Healer* (1995). This was a time-consuming work not only because of its scale, measuring three by five feet, but because of the amount of crucial dexterity needed in order to gain the effects that she wanted to achieve. This male image offers a spiritual insight more related to illumination than to darkness; it carries the feminine as well as the masculine. Based on an early collage painting entitled *Cloud Figure Seated* (1976), the etched version carries an even greater visual and emotional grandeur. This is due to the method of burnishing used in order to accentuate the blue textural nuances within the head and torso of this imposing mythological deity.

Another side of Grossman's art, the side that is rarely discussed, is the sculptural reliefs made of mixed-media materials in the mid-sixties. In the catalogue essay for the artist's three-part retrospective in 1991, art historian Arlene Raven discusses Grossman's work as "employing leather interchangeably with metal and wood . . . spirited by quick, graceful movements among their internal forms."[9] This is reminiscent of a statement made by Marcel Duchamp in describing his cubo-futurist style of painting in *Nude Descending a Staircase* (1913), composed of "mechanical parts and visceral organs."[10] The allusion to Duchamp is not entirely inappropriate to Grossman's work at the time. Neither are the mixed-media reliefs of Lee Bontecou or the welded sculpture of David Smith, an artist who Grossman knew personally.[11] Although rarely mentioned, the work of sculptor Robert Mallary should also be noted in this context.

But what is the context exactly? One might state it as follows: a hybrid between neo-dada, of course, influenced by Duchamp during the late fifties/early sixties, and the mythological figurations of Smith. The Bontecou reference is the most elusive, however, and in some ways the most interesting. Bontecou had a certain presence in the New York art scene of this period and was championed by the critic Donald Judd. She had a certain mysterious aspect to her work not removed from that of Grossman. It was a dark, torrential side, a disturbing aspect; yet one that was always contained and formalized within the context of its self-generating mystery. It is Bontecou's sculpture, which employed canvas and metal parts, that connects most accurately with the gestural reliefs on canvas made by Grossman in 1965. Yet there is also a connection with the more recent sculptural reliefs, completed by Grossman thirty years later in 1994 and 1995, such as *Black Lavascape* and *Opus Volcanus*.

Both of these reliefs—employing black leather, rubber, metal parts, wood, and acrylic—are extensions of the 1993 collage/drawings that were influenced by a trip to Hawaii. What struck Grossman about the volcanic sites in Hawaii was the sheer physicality and the unbridled force that was beyond rational comprehension. It was the

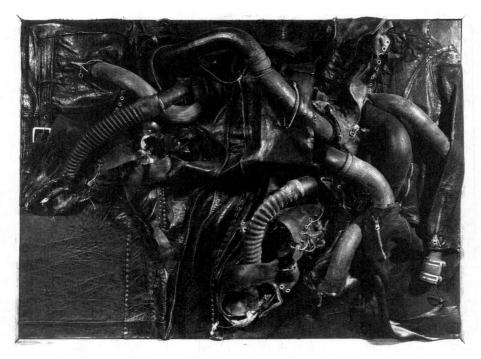

Nancy Grossman, Ali-Stoker, *1967. © Nancy Grossman/Licensed by VAGA, New York, NY.*
Photo: Geoffrey Clements.

experience of confronting these sites that moved the artist to try to deal with opposing forces in her recent work. One can see a direct linkage between one of the later sculptural reliefs, using these same materials, entitled *Ali-Stoker* (1967) and the more recent *Black Lavascape* (1994–95). The folds and turns and placements and juxtapositions of the winding, bending shapes and lines have a certain elastic resonance, a quick pulsation as if they were under the command of some extraterrestrial biological time, moving through space on their own accord. Yet there is a sense of disturbing absence of closure that is seething with opaque mysteries, comparable to the filmmaker James Cameron's *Alien*.[12] One never knows for certain whether the beast is dormant or deposed. Looking at Grossman's *Opus Volcanus* is like staring into a pit of lava, the larynx of the earth's encrustation where perception can no longer detect its limits.

The forces at work (and play) in Grossman's *Opus Volcanus* are comparable, on the structural level, to her 1984 drawing of *Five Figures*. What is important is not the surface representation so much as the strident elements opposing one another in the dark penumbra between virtual and fictive space. There is a formal tactic in operation here, but there is also the fear and trepidation of the viewing subject being caught up in this drama of emotion, of being carried away by the nearly hallucinogenic atmosphere, the hysteria of the earth's crust spewing forth its defiance, its hidden, unspeakable detritus, bellowing forth the industrial (and postindustrial) waste of the last

hundred years. What is remarkable about Grossman's achievement is how the structure of these forms is so ineluctably consistent that the contrasting elements seem to coalesce and discover their own consummation.

Like any significant art of this century, Grossman's is dealing with abstract forces that have become formalized as properties within a given perceivable space, an environment that has been transposed and possessed with the process of its own making. In *Opus Volcanus*, there is the trace of the human hand, yet there is the assertive form of the triptych. There is also an absence, a deep longing, perhaps the longing for hope and a better world amid the chaos and trepidations of the present. Was it Erich Fromm who once described the human imagination as a volcano with the potential to both create and destroy?[13]

Grossman is on the side of creation. She maintains an indefatigable courage to face the human reality of the present. Her art is one that captures the conflict of transition, or being within the moment of a heightened transition, between the old and the new world, where the analogs are slowly being replaced by rapid systems of information transport. And within all this invisibility, Grossman's figures and industrial entrails come together as a sign of how we must restore our sensibility to the tactile experience of being aware in a world that is changing before our eyes.

Sang Nam Lee:
Minus and Plus

In an environment where the spirit of art suffers from a hyperconscious lack of recognition—where the slightest reference to "spirit" is interpreted either as obsolete metaphysics or as hopelessly out of touch with current postcritical or deconstructive strategies—the paintings and drawings of the Korean artist Sang Nam Lee hold forth with a particular assiduity, what the artist calls his "eternal vigilance."

A few years ago, such terminology would have been passed over in the New York art world, virtually ignored as being too literary. To speak of "eternal vigilance" as a state of being with one's art would immediately classify the creator as "premodern" or enmeshed in ontological arguments that were antithetical to postmodernism. Little tolerance would have been felt, especially in acknowledging the artist as a "creator."

Recent strategies in artistic practice, overtly and unashamedly purloined from artists working nearly two decades ago, are not so much involved in creativity or originality as they are in appropriation or simulation. Based on a gross misunderstanding of Duchamp's readymades and on an arrogant denial of history, many favored young artists currently on the cultural scene choose the metalanguage of mass media as if to "deconstruct" the hostile messages of late capitalism.

This new common language, a hybrid of philosophy and social science, often ignores or derides the notion of "spirit" in art and is lavishly hell-bent, though masked in a cool veneer, on aborting the normative context of such archaic words in favor of an inert defiance known as the language of "otherness."

The real irony of this new common language is that its vengeance is wreaked not so much against the presumed sentimental disguise of power as spirit, but against the aesthetic pleasure that art potentially signifies. One might say that the jargon of recent theory—largely appropriated from American translations of works by recent French philosophers, such as Deleuze and Guattari—has enshrouded the art world in a kind of paralysis where art that is not directly representational has difficulty in being either accepted or understood.

Sang Nam Lee does not require a form of externalized theory in order to justify what he does. Nevertheless, the reception of abstract painting today is often

viewed with suspicion unless there is a stated intention in the form of an accompanying text. Some consider abstract painting impenetrable. Without a text, the work has no foundation or authorization. This is one of the great fallacies of art education.

Sang Nam Lee was raised a Buddhist. The sutras, of course, are the sacred texts, and the scrolls are the sacred geometry. One might speculate that his closeness to theory—in terms of the sutras and the visualization of text as embedded within the scrolls or thangkas—is something that the artist does not need to reiterate. As a mature artist, he is sensitive to avoiding the trap of trying to illustrate a theory. Theory is unnecessary as an external mechanism if it already exists within the embedded thought process of the artist; therefore, it is simply not an issue. The real issue for Sang Nam Lee is more related to the manifestation of science as an inner phenomenon, a kind of reification of science in visual and symbolic terms.

As a methodology for postmodernism, one might consider that culture and theories about culture are manifestations of the same fundamental human activity. They do not exist as isolated moments in time, but exist in the present. In the post-modern environment, the ideas and models from the cultural past constitute a new "multiculture" in that they exist as a free standard. They are open sources for investiga-tion. They should not be limited to the kind of cynical displacements of felt experience that characterized much of the neo-geo and simulationist art of the previous decade.

Ideas and models borrowed from constructivism or from quantum physics or, as in the case of Sang Nam Lee, from the natural sciences, are available in terms of another recontextualized state of being. They eventually find their way into abstract painting as felt subject matter within the realm of the subject. Put another way, the subject does not necessarily disappear within the tension and harmony of physical dynamicism. Rather, there is a deferral within the visual reality of the mind's eye.

Whereas in Buddhism the geometric principle is used as an ordering device in order to situate the hierarchy of deities—various androgynous incarnations of Sakyamuni, the many followers and attendants, represented as anthropomorphic forces that abide in the material world but also exist in a world beyond time. It is the factor of time—or being within time, the contemplative state called Samadhi—that seems close to the metaphysical drawings and paintings of Sang Nam Lee.

The spatial dynamics of plus and minus in physics require a stable center, a vortex of gravitational force from which the inertia of space-time settles into its own velocity. It seems clear that Sang Nam Lee is creating a metaphor of the human spirit in works that use concentric circles and arcs over a painted ground. Whereas the drawings tend toward the diagram, the paintings tend toward the emblem, given their circular vortex imagery.

This is again consistent with the artist's Eastern roots, specifically as they are expressed in the abstract ideograph—the energetic mind-picture or idea-picture, as once described by the poet Ezra Pound; but what is far more significant is how Sang Nam Lee has managed to move space-time into an internal dynamic that projects outward and that cancels itself in time, only to rejuvenate in its accelerating force. This, of course, happens by way of static placement and references to vectors and physical motion and speed. This speed is not a futurist speed, as in Boccioni, but it is a speed of

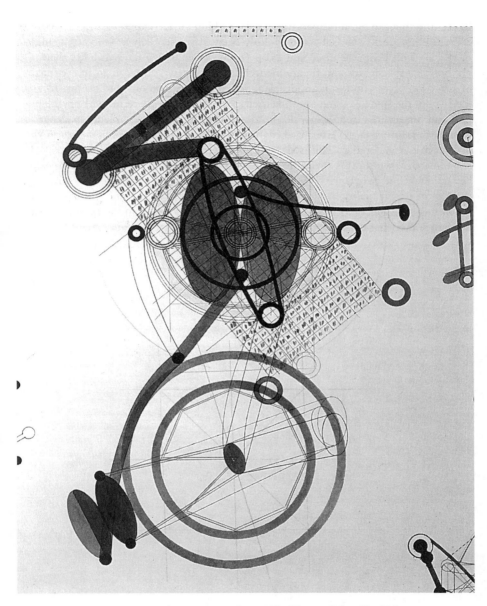

Sang Nam Lee, Polygon.A, *1993. Courtesy Elga Wimmer Gallery, New York.*

light—the amalgamation of space-time. It is the kind of phenomenon introduced earlier in this century by Gabo and Moholy-Nagy. It is essentially a Neoplatonic idea.

This being the case, Sang Nam Lee has given us a visual sensibility that symbolizes a specific instant, the moment of intense receivership, caught in the fraction of a fraction of a second. It is an idealism, perhaps, but not an outward utopia. It is an idealism of the spirit, seeking to refine itself, seeking to come to terms with fragmentation and despair in a troubled world. It does not refrain from the difficult challenge of coming to terms with a Westernized environment from the position of an Eastern view of science and materiality. This is also a postmodern dilemma.

It is within this environment that the paintings and drawings of Sang Nam Lee maintain their vigilance—eternally—in the sense that they struggle to determine the vectors of spirituality in an abundantly secular world. The balance of the plus and the minus is his metaphor for the present moment—the democratic spiral that elevates thought and feeling on a new physical plane.

The Fundamental Theology of Gilbert and George

Aestheticizing the abject has become a virtual sign of the times. Perhaps, it is based in the existential fear and dread of coming to the end of a millennium, a kind of isolation of the soul as it speculates on confronting the negation of the self (nonbeing), a scatological secret, or even, in some cases, an augmented anxiety about the Day of Judgment. Our deepest fears become sublimated in such a way that beauty is transformed into glamour and truth becomes media. Whereas in the early nineteenth century the age of romanticism became a sublimation of the fears of industrialization, one might consider the fashion world today as a sublimation of fear of the end of the millennium. Where are we going? What are we doing?

The popularization of art, or what is now confused as "visual culture," has not only become a means to avoid the radical notion of quality, but it has also become both the sign and effect of beauty. Put another way, much of the art we are seeing today has become hard-pressed to signify anything beyond the allure of the media, the quick-take, the image-making machine that drives our information-based society. One could say that we live in a dialectical world of images, fleeting images, images that come and go, that appear and disappear, images in which there is no further commitment than the momentary allure or titillation they provide. Here it is, and there it goes. Tactile experience has been left in the dust. Only the virtual survives. Only the image in all its permutations. The image of the abject played out into eternity.

Even so, the 1997 exhibition, entitled *The Fundamental Pictures,* shared by the Lehmann Maupin Gallery and Sonnabend Gallery, is collectively Gilbert and George's most incisive and provocative series of work in well over a decade. The two-part exhibition offers a series of large-scale color photographs in a grid format. Gilbert and George give us an unabashed, though detached, honesty that is more than alluring. It is an exhibition filled with self-indulgence, macro images of feces and other bodily secretions, and "fundamental" words like "piss," "shit," "blood," "tears," "spit," and "spunk." We are perpetually confronted with the naked bodies of the two artists, either facing us or bending over to reveal their buttocks and recta, as in *Front and Back and Piss* (1996). These works represent a convincing display of obsessiveness, an unmistak-

able self-effacement, and a blatant narcissism. Lesser artists tend to sublimate or conceal these traits by displacing them in favor of commodities, digital technologies, or slick video projections—as if to prevent the core of the issue from being seen.

While tight and nearly systematic in its presentation, the exhibit tends to become overly repetitive. There are failures as well as successes. Trivial works, like *Bloody Shit House* and *In the Shit* (both 1996), tend to be prosaic in their representation and superficial in concept. Other works make up for the trivial ones: namely, *Spat On* and *Bloody Naked* (both 1996). The best works, like *Spit Blind* and *Blood and Piss* (both 1996), have an extraordinary visual power in their iconic desire for transcendence. *Spit Blind,* in which the two images of the artists cling together striding forth in an enlarged pool of saliva, is a veritable tour-de-force, reminiscent of Masaccio's *Explusion.*

These are abject images that are both eschatological (fascination with the coming of last events as in the chronicle of St. John of Patmos) and scatological (fascination with feces). Aestheticizing the abject, the dark side of human existence, in current art is a synthesis between theology and bodily secretions; indeed, it is an eschato-scatological phenomenon. (How else could one rationalize the fact that the most popular issue of *Art Journal,* the official publication of the prestigious College Art Association, is a 1996 issue devoted exclusively to artists who use excrement in their work.)

Gilbert and George began to achieve recognition in the late sixties. Upon graduating from St. Martin's in London, they declared themselves an artist-dyad, or, in sociological terms: the minimal unit, a two-person group. They further declared that they did not need to make any more sculpture, because they *were* sculpture. This was, of course, during the heyday of British conceptual art. Several artists, such as the Art and Language group in Coventry, were focusing specifically on the transformation of the art object into language propositions. Making such statements at that time was not uncommon, and Gilbert and George were part of the action.

Best remembered from this early period is their famous *Singing Sculpture* (1970), in which the two artists, dressed in suits and with bronze-colored faces and hands, perform like marionettes while mouthing the words to a recording of a favorite Edwardian ballad called "Underneath the Arches." Four years later, Gilbert and George were to perform their masterpiece *The Red Room* (1974) at the Sonnabend Gallery. For this work, the artists had their hands and faces painted in red prior to the performance while wearing similar tweed suits as worn in the *Singing Sculpture. The Red Room* was a choreography in which the dyad moved according to a specific architectonic plan during a lengthy duration of time, again impersonating marionettes. This work could be viewed as a culmination of the early-twentieth-century concept of the *Übermarionette* introduced by the theorist and dramatist E. Gordon Craig.

The pair's interest in photography as a means of documenting their silent performances became an important aspect of their work early on. The first photographs—always of themselves in a state of either contemplating or observing—were relatively small in scale, black and white, and usually framed in multiple parts. By the late seventies, the works became larger and the grid had become their standard format. By the eighties, color and larger-scale formats entered into the work. The content of the

photographs also became increasingly oriented toward gay issues, often involving explicit homoerotica. While using a conceptual underpinning in their work, Gilbert and George have generally focused on humanistic issues, including social and political problems ranging from alcoholism, drugs, pollution, health epidemics, class conflicts, and the threat of nuclear arsenals.

The best of the works included in the cosponsored 1997 exhibition represent a cool, nearly pathological desire for exhibitionism—a pop conceptual mode of delivery that relates the existential lives of these artists to the rest of the world. I read this exhibition as being about much more than the travails of two gay British artists. In spite of its obvious deficiencies, Gilbert and George's exhibition is about survival, defiance, and—as one of their titles suggests—maintaining the "bloody faith." Although *The Fundamental Pictures* is fraught with the abject, it somehow manages to represent this dire aspect of the human condition with a certain detached, though poignant, dignity. I read this work as attempting to bridge the split, the fissure between the outside appearance—the world of fashion—and the inner soul. I have to say that in spite of its repetitive narcissism and self-indulgences, the work of Gilbert and George constitutes something significant—a statement that raises many issues that need to be confronted in a world struggling to find its humanity at the end of the millennium.

Carolee Schneemann: The Politics of Eroticism

It is remarkable that an exhibition of the work of an artist such as Carolee Schneemann could have occurred during a period of major redesign and interior reconstruction at the New Museum of Contemporary Art in SoHo. One reason alone is that the breadth of Schneemann's multifaceted output for nearly four decades has been considerable, and while it may be said that she espouses a definitive sensibility in her work, it would be difficult to call her work "stylistic." While often associated with fluxus, neo-dada, the beat generation, and the happenings at the beginning of the sixties, Schneemann's work could either defy or consume all these categories. Although younger than other artists associated with this highly charged experimental period of the early sixties, Schneemann saw her linkages as not restricted to painting or even to the plastic visual arts. For example, she admired the work of poets like Michael McClure, filmmakers like Stan Brakhage and Bruce Conner, and composers like John Cage and James Tenney. While sources outside conventional artistic practice were abundant at the time, Schneemann never equivocated in terms of her own direction.

In one sense, it would be accurate to say that she has worked simultaneously in three disciplines: mixed-media installation, filmmaking, and performance art. In another sense, with Schneemann it is difficult to draw the line between one medium and another. To make separations or distinctions would, in fact, seem antithetical to her position as an artist. Contrary to other artists in succeeding generations who have followed her example in terms of a sexual openness and expressiveness, Schneemann has never tried to pursue a slick stylistic approach to materials or to image-making. She has never followed or administered a single stylistic orientation. This may be why Schneemann's work has been sadly neglected by major museums and by curators who are obliged to accept works that are stylistically coherent and accessible, yet with little of the energy that exudes from the works of Schneemann in performances such as *Illinois Central* (1968) or *Interior Scroll* (1975).

For what her work represents at its very best is an impulse toward liberation of the body and the mind as a totality. This kind of Blakean mind-body coherence within the context of her images and materials is threatening to some, maybe even

127

repulsive; but for others, Schneemann's work is possessed by an eccentric brilliance, as in *Cycladic Imprints* (1991), a performance at the San Francisco Museum of Modern Art, or her harrowing, yet transcendent, *Mortal Coils* (1994), first installed at the Penine Hart Gallery in New York and later exhibited at the Kunstraum in Vienna (April–May 1995).

While Schneemann may connect or even argue with those practitioners who are in some way indebted to her work, she never refuses to acknowledge their place as part of the dialogue within the art world. Like many of the best, even the greatest artists, Schneemann has a certain generosity in acknowledging what she understands as authentic in the work of her peers and in the creative efforts of those with whom she feels an artistic connection. Again, like any important artist, regardless of history, culture, or geographical location, she understands fully the subjective human desire to create. Consequently, she cannot be categorized as simply another pawn in the game of recent visual culture. Schneemann's insistence on being an artist in an age where the desire to make art has been reduced to the same horizon of neutrality that one sees in commercial films, electronic media, and fashion extravaganzas, is, to say the least, commendable, if not laudatory.

Yet, she has paid a certain price for her insistence—at least from the standpoint of her early career. While it is true that Schneemann's exuberant performance-oriented body works and her formally chaotic assemblages ran concurrently with related movements of the early sixties, such as fluxus, Schneemann also has always run on her own track. In retrospect, we might call this track a type of "proto-feminist" sensibility in that she was clearly ahead of the feminist movement as a formal idea in art as it emerged at the close of the sixties and into the seventies. Yet, Schneemann's thinking was always there, always at the core of her belief in feminism, even when such a position remained inchoate at a time when women were being denigrated as artists and were being denied access to exhibitions in important galleries and museums. This was particularly the case if the artist was on the fringes of conventional art-making or within the hybridization of some artistic crossover. Schneemann was not exactly a formalist or a color field painter or a public sculptor. She was always on the fringes, and in being on the fringes, she was squarely within what in the sixties was still called the "experimental avant-garde," a place also occupied by Rauschenberg and Oldenburg during the early years.

The retrospective exhibition at the New Museum took its name from the title of one of her earlier performance works, *Up to and including Her Limits* (1973). Curated by senior curator Dan Cameron, this was the first museum exhibition in the United States given to this seminal feminist performance artist, pioneer of installation art, and radical underground filmmaker. The exhibition was a complex one, both in thought and material—visually excessive, frequently stunning, and, at times, emotionally overwhelming.

The selection of works consisted of early paintings and assemblages, videotaped performances, photographs and photocopied images, and a selection of mixed-media installations. Given that much of the work in Schneemann's career has been in the area of performance and film, or nonstatic art, it was necessary to present still

photographs and video documentation, along with other artifacts, sketches, and notes, that related directly to important works, such as *Meat Joy* (1964), *Snows* (1967), and *Illinois Central* (1968). Given the limited amount of downstairs space available (in the middle of the museum's renovation), and the unfortunate decision to include three room-size installations by other artists in the back galleries, the Schneemann exhibition felt unnecessarily compressed. The front galleries showing works and documentation from the early period were especially congested.

While modest in size, given the stature of Schneemann, the catalogue that accompanied *Carolee Schneemann: Up to and including Her Limits* is useful in providing scattered fragments of visual documentation and important background and interpretative information through the three essays by Dan Cameron, David Levi Strauss, and Kristine Stiles. Specifically, the essay by Stiles, an art historian and longtime associate of the artist, is particularly useful and insightful as it goes to the core of many of the important feminist issues, including the mythological basis for much of her work. (Stiles is also the editor of *It Only Happens Once: Letters and Performances of Carolee Schneemann,* published in 1998 as part of the Art + Performance series of PAJ Books, an imprint of Johns Hopkins University Press.)

Schneemann's career began as a painter in the late fifties, working in a style related to second-generation abstract expressionism. This soon evolved into a neo-dada style, as in *Native Beauties* (1962–64), in which Schneemann worked with boxed constructions and expressionist forms, allowing her brushwork and collaging of found objects to subvert the compartmentalized structure. Another mixed-media expressionist work, *Letter to Lou Andreas Salome* (1965), pushes beyond the theatrical framing device of boxed construction into an open field of turbulent gestural brushwork and found objects, creating a dense textural overlay, in some ways reminiscent of Rauschenberg's combine paintings. In contrast to Rauschenberg, however, the painterly works from this mid-sixties period are more internally obsessive and therefore less detached in their relationship to external signs in the mundane world.

One can argue that Schneemann, rather than going outward into the realm of pop culture or inward into the existential metaphysics of the self, found a unique equivalence with the body. One looks at these works from the early to mid-sixties as being about the body, a correspondence to the body, not in the symbolic sense, but in terms of a physical manifestation, an expulsion, laden with libidinous energy. It is through this approach in Schneemann's assemblage style of painting that one finds the model or the sign that inspires her venture into Dionysian performance and ultimately into film. Finally, in 1975, with her major work, *Interior Scroll,* one discovers the lamination of performance in relation to film, the overlay of past memory and the naked reality of presentness, the full Dionysian abandon that identifies her particular direction as an original feminist artist.

By 1963, she had established her version of happenings with a group called Kinetic Theater, an experimental, cross-disciplinary company of dancers, artists, musicians, writers, and performers. Probably her best-known and best-documented performance from this early era was *Meat Joy* (1964), in which the seminude performers interacted with various organs from cattle as well as sausages and fish. This wildly

ecstatic performance has been fully documented along with other body and perfor-
mance works in *More Than Meat Joy,* originally published in 1979 under the Docu-
mentext imprint by Bruce R. McPherson. Further documentation of her work can be
found in a revised and expanded edition of this volume, published in 1997 with an
introduction by the publisher and the addition of two performance documents, *Fresh
Blood—A Morphological Tale* (1983) and *Vulva's Morphia* (1995). In addition, a limited
edition of thirty-five copies of an artist's book, *Vulva's Morphia,* consisting of thirty-six
laser images, has been produced through Steven Clay at Granary Books.

Schneemann realized upon the instigation of *Meat Joy,* performed with her
Kinetic Theater at the Judson Memorial Church (1964), that the documentation of the
performance was a necessary and important part of the event. In order to communicate
the expressionist aspect of the work and to reveal its structure, the use of film and still
photography became essential ingredients—expedient, though detached from the
actual staging of the work. This realization led Schneemann to pursue the medium of
film as a mixed-media form unto itself, and upon occasion, as in *Snows* (1967), within
the context of a happening. Her early films include such important groundbreaking
works as *Fuses* (1967), in which she engages in explicit lovemaking with the composer
James Tenney, and her Vietnam protest film *Viet Flakes* (1965), which was eventually
incorporated into *Snows.*

The spectrum between eroticism and politics has always been a central
theme in Schneemann's work. It is difficult to think of the artist's work as separate from
this tension: what is erotic has political significance, and what is political is transformed
into the erotic. Take, for example, the following excerpt from the writings about the
performance *Interior Scroll* (first performed on August 29, 1975, at the Women Here
and Now festival in East Hampton) and included in Schneemann's book *More Than
Meat Joy:*

> I thought of the vagina in many ways—physically, conceptually: as a
> sculptural form, an architectural referent, the source of sacred knowl-
> edge, ecstasy, birth passage, transformation. I saw the vagina as a translu-
> cent chamber of which the serpent was an outward model: enlivened by
> its passage from the visible to the invisible, a spiraled coil ringed with
> the shape of desire and generative mysteries, attributes of both female
> and male sexual powers.

A pivotal performance work in bringing together issues of eroticism and
politics, *Interior Scroll* should be considered one of the fundamental works not only in
Schneemann's career but also in the history of feminist art of the seventies. The layers
of interpretation are vast and never cease to provoke new ideas. The performance
involved a nude Schneemann unwrapping herself from a sheet while standing on a
table, then pulling from her vagina a small scroll on which she had written a "secret
text" to be read to her audience.

To understand this work is to place it in the context of the postminimal and
postconceptual era of the seventies and to see the artist's feminism as being about the

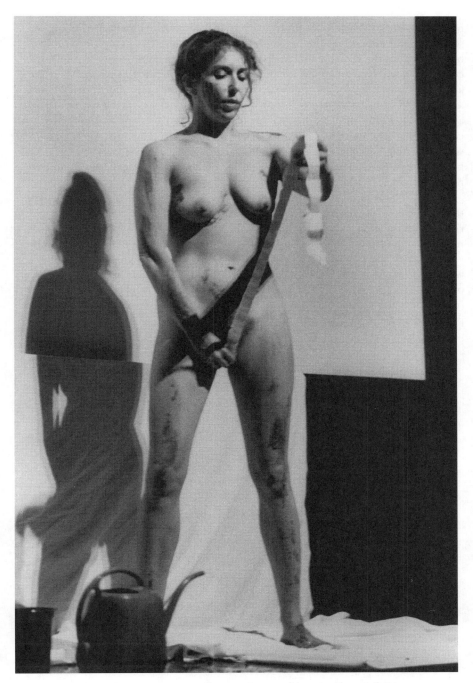

Carolee Schneemann, Interior Scroll, *1975. Courtesy of the artist. Photo: Sally Dixon.*

body in contrast to the insular protectiveness of the masculine brain. By pulling the scroll from her sex and reading it aloud, she is stating that what is inscribed on the body or within the sexual body is a discourse that is inseparable from that body. In comparison with an earlier performance work from 1963 called *Eye Body,* where the artist wears two horns on her forehead (reminiscent of the prayer horns that Michelangelo attached to his *Moses*), Schneemann's *Interior Scroll* locates the source of power and intellect within the female sexual organs—the intuitive as opposed to the rational concept of artistic thought. In *Interior Scroll,* the artist virtually turns the table on what was happening in the late sixties—minimal and conceptual art as associated with male productivity—into a feminist discourse on the body: creative, organically conceived reproductivity.

The antecedents in Schneemann's work go as far back as the Gnostics and the mythic cults of goddess worship in prehistory. She will often contrast these ancient rituals with the more current problems of the mind-body split that arose in the wake of modern technologies. There is considerable intimacy in Schneemann's work, combined with ideology and politics; yet she never forsakes the visually expressive means by which she represents the emotional content of the idea. Schneemann has always been on her own track and always aware of her own position as a thinker and maker of art. It is to the credit of the New Museum that it should have gone against the grain and presented an artist of such significance.

Bruce Conner: Engraving Collages and Films

Anyone who attended the 1997 Whitney Biennial has probably seen the somewhat demure inkblot drawings by San Francisco artist and filmmaker Bruce Conner. Relatively speaking, Conner's contribution to the exhibition is small; that is, small in scale. On another level, his drawings are monumental manifestations of a psychic power that are given their own formal language. As I suggested five years ago in another essay, Conner's drawings are prophetic of the art that will emerge as "great art" light years ahead of us. They speak a language of intense feeling and they exist in an intimate space. They are drawings of the mind, abstract renditions of what one might see in Chinese scroll painting from the Ming dynasty.

As with his inkblot drawings, Conner's collages are extremely elegant, inner-directed works. They are usually put in frames, but occasionally they are bound. A good example of the latter would be a work of twenty-six etched images called *The Dennis Hopper One-Man Show* (1964–70), in which the artist simulated several of his collages. Conner is not at all concerned with the lassitude of pop culture or the extravagant, pathetic dead-end materialism that abounds in the current playfield of our hyper-mediated "visual culture." When he does turn his attention to these concerns, the edge is usually a political one. And this becomes apparent in his significant group of independent films that he began to collage in linear fashion as early as 1957. Films such as *A Movie* (1958), *The White Rose* (1967), *Marilyn Times Five* (1968–73), and *America Is Waiting* (1982) are some of the classic underground films made before digital imagery usurped our attention span and our ability to see clearly the semiotics of film and the attendant emotional counterpart to those sign systems.

An unusually concise and magnificent exhibition entitled *Bruce Conner: Engraving Collages, 1961–1995* was mounted at the Wichita Art Museum in Kansas. Why Wichita? Besides being the centermost town in the exact center of the continental United States, it happens to be the place where Conner was born (1933), raised, and attended art school (at least for the first two years). Also behind the exhibition are the highly intelligent efforts of the independent collector and curator (and self-taught art historian) James W. Johnson.

Johnson instigated, through the help of Paula Z. Kirkeby Contemporary Fine Arts, an exhibition worthy of being seen not just in Wichita but anywhere in the United States, including New York. If you found the small selection of inkblot drawings at the Whitney intriguing, chances are that you would discover an equally uplifting spiritual intensity (and humor) present in the engraving collages shown at the Wichita Art Museum. This series of work borrows and appropriates imagery from other sources—namely, late-nineteenth-century engravings—which are then represented in a new, often mysterious symbolic context. Such works as *Deus Ex Machina* (1987), which adorns the catalogue cover, or the more recently obsessive, half-demented *Psychedelicatessen Owner* (1990) have resonances and affinities that extend somewhere between Max Ernst and Ivan Albright. In addition to the eighteen engraving collages, which are discussed with insight and passion in the catalogue essay by Johnson, the film program was perhaps the most thorough to date. Quality prints of Conner's films were assembled and shown at various times during the course of the exhibition.

It is not so common that a New York art critic would be invited to a place like Wichita to view such an exhibition. Although modest in scale, this was an important selection of work by a conceptually visionary artist, who for forty years has worked on the fringes of the beat generation. His artist-colleagues have included Wallace Berman, Jay DeFeo, Wally Hedrick, Jordan Belson, Michael McClure, Carolee Schneemann, and Dennis Hopper. In fact, Wichita was part of the beat experience in the fifties and sixties: Conner, McClure, Dave Haselwood, and Charles Plymell are all linked to Kansas.

A little further north from Wichita, you may have run into the cyberbeat writer Bill Burroughs who lived in Lawrence. And it was no accident that the late poet Allen Ginsberg wrote his most famous antiwar poem, "Wichita Vortex Sutra," while driving through this area in 1966. Another aspect of the beat generation—not revealed in the less-than-successful Whitney beat show (1996)—was how the burgeoning tendencies of this important literary and artistic movement came as much from the heart of the country as from the cities on the two coasts.

Wichita is a kind of beat place, torn between the Bible Belt and the aeronautics industry. It is a cattle town with a major rendering plant (a place where the innards of cattle are mechanically ripped out and the flanks are cut into steak). There is some good country-and-western music and occasional blues that drifts up from the Delta region. The land is flat. There are no mountains and no ocean. Though somewhat segregated from the white middle-class Christian communities, Wichita proudly carries the cultural traditions of native American, Hispanic, and African-American peoples. Wichita has a fairly decent middle-brow university (with a prize-winning basketball team) and a lot of public art, including one of the largest tesserae murals designed by the late Catalan surrealist Joan Miró. The people are generally friendly and usually courteous (in the manner of Bob Dole).

Wichita is a place to work by day and regard the stars at night. The sky is big, the light is bountiful. Sometimes the weather can be threatening: snow blizzards and tornadoes, flooding and windstorms. Yet the plains around the city offer a visionary landscape. The landscape can be so powerful as to sublimate the metaphysical

Bruce Conner, At the Edge of the World, *1995. Courtesy Curt Marcus Gallery, New York City.*

realities within one's daily routine—a form of denial that eventually becomes transformed into an overt reactionary politics. It is precisely this overlay or tension between the inner and outer, the metaphysical and the political—the full array of moral dualities as perceived in everyday work and play—that offers an oblique, though relevant image of the western cowboy, the newly unexpurgated American temperament at the end of this century.

It is here, in such an environment, that the intimate visions of Bruce Conner seem to fit. Conner is the iconoclast of an era, the proverbial artist ahead of his time. The surface of his work is beginning to be tapped, thanks to the efforts of Mr. Johnson and Ms. Kirkeby and their many devoted sponsors and assistants. What I find refreshing in Wichita is a lack of overt cynicism about art. These people seem to care about art as a means toward upgrading the quality of their lives. In such an environment, nothing can be taken for granted. Art exists as its own reality—and that is enough.

Rauschenberg: Supply Side Art and Canoeing

In an interview late in his career, Marcel Duchamp made a witty and accurate comment about his readymades (1913–21) by asserting that in choosing one or two a year he still had plenty of time for something else. The "something else" in this case might have referred to the fact that he was working on his masterpiece *The Bride Stripped Bare by Her Bachelors, Even* (1915–23). On the other hand, Duchamp may have been implying something more mundane, such as smoking cigars and playing chess—two activities for which the artist became well known.

This apparent nonconflict in the career of Duchamp undoubtedly had some impact on Rauschenberg's famous statement in 1960 in which he asserted that he chose to act in the gap between art and life. Specifically, Rauschenberg was citing his combine paintings from 1955 to 1961 in which he took actual objects—not brand-new objects, but detritus from the street outside his Bowery loft—and recycled them in relation to abstract expressionist brushwork on his canvases, works such as *Monogram* (1955–59) and *Winter Pool* (1959).

The problem today is quite different from the aesthetic breakthrough Rauschenberg made in the fifties. Instead of the neo-dada "junk aesthetic"—evident in the late fifties among artists such as Richard Stankiewicz, Boris Lurie, Sam Goodman, Robert Mallary, the Swiss sculptor Jean Tinguely, and, to some extent, Lee Bontecou— Rauschenberg has moved on to new territory. This new territory is more related to the excess of popular culture, the overflow regime of late capital, the unutterable heaps of printed imagery that bombard us day in and day out.

This is particularly evident in *¼ mile or 2 furlong,* a piece shown originally at the Metropolitan Museum of Art in the late eighties and more recently displayed at the Ace Gallery at the time of Rauschenberg's Guggenheim retrospective. There are endless fabrications and associations that the viewer can make with the juxtaposed images and objects. One may become convinced rather quickly that in spite of the developments and innovations in conceptual photography and minimal art, as well as postmodern lack of resolution within a compositional/pictorial space, somehow Rauschenberg got there first.

I am willing to give Rauschenberg credit for a good deal that has happened in contemporary and postmodern art over the past four decades. The problem with this gargantuan Guggenheim exhibition is not at all related to the artist's remarkable innovations in contemporary art. Rather, the problem is in how one makes a selection as to what is significant and what is not. One can always retreat to the famous Kierkegaardian position that aesthetics are easier than ethics. That is, one can readily see an aesthetic object or a "beautiful" association between objects—a trait well known in the Rauschenberg legacy, although purloined from both the dadas and the surrealists. The real problem is in the selection, the ethical position as to what has significance and what does not.

It is well known that our transglobal culture is fraught with image bombardment. Is Rauschenberg merely reflecting this condition or is something transformative in the process of happening? I would argue both ways. I dislike the fabric work with poles that the artist made at the end of the seventies, but very much like his more recent *Anagrams* (1996). I am a great fan of his *Currents* (1970) but am less drawn to many of his collaborative works done in China in the late eighties. Critical distance, as always, becomes the key.

Then there is the wonderful film, shown perpetually outside the Guggenheim SoHo during the retrospective, called *Canoe* (1966). This is a humorous and profound and absurdly beautiful work—a rare film work—that connects with not only the activity of experimental filmmaking in the mid-sixties, including Warhol, but also connects with Rauchenberg's collage aesthetic, the place where the artist's career blossomed in the fifties. I first saw *Canoe* some fifteen years ago. I cannot recall exactly where I saw it, but I do recall being mesmerized. The editing technique appeared, in the tradition of the best Rauschenberg works, aleatory; that is, based on chance operations. *Canoe,* however, is not spatial, but linear. It is about a recreational sport—canoeing. The film is in black and white. (At the Guggenheim, it was transferred to video and shown simultaneously in three vertically positioned monitors.)

The absurdity of the activity in *Canoe* offers a real statement on postmodern life where the lack of resolution becomes an acceptable fact of being in the world. Men load the canoes with supplies and then proceed to paddle through the "white water." It is amazing the way Rauschenberg has cut the sequence back and forth so that the sequence is entirely out of sequence, yet completely engaging and hypnotic. *Canoe* represents the best of Rauschenberg; and at the Guggenheim, Soho, it represented a point of view that clarified the entire venture of this retrospective. It was a democratic installation; anyone, any passerby, could see it at any time of day. In doing so, one gets the message of Rauschenberg: that we live in a collage world, and that we might as well enjoy it.

We can enjoy it, but we can also select what is significant within the process of enjoying it. It is within the province of the artist to deem what is significant with the ecstatic play of imagery. There is no better artist to do it, but the curatorial rigor is often what is missing. At least, this is where I felt the lack in an otherwise illuminating and provocative body of work by this remarkable and inspiring artist.

Nancy Graves:
Translucency

When Marinetti wrote his "Futurist Manifesto" in 1909, he espoused that "a roaring car that seems to ride on grapeshot . . . is more beautiful than the Victory of Samothrace." What may strike the reader about this phrase is the violence of its opposition, the defiance of the past. Marinetti was subject to a kind of overdetermination, working from a certain cultural sense of inferiority. It was not a question of how to evaluate Italy's great art-historical achievements; rather, it was a question of whether or not Italian culture could face the future without being intimidated by its own sense of the past. In essence, Marinetti was profoundly affected by the encroaching industrialization of the north and was seeking an aesthetic means by which to cope with it. Put another way, he wanted to come to terms with art history in relation to the present culture at the outset of this century. In order for this to occur, a certain denial was necessary. This denial was about bracketing the past—shoving it out of the picture, so to speak—in order to envision the mechanical reality of the future as art.

I allude to this situation at the beginning of modernism in order to suggest something about the sculpture of Nancy Graves. In one sense, it could be said that Graves has been engaged with a certain aspect of Marinetti's project, but in an unexpected, in fact, an unpredictable way. As we approach the end of the millennium, and presumably the end of a century of modernism, Nancy Graves has emerged as an artist whose archaeological sensibility offers us a new record of the present in relation to the past. She is not beholden to the machine age, as was Marinetti, but she is endowed with another psychosociological reality, namely, the information age. Her sense of the archaeological is a sense of being in the present while excavating the layering of historical evidence, the traces of images from other cultures in other times, and in other places in the world. A wall ensemble, *While Embracing* (1991), for example, combines images from ancient Egypt and Greece, erotic images and secular images, signs of Eros and Thanatos.

Nancy Graves has been dealing with the problem of sculptural composition for over two decades. By "sculptural composition," I am referring to the notion that space in Graves's sculpture is raw material. To deal with space, the artist requires a sense

of the contour, a way of surrounding space, of capturing space; yet, concomitantly, the artist needs a manner for getting inside space in order to reevaluate what is given as virtual reality. If we are to heed the teaching of Gombrich, space offers a sense of identity, a cultural location for the self. What gives Graves's work its incredible presence is the tactility within the idea, a concept that is not merely in suspension, but one that is grounded in the reality of understanding space, her own spatial vocabulary.

Graves is fully capable of maneuvering her forms within space. Whether it be in a flat ensemble of diagonally poised canvases such as *While Embracing,* a light sculptural relief such as *Canoptic Legerdemain* (1990), or a full-standing, three-dimensional bronze, such as *Between Sign and Symbol* (1992), the spatial and tactile resonances are evident. They are never imposed or calculated. To understand sculpture as an organizing principle is partially a matter of design. Design exists as a means of refinement, but also as a way of stating a position. The position does not have to resort to didacticism; and, indeed, this is not the approach that Graves utilizes. She is not, by any stretch, a didactic or a moralistic artist. To call her work "formal" may have a certain accuracy. Formal, yes; but formalist, no. Graves carries a formal vocabulary that is well grounded. In this sense, she is like a good architect. She has a formal sense about her work. Yet, to have a formal sense does not imply that formalism is somehow the direction of the work.

What distinguishes Graves from other sculptors of her generation who are also possessed by formal acuity is that she looks beyond what is self-evident to what is hidden; that is, her concern for spatiality is the result of a certain gravity, a clarity of sensibility. Therefore, when Graves "appropriates" images and fragments from other cultures, times, and places, she is doing so on the basis of a formal/spatial vocabulary that is already secure. No appropriation will function adequately for Graves without the inner stability of a formal/spatial vocabulary. Her sculpture works because the tensions and balances work, but it exists as something more than a formal strategy. Graves is a sculptor who has grasped the scaffolding by which she can then build her statement. Thus, Graves's sculpture can appear completely au courant. She can be classified as both postmodern and multicultural; the point being that nothing is imposed, nothing is strategized. Making sculpture is not a social game. It is not about careerism, as it has become for so many artists who emerged into prominence during the art market of the eighties.

One gets the impression that the goal of Nancy Graves is to make sculpture as convincingly as possible. The basis of making sculpture is deeply formal in the sense that a sculptor needs a stable ground. If this sounds overly modernist in its connotation, then so be it. Graves emerged as a prominent sculptor in the late sixties—the era of late modernism. She knows her tools and her methods. She knows how to work with content and context. But in working with content, she has rarely mitigated her attention to form. With Graves, form is not a mystique, but a curiosity; in fact, a sculptural reality. To have a stable ground does not mean that one is necessarily outside the currency of the postmodern. What enchants the viewer who is sensitive to Graves's work is how poetic it is. The work is not about classifications or divisions between late modernism and postmodernism. The sculpture of Graves is an empathetic pursuit. She

has the capability of keeping in touch with certain psychological, aesthetic, and cultural realities. Her sculpture is not concerned with the fashionable. This is antithetical to what she represents. Her work is ultimately an intuitive evocation in which the structural process is simply felt. She has removed the weight from art history, and in doing so, she enters into a postmodern discourse.

In *Canoptic Legerdemain,* the poetic connotations are abundant. There are references to ancient Egypt—papyrus plants—and a fragment of Aphrodite from ancient Greece, traditional Japanese motifs, and Michelangelo's hand of God. It is constructed out of cast fiberglass elements, laser-cut templates, aluminum board, and other materials that are adhered and wired to one another and to the wall. The structural engineering of the piece is remarkable. Also, the piece is rather light in terms of its weight. This lightness operates both as a metaphor for the sculptural process, deployed in the conception and construction of the piece, and for the sense of relief from the burden of history. This latter point deserves attention.

Graves is an artist whose foundation was set, so to speak, well before the fashion for appropriation techniques became widespread in the early eighties. Her use of art-historical and multicultural references is not the sole foundation of her work—either in her flat two-dimensional paintings or in her hybrid reliefs or in her aluminum and bronze sculpture. The deployment of appropriation and quotational devices in her art is a consequence of her continuing search for significance, not through narrative, but through sign and symbol. One could say that her work is poetic, but not narrative. It carries a certain interplay of semiotic elements based on morphological juxtapositions and association. This interplay of quotational elements allows for a resonance through what semiologists call "deep structure." That is, the relationship of the bust of Aphrodite to an Egyptian falcon, or the crying head of Laocoön to the head of Empress Theodora at Ravenna, is not about conceptual linkages that have been preset or determined through some form of external schemata. Rather, Graves is dealing with these elements as an operable personal vocabulary of signs. As these signs begin to formulate a syntax and thereby achieve the status of a visual semantics, they may assume, as Samuel Beckett once suggested of Proust, autosymbolic meaning. This is to suggest that Graves is constructing her own context isolated from the history and the culture from which she has appropriated various signs. This is not to suggest that she is oblivious or blindly subversive in relation to her manipulation of visual language; rather, it asserts a layering of significance upon the formal ground she has already established as a sculptor in command of space. Primarily, Graves determines space in relation to form, then sign in relation to symbol. The action is an intuitive one in that it is dependent upon a process orientation to her work.

The foregoing explanation applies directly to her 1992 bronze and glass sculpture called *Between Sign and Symbol.* Superficially, this work has a resemblance to her earlier clock-sculpture, cast the same year, entitled *Unending Revolution of Venus, Plants, and Pendulum.* While the earlier piece has a utilitarian (and symbolic) function—in that it functions as a clock—the more recent work is purely visual and without kinetic components. The resemblance, however, is in the morphological association and interplay between the signs. The relationship of natural and constructed forms is apparent in

each. There are elements of Greek statuary, farm tools, filigreed evanescences, plants, discs, ropes, tribal-looking relics, Egyptian heads, fish, pedimental decorum, and more. The signs literally spill over beyond the scope of any rational cohesion.

One cannot expect to find rational cohesion in *Between Sign and Symbol.* It is the very absence of the rational that allows the sculptural presence of these forms to unify themselves intentionally within consciousness. This statement suggests a kind of phenomenology of the sign not unrelated to the perceptual mechanisms noted by Merleau-Ponty. To see *Between Sign and Symbol* is a matter of getting into an experience through the work's visual and material properties. By getting into it, one has to accept certain ground rules, and these ground rules are primarily formal. From the formal follows the linguistic notion of appropriation. This notion is basically poststructural. *Between Sign and Symbol* goes beyond the automatic and unquestioned sign value of the elements. Their semiotic connections are within the personal vocabulary of Graves's visual lexicon. The point being that Graves is not merely playing games with history and culture; she is creating an interplay of sign—transforming, through a consciously subversive effort, the automatic references that are attached to these signs. These signs from ancient Greece and Egypt, for example, run amok in Graves's recent work. They represent, in one sense, the birth of Western culture. They carry a certain a weight, a burden within consciousness, particularly within the feminist consciousness—in this case, the artist trying to alleviate the burden of these signs as they have come to reflect an oppressive view of history.

Graves's entry into the linguistic galaxy of appropriation through the visual sign is a display of intense fortitude. It is a form of representation that exceeds the limits of what is assumed in relation to the birth of culture. It suggests a certain repression whereby the artist is attempting to alleviate the flow held in check by the canon of critical acceptance. *Between Sign and Symbol* represents a passageway out of this historical repression, this burden from the past. It represents a moment of transition—the moment in which the historical sign is suddenly transformed into a personal set of symbols or whereby the signs are subsumed by the artist as a new interplay consisting of weightlessness; in essence, an alleviation from the burden of history, a moment of translucency, of ultimate aesthetic clarity, in which the past becomes the present as if the moment held the mirror of completeness and ecstatic delight.

Another central concern in the work of Nancy Graves since 1979 has been the interaction of color with form. One might attribute this concern to several factors. Probably the most significant is the hiatus that Graves took from sculpture from 1972 to 1978 in order to rediscover painting. The one exception to this exclusion of the three-dimensional was a continuing work out of fossils, eventually cast in bronze on a Cor-Ten steel base, called *Ceridwen,* and dated 1969–77. Typical of her interest in interior skeletal forms as simulations of natural history, *Ceridwen* is specifically derived from the front and hind leg bones of a camel as discovered from the Pleistocene period. In 1978, Graves returned to skeletal and other natural biomorphic forms, perhaps less literal than in the earlier period but with a delicately subdued concern for color. An example would be the variety of patinas used in *Quipu* (1978), a series of bronze-cast floor pieces made from thickly coiled segments of rope.

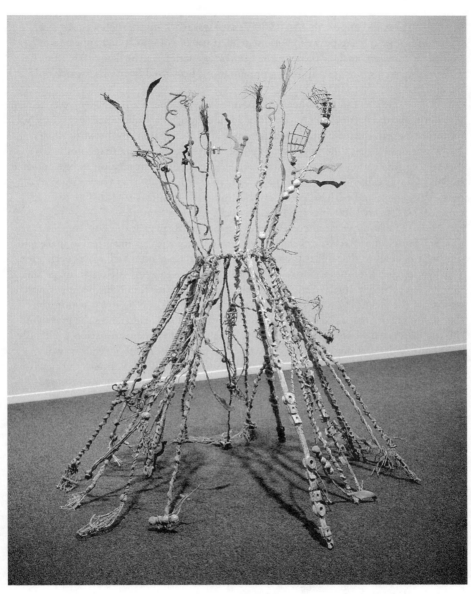

Nancy Graves, Quipu, *1978. © Nancy Graves Foundation/Licensed by VAGA, New York, NY.*

It would appear that by 1978 Graves was working through a process of trying to bridge the gap between a more explicit use of color as it had appeared in her pointillist canvases, such as those in the *Camouflage* series, dating from 1971, and her *Paleontology* series, being sculptural representations borrowed from observations of natural history.

Color, as Linda Cathcart has pointed out, has been a means by which Graves distinguishes one part of a sculpture from another and, in a paradoxical way, gives her sculpture a greater three-dimensional presence. This is apparent in the work since 1979, but not before. One might amplify this comment by saying that color lends a pictorial quality to her sculpture so that the elements "float" in relation to one another in what Graves calls "an energized space." There is little doubt that Graves's use of primary enamels and patinas has an extraordinary effect in this regard. The two versions of *Trace* from 1980 and 1981, respectively, are clear examples.

The latter version, currently on permanent display at the Los Angeles County Museum of Art, brings the viewer into contact with an imaginative space and symbolic coherence that defies the rather congested terrace on which it has been sited. The bronze-cast wire mesh, borrowed from illustrations in ancient Roman maps and notebooks, provides much of the quotational subject matter found in the uppermost regions of the ascending sculpture. There is an exuberance and lightness about *Trace* that defies gravity just as Marcel Duchamp's domain of the bride defies the gravity of the bachelors in his Large Glass (1915–23). The painted elements function to literally define the sculptural presence. In that Graves's sculpture since 1979 tends to work toward lightness and translucence rather than toward gravity (the camels, the carcasses, the fossils), the elements tend to be linear or to follow one another in a contoured spatial sequence.

This is also apparent in two works from 1989 called *Splendid Mental Isolation* and *Esthetic Dominance*. In each case, the construct follows a linear assemblage of parts in relation to spatial volume. Thus, the pictoriality is set up in relation to the spatial environment, whether interior or exterior. Like all significant form, the spatial counterpart never acts as a given but as something discovered or called into being. In each of these works, the three-dimensional volume is never static. There is a persistent dynamicism that recalls the legacy of the quoted artifacts, shards, and fragments from various cultural arenas.

Is Graves's playing hierarchical in relation to these multicultural sources? I think not. Rather, I would look for the explanation in terms of alleviating the burden of a cultural hegemony. There is nothing about dominance in the volume of these pieces. There is nothing to suggest a hierarchy of one form over another. It is, in fact, the rhythmic flow that achieves significance through the act of perception.

As stated before, it is the phenomenology of perception that occurs in relation to following the variables and the permutations of the linear construct as a pictorial experience. Color is essential to this rhythmic flow. In many ways, color substitutes for volume. The lightness of the aluminum implies a reflective surface, a light sensitive surface; yet the planar elements are always minimized. It is not so much a play of planes as it is of lines. Within the abrupt interstices of the linear flow, one may

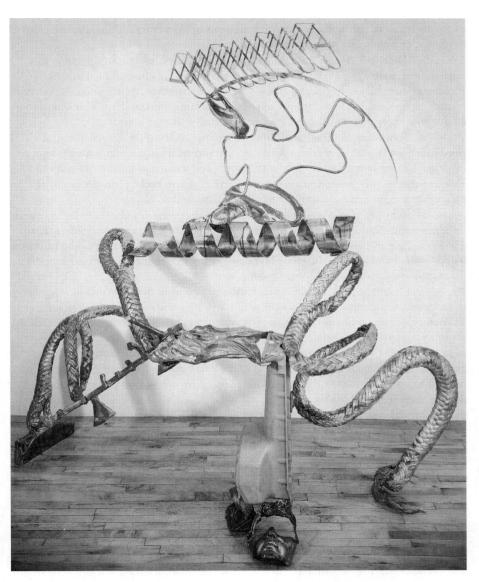

Nancy Graves, Esthetic Dominance, *1989. © Nancy Graves Foundation/Licensed by VAGA, New York, NY.*

catch the traces of cultural remains—of fragments of garments, of appendages—signs of ecstasy, of indulgence, of rumination.

There is a certain Romantic intrigue about these pieces, an undeniable resistance to the gravity of the past; yet history echoes throughout. The resonance of *Esthetic Dominance*—a wonderful title—gives way to another layering, another circumstance, where meaning is not simply referential, but fully postmodern. This offers a language of signs, but, at the same instant, a diffusion of that meaning.

To understand these sculptures is a matter of attuning one's vision to their rhythmic flow. It is an aesthetic experience—a traditional notion that a special kind of experience exists in relation to the dictum of the eye, a concept borrowed from the Enlightenment. It is the notion that somehow the eye can evoke pleasure, and that pleasure can exist in visual terms. Other critics have spoken eloquently about Graves's equivocation between inspiration and technique—that there is a craftlike elegance both in her sculpture and in her recent painting ensembles, such as the remarkable *Magnetic Plate of Calls and Answers* and *In Care of Solitude.* This artisanry—quite evident in these works—is not simply an indulgence that denies the intention; rather, the artisanry is a means toward achieving an effective palimpsest.

Linguistic philosophers from Umberto Eco to Jacques Derrida have spoken in terms of the palimpsest—the case in which writing occurs over writing—a kind of archaeology of signs. Instead of the linear sequencing of signs in terms of grammatical meaning, the palimpsest offers a density, a layering, where meaning retrieves unexpected references from a lost past or a forgotten future—where the sign of writing becomes the writing of the sign. It seems to me that Graves's *Magnetic Plate* is such a work. The visual rhythm of the work is never forsaken; yet, within this rhythmic density there is embedded a particular kind of language, a palimpsest. The meaning is sensed through a syntactical energy that echoes through the past into the future. The writing never stops; it is continuous. The mystery is never eluded, but is eternally present.

One could speak of the delicacy of the tracery in other works as well. The aluminum cast ropes that symmetrically bridge *Esthetic Distance* could be read as snakes—redolent and dynamic, pulsating as they weave a hallucinogenic vision around and between other machine parts. There seems to be a struggle between the refuse of industry and the organic magic of nature that continually intervenes. (Duchamp once made the comment that his Large Glass consisted of geometric elements and visceral organs.) The energy is a real factor—the "dynamicism." Is it no wonder that Calder and David Smith played a fundamental role for Graves in her years at Yale. The intuitive sense of structure is unmistakable—a structure that seems to reside within the unconscious, one that cannot be rationalized or predetermined. (Is this why Duchamp gave up working on his Large Glass—too much predetermination?) Yet, *Esthetic Distance* is not simply about a mystique. It is evocative of structural parameters that are not readily available in the mundane world. Aesthetics is not a part of everyday life in the late twentieth century. This is a fact. For a work of art to evoke feelings that exist beyond the mundane is a considerable feat.

The intuitive structure in *Esthetic Distance* is a matter of seeing its lightness,

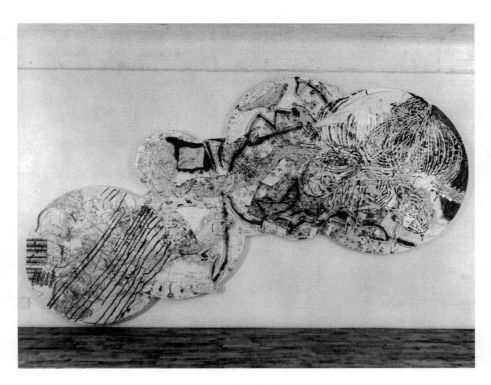

Nancy Graves, Magnetic Plate of Calls and Answers, *1991.*
© *Nancy Graves Foundation/Licensed by VAGA, New York, NY.*

of seeing translucency through opacity, of getting the idea through feeling, of sensing the work's wholeness. (Whereas the metaphysics of the past, including futurism, may have searched for light, the postmodern mode would be more about lightness.)

It is a matter of traversing the opaque distance between sign and symbol, as Graves would have it, and of arriving at some inexorable place, some ecstatic insight. The contour drawing is a reasonable prototype for the recent work of Nancy Graves, the drawing in space that knows gravity and yet knows its opposite, its pattern into flight. I am reminded of the early paintings of the Italian futurists again—Balla's study of birds or Severini's interpretation of light—or Boccioni's bronze sculpture *Unique Forms of Continuity in Space* (1913). I am reminded of the dynamic feeling and lightness inherent in these works. (Marinetti once considered "dynamicism" and "electricism" as alternative names for the movement, but eventually decided on "futurism" as being most expressive of his concept.) Then there are the photographic studies by Muybridge and Marey—the former being an acknowledged source of inspiration for Graves.

Again, there is the emphasis on the kinetic, the mobile, the concept of movement through time and space. Muybridge pursued his concept of human locomo-

tion, through what he called zoopraxology, in the 1880s and 1890s. Much of his attention was given to the modular seriation of the human animal: how human bipeds walked, skipped, ran, rode a horse, etc. In spite of Muybridge's scientific authority, there is a passion about these images that is immediately startling and recognizable. This passion—a difficult term to explain, yet somehow innate to some of the greatest accomplishments of our time or any other—may have something to do with the desire to defy gravity. The recognition of gravity as a condition of human life and, formerly, of human history has a certain reality, yet now we have surpassed that assumption. Flight is now as much of a condition as gravity.

For Nancy Graves, these might operate as extended metaphors. The tension between these forces is the tension between the recognition of oppression and opacity in relation to liberation and translucence. The symbolic language of Graves is toward the latter state of mind. Her bricolages and reassemblings of historical and cultural fragments are about a celebration of what is possible when the mind is liberated from the hierarchies and oppressions of the past.

Bill Viola's Simulated Transfiguration

The video installation at the Guggenheim SoHo during the late winter and early spring of 1998, entitled *Bill Viola: Fire, Water, Breath,* has had a strong experiential impact on its audience. For many who have seen it, the visual force and scale of the piece has been extraordinary, perhaps even overwhelming. On all levels of the critical hierarchy, throughout the art world, whether at the top or on the bottom, whether in New York or in Europe, there is a consensus that Viola's video installation is a technical and performative triumph.

But is it a triumph as art or simply another manifestation of popular culture? Does it have something in common with *Evita*? Or with late-nineteenth-century French symbolist painting? Or maybe the blatant sentiments of Pre-Raphaelite painting? Or possibly even the late salon of Bouguereau? Perhaps it is a combination of both cinema and painting, an ecstatic (semiotic) conjugation of some sort, expertly tuned in its electronic aura.

Given its scale and its relationship to the flat screen, *Fire, Water, Breath* functions very much like cinema in spite of its dematerialized presence as a video installation. What makes it suitable to the gallery or museum in contrast to the movie theater is its spatial context; that is, the way the viewer is supposed to confront these moving images. The work is actually composed of two separate works: one is a two-channel video work called *The Crossing* (1996) and the other is a single-channel piece called *The Messenger* (1996).

In *The Crossing,* a walking male figure moves from the horizon toward the viewer in slow motion. This action occurs simultaneously as two projections occur on two separate screens. The screens are free-hanging and parallel to one another, yet several feet apart. Once the figure reaches a certain proximity, he stands facing the audience for several moments. Then the action begins to occur: In one projection, a single drop of water falls on the performer's head, while in the opposite projection a fire begins to appear at his feet. Gradually, the drop of water—referring to an early Viola installation from 1976, entitled *He Weeps for You*—becomes rain, and eventually becomes a veritable deluge that obliterates the presence of the figure. Concurrently, the

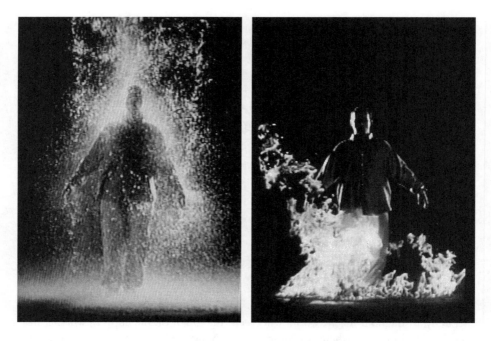

Bill Viola, The Crossing, *1996 (details of video/sound installation). Photo: Kira Perov.*

fire becomes a roaring conflagration that also appears to obliterate the figure. As the rain falls down, the fire goes up. As the deluge subsides to a trickle, one notices the absence of the figure. As the conflagration subsides to a few embers, the disappearance of the figure is also evident.

At the opposite end of the downstairs galleries, *The Messenger* narrates an equally simple structural drama. By "simple" I am not suggesting that it is simplistic; rather, the structure of the image is open enough to impart considerable literary connotations. In *The Messenger,* a larger-than-life male nude gradually emerges from a pool of water. One confronts the figure's head and torso poised diagonally and floating in a supine position on a single large screen. Gradually, the figure begins to subside beneath the water again in slow motion until he virtually disappears.

Given the Romantic inclinations of the British (and the self-conscious reaction to it, i.e., the Art and Language Group), it is little surprise that this work was commissioned by the Durham Cathedral in England. The correlation between romanticism and religious inspiration is clearly evoked in works of the early-nineteenth-century poets Wordsworth, Shelley, Byron, and Keats. To see nature was to experience the presence of the divine. Later, John Ruskin would acknowledge the representation of the figure as a symbol of the embodiment of divine grace. From an American context, I see *The Messenger* as an attraction not dissimilar to the kinds of large-scale evangelical spectacles that pervade southern California—in places such as Garden Grove where one

can attend a drive-in church or the quaint little chapel at Knott's Berry Farm where an iridescent painting of Jesus suddenly opens and closes his eyes or the enormous mural at Forest Lawn Cemetery representing the Martyr at Calvary.

Fire, Water, Breath gives a convincing argument for the power of the spectacle. Whether it be from the position of Guy Debord's Marxism where the spectacle represents relief from the pain of capitalist exploitation, or something that can visually simulate the concept of spiritual power and awakening. On another level, *The Messenger* is not far distant from the theosophy of Mondrian as seen in his early triptych—also intended as an altarpiece—called *Evolution* (1911).

Religious spectacles are meant to provoke human emotions from the simulation of the spiritual to the abstraction of political power. The general intent is to offer a convincing emotional context for some sort of uplifting feeling. Still, we cannot forget that this "uplifting feeling" is as fleeting in the cyberspatial era as Madonna's *Evita*.

Viola's work exists on the level of a neometaphysical apology, a spectacle, that heralds a certain righteousness of being through spiritual materialism. *Fire, Water, Breath* is a triumphant articulation of our puritan legacy. It is a work steeped in Eurocentricism, though borrowing heavily from primitive sources and myths. The fact that it borrows from these overused sources does not make it a specimen of the real, nor is it universal in the sense of a multiculturalist metalanguage. Viola's work is pure fiction—a fiction that leans toward narcissism, a form of self-indulgent religiosity.

I read Viola's video spectacle in the context of some kind of "universal" metaphor, a transfiguration of mind and body that has been given a high-tech, state-of-the-art sleight of hand. The message is still the medium and, in this case, *Fire, Water, Breath* transforms the space by representing a ritual about the cleansing power of fire and water. It represents a simulated apocalypse, one that has been systematically ordered through electronic manipulation, and thus given a new kind of museum aura.

Kevin Clarke: Signs of Loss and Intimacy

In this market-driven art world of the nineties, where spectacle builds upon spectacle, where artists compete to discover greater images of abject reality, produced on the basis of shock and allure, where the status of capital leaves little room for unwarranted or deeply felt interruptions, it is always a wonder to encounter work that goes in the other direction.

I am speaking of a kind of art that is so entirely confident and self-possessed that we are moved emotionally by its presence, by the very act of seeing it. This kind of experience almost always occurs without the outward trappings of a projected narcissism. It is an experience that simply lifts the mind and heart into another level of reality.

A hundred years ago, this phenomenon was called an aesthetic experience. Now, of course, in this accelerated information age of the hyperreal, it might be termed differently. Yet, I am convinced that the potential to have an experience through art that will transport the viewer to another sensory level still exists, regardless of the words used to describe it. (When it comes to feeling, language persists in keeping us all in a quandary!)

An aesthetic experience suggests something more than mundane events; yet, in the most expansive postmodern sense, aesthetics does not have to be exempt from the political or the ideological, the mystical or the beautiful. If the aesthetic experience signifies a sensory reality on the most personal level—which I believe it does—then it implies a gamut of emotions: some pleasurable, some less than pleasurable, some thought provoking, some profoundly spiritual, and some psychologically penetrating.

To evoke the emotion of grief or grieving in a work of art is not an easy task. Pleasure is far more accessible, whether in Matisse, Bonnard, or Frankenthaler. But grief is something else. The Renaissance masters found the means to express grief in their frescoes and altar pieces through the litany of the Church. Giotto, for example, or Simone Martini or Masaccio. In the century of modernism, some artists have turned to abstraction as a means to express deep sorrow and to communicate their feelings more directly. There is a fine line of self-indulgence here that, from a retrospective point of view, exists as pure speculation. Was Rothko or Pollock self-indulgent? Or is the con-

tent of their greatest paintings so deeply personal as to imply suffering or deeply conflicted disturbances? Can we immediately project this content away from the specificity of feeling into some vague metaphysics? This, of course, is a theoretical issue and has little to do with any aesthetic response.

To make grief convincing as subject matter in art requires letting go of mundane conceits and the overt representation of self-consciousness. It requires a sense of passion and compassion. The ability to express grief is concomitant with the ability to give and receive; to empathize, to identify with the emotional state of the other or the beloved. In this sense, the expression of grief is fundamentally an act of love.

In art, the expression of grief also requires a heightened maturity as an artist, a certain degree of virtuosity and a comfortable command of one's visual vocabulary. It is an expression that goes beyond adolescent cynicism. At times, when the grief is so strong, so indelible, the artist may need to get at the feeling through some indirect means, some oblique angle, where the inner resource of one's emotional being is pushed beyond the limits of one's own understanding.

Seeing the small exhibition of color photographs by Kevin Clarke at Tricia Collins Contemporary Art became a catalyst by which to feel art on another level—not just a formal or theoretical or expressionist level, but to feel art on the level of a specific content. My experience with these photographs extended beyond the appearance of things, yet at the same moment was deeply embedded within the visual structure of the act of seeing.

Kevin Clarke is a well-known artist/photographer and author of photo-essays published in the United States and Germany, including *The Red Couch: A Portrait of America* (1984) and *Kunst und Medien, Materialien zur Documenta 6* (1977). The overall theme of the current exhibition is the deeply felt love between the artist and his wife, Janet Hasper, who died at the age of thirty-eight of breast cancer a few months earlier. She was also the mother of their two children. Clarke is exhibiting this simple, yet extraordinary, series of seven digital Cibachrome panels in the White Room of Collins's gallery.

Rather than prints of the subject (who wished not to be photographed during her illness), Clarke focused on the environment both in the hospital room and outside the hospital. He misused the Cibachrome process to create negative images—the reverse of what he was seeing. The result is a photographic process that carries a close affinity with Clarke's internal reality as he sat with his dying wife. He eloquently describes this reality in the accompanying catalogue, an excerpt of which is worth quoting:

> The photographing wasn't important, and when it happened, it happened in that parallel time that photography happens in—those split seconds between anticipation, random capture, the moment you decide to accept all your decisions; the framing, light, exposure values, and you just get on with it, you click the shutter. Knowing how to make pictures, I decided not to think about these things, to shoot it all a bit wrong, to develop it wrong. The place was functional, the weather incidental. Only Janet mattered and she was slipping away and drifting back and writing

Kevin Clarke, The Couple, *1997. Courtesy Tricia Collins Contemporary Art, New York.*

me a note and gesturing for something she needed and smiling and then resting for a while.

These are some of the most poignant and memorable images of loss I have ever encountered. Clarke's photography summons a certain innocence and wisdom in the same breath. A lingering absence is transmitted through the medium of the camera, the film and its exposure to light. There is a pervasive condition of silence in the world, and he is the witness to it. Desire is constrained by absence. The images of buildings outside, for example, do not so much as capture these feelings, but reflect them. It is as if every picture had an echo, a memory that something was fixed in the continuum of time.

The *Vernal Passage*, as Clarke has named the suite, grabs you. It takes hold of you and makes you feel, feel the instant transmitted in these dark signs, these intuitive moments of rarefied beauty. We see darkness in the color reversals, but we also see the light. These negative images are not about despairing so much as sadness, a shared sadness, and an unremitting tenderness. This is an exhibition like few you could have seen in 1997. It is not a spectacle, but a testament to the reality of intimacy. It reveals the power of art to communicate a glimmer of what it means to love in a world caught up in the banalities of marketing, media, and mindless excess.

Michael Bramwell's "Conceptual" Sweeps

I met Michael Bramwell in the summer of 1994 during a three-week residency at ART/OMI, an international artists' workshop in upstate New York. As a visiting critic, I had been invited for the purpose of meeting the artists and discussing their work. At the time, Bramwell was sweeping the concrete floor of a large barn that had been converted into a series of studios. When I asked him what he was doing, he replied that he was "making art." We began a conversation that included a number of issues ranging from the division of labor in a capitalist system to theology, from conceptual art to the status of African-American men in American society. The discussion continued well into the afternoon.

Since then, I have followed Bramwell's career both on the national and international circuit. I would characterize his approach as one of making conceptual actions; in simple language, he is doing common everyday routines, particularly sweeping, in various public situations. Often these situations carry specific social, psychological, and political assumptions. For example, at ART/OMI he was a participating artist in an artists' workshop; yet he had delegated himself to maintaining the premises of the studios. In this way, Bramwell is questioning the kind of routine that is often given to African-American men. The psychological aspect of Bramwell's work is of particular importance and brings a curious aspect to his style of performance. He engages people in conversation as they observe him at work and thus brings out the nature of the observer. At the outset, there is often the fear of the unknown. Why is this African-American man sweeping? What does it mean? Why is it art?

Bramwell's dedication to his work reminds me of a comment reportedly made by Alfred Barr, the founding director of MoMA, to the young painter Frank Stella upon seeing the artist's early "black paintings"—something to the effect that Barr did not understand exactly what Stella was doing, but he admired the commitment. In the case of Bramwell, there is not only a commitment, but a coherence that is found in the best conceptual art. In fact, I would go so far as to claim that Bramwell's work gets better with time, and not only with time, but in time. The late performance critic Michael Kirby once wrote a book called *The Art of Time* (1969) in which he discussed

the kind of "nonacting" that requires time. Kirby was talking about time in a very literal way. In the case of Bramwell, in order to sweep, he must be engaged in real time—a literal situation. He is not acting, yet he is performing. One has to acknowledge that he has gone far beyond the static object that is normally identified with art. He has gone further than the obvious significations given to most performance art these days, particularly when the art presumably concerns some aspect of identity.

Bramwell is a performance artist who sweeps. When he performs, he wears the normal attire of a custodian. He is engaged in what the artist Allan Kaprow once referred to as "nontheatrical" performance and what Michael Kirby termed "activities." There is no audience necessary for Bramwell to do his art. One can accurately say that most people would not even recognize what he does as art. He performs a task—doing the task as if it were his job. In fact, it is a job, but it is also his art. It is a job because it involves hard work, tedium, and real physical labor. It is art because Bramwell is making a statement. The statement is a comment about how we might regard someone in the position of a custodian, how we might ignore the human aspect of the person behind the broom.

There have been some curious antecedents that have preceded Bramwell, works by artists that also involve sweeping. One was by the so-called maintenance artist Mierle Laderman Ukeles who worked with sanitation workers in public buildings in New York over a period of several days in 1976. Another was the San Francisco artist Jo Hanson who discovered that by sweeping the sidewalk and street each morning in front of her house in a run-down urban neighborhood, the rate of crime was reduced dramatically over a period of a year.

Bramwell takes the act of sweeping one step further. His work moves in a more psychosociological direction. It is not just that he is an African-American man sweeping the floor, but he is sweeping in order to emphasize the presence of the person who sweeps. It is this symbolic presence—regardless of what space, what time, or what cultural background—that makes what he is doing art. It is an act of contextualizing the place and empowering himself in the process. As he once explained: People from whatever race or cultural situation tend to hold on to their memories of personal tragedy or the tragedy of their people. This becomes a form of identity—an identity that separates one group from another. Bramwell refers to the "ways of separation" that cause one racial group to deny another. "Rather than see the tragedy as an African-American one or a Jewish one or a Japanese one," says Bramwell, "would it not be more fruitful to understand these tragedies as human tragedies that have the potential, if realized, to make us more human so that we can better understand one another?"

I find Bramwell's message—whether he is performing in New York, Hiroshima, or Auschwitz—an important statement for our time. Indeed, he has worked in these and other places loaded with the tragic side of the modernist dilemma where mindless ideals led to warfare without acknowledging the human beings that suffered for no reason. Bramwell has caught something in his work that we cannot afford to ignore. He is diametrically opposed to the cynicism of the present era. His art is about hope. It is about not giving up.

Like the best art of other eras, it is a silent art and yet so far beyond the

trends and market-driven spectacles currently being shown in respectable, obsolescent art world institutions—spectacles that represent the end of the art world. Bramwell's "conceptual" sweeping represents the past, the present, and the future. It is an art of time. It is an art that helps us remember who we are in relation to one another, or—as Bramwell puts it—not what separates us, but what makes us whole. Ironically, his art is a revival of heroic form—accomplished not through extravagant material, but through simple means, an utter economy of means. Neither bronze nor marble, Bramwell's art is a kind of living sculpture where art and life connect on the same level. This suggests that both the experience with the work and the dialogue with the artist are all-important. Bramwell is aware of this, and prepares himself for it by going to the limit of absence in art and by giving the impression of self-effacement. It is within this disappearance that the observer comes forth and tells his or her own story—face-to-face with the racial fears that have lingered so long within our history. Through the absence of sweeping, Bramwell brings out the observer—out into the light of day, away from the racial fears and bigotry of the past, into the new possibility of the present.

Philip Glass:
The Photographer

In browsing through a collection of photographs by the late-nineteenth-century zoopraxologist Eadweard Muybridge, one is immediately struck by the logical association to the music of Philip Glass. The title of the book is simply *Animal Locomotion* (1887). Each sequence of photographs is constructed within a grid and constitutes a specialized study of either an adult male or female in the positions of walking, climbing, running, dressing, lifting, bathing, jumping, or performing a multitude of other mundane activities or chores. The figures are either partially clothed or naked. Occasionally, there are photographs of children as well—an infant crawling, a toddler running.

Were it not for the pretense of science, one might refer to these examinations in terms of an obsession. Apparently, there are hundreds—maybe thousands—of these photographs taken by Muybridge from different angles, using different lenses, offering varied perspectives and points of view of men and women posing and performing in front of the lens. They appear as pictograms of the culture of diurnal work and play. There is something fundamental about these photographs, some basic truth—an odd summation, perhaps, given their allegiance to structuralism. Yet there is something ineluctably moving about these studies of the human animal. They are capable of eliciting an emotional response, a particular sensitivity. It is, perhaps, in this spirit that Philip Glass chose to work with these images as signifiers of time, specifically modular time, the kind of tempo that connects with a structuralist sensibility or raison d'être.

Indeed, the modularity of Muybridge's zoopraxological photographs, taken in the latter part of his career after the famous duel in which he shot and killed his wife's lover, is the formal affinity upon which the opera *The Photographer: Far from the Truth* was based. The production premiered at the Brooklyn Academy of Music on October 4, 1983, and was directed by JoAnn Akalaitis, choreographed by David Gordon, written by Robert Coe, with set and costume designs by Santo Loquasto.

If one is to question why the composer Philip Glass decided to become involved in writing a score for an opera based on the later career of Muybridge, it is clearly because he felt a connection with the structuralist parameters inherent in the

work. Glass has an association with advanced visual artists, particularly with minimal art and structuralist filmmaking. For example, the playwright Richard Foreman has compared the early music of Glass to the films of Canadian artist Michael Snow.

One might say of the later sixties in New York that the idea of structuring reality according to principles of modularity and repetition in a disinterested context was simply "in the air." There are numerous examples ranging from the sculptor Don Judd to the conceptual artist Sol LeWitt to the "white paintings" of Robert Ryman. The metaphor of Muybridge's visual taxonomy in relation to Glass's approach to music—as with other artists working in their respective mediums—suggests that the composer was not simply illustrating a dramaturgical event, but was engaged in these structurated photographs on a deeper level.

It is interesting to examine Philip Glass's development as a composer and musician before and after the success of his first operatic piece, *Einstein on the Beach,* co-authored with Robert Wilson in 1976. In the late sixties and early seventies, the sound of Glass's music was closely aligned to minimal art. The building and repetition of phrases, the playing in unison, and the logical progression of sound textures were all made explicit and existed as key elements in his performances.

In recent years, Philip Glass has ostensibly expanded his idea of "process" or "phase music," as it was sometimes called, by taking it into more complex permutations. Glass's relationship to performance is still integral in his approach to composition, but at times the complex layering and diversity make for an unevenness in the transition between passages. The cumbersome aspect of these transitions is uncharacteristic of Glass's earlier structuralist works. This suggests that the music heard in a performance (that is also seen) has a different effect than the same passages heard on a recording. There are other interesting examples of this problem as well, both related to operatic collaborations and to his recent film scores.

In his 1983 CBS recording of music for *The Photographer,* Glass no longer adheres to the purely systematic progression of sequence. His phrases do not develop in a steady line. Instead, they build for brief intervals and then shift abruptly into other modes of repetition. There are both vocal and instrumental components interacting in relation to one another. The structural device here is indeed more complex, but it holds less of the pervasive tonal evolution found in earlier works, such as *Music with Changing Parts* (1971) or *Music in Fifths* (1969).

In these earlier compositions, Glass's variations on a musical structure stress fundamental principles of composition that may be more radical as a truly innovative departure from traditional Western music than the more operatic and cinematic works. One might consider that any radical departure in musical composition or, for that matter, any other art medium or intermedia structure, is not exempt from qualitative standards even though it may significantly shift the criterion of evaluation to another level. The critical concern raised by *The Photographer* is the degree of significance this recording has when compared, for example, with one of the last pure structuralist recordings like *Music in Twelve Parts* (1974).

There are some exceptional moments, however, to be heard on the selections chosen by Glass for the recording of *The Photographer.* Occasionally, the shifting

structural lines really work, and when they do, they reveal some of the composer's most interesting work since *Einstein on the Beach*. One cannot help but acknowledge exhilarating and heightened moments in Glass's performance in *The Photographer* with or without the visual effects and set designs. The rhythmic momentum achieved in the instrumental section toward the end of act 2 and the virtuoso violin by Paul Zukofsky in act 3 are both exemplary in this way. In such passages, the spectrum between structuralist and Romantic music does not seem so wide. One gets the point of Glass's systemic rigor and overlayering complexities as bringing these two disparate antipodes together.

On side one of *The Photographer*, there are two versions of a motif called "A Gentleman's Honor." The first is a vocal arrangement and the second is primarily instrumental. Glass's vocal section makes for difficult listening in that it splits the musical texture into two discrete components: a metaphorical narrative—which in its insistence appears forced—and a progressive modular and modulating structure. The problem is that the voices do not harmonize adequately within the system. This is true in parts of other works as well, including Glass's recent soundtrack recording for the film *Koyaanisqatsi*.

Where the vocals do succeed in *The Photographer* is when the libretto is purely phonetic as opposed to its generally failed attempts to make meaning. Even so, one senses a conflict in the vocal section of "A Gentleman's Honor," for example, where Glass tries to keep the lyrics "anonymous" and then uses repetition to somehow instill a metaphorical content within the theatrical event. By attempting to keep the vocals anonymous—as if to create a vocal counterpart to "systems aesthetics" (a term attributed to the critic Jack Burnham)—in the same way as the instrumentals, Glass overrides the possibility of lending an emotional ingredient to the score.

As previously suggested, the conflict is truly interesting when structuralism and romanticism are hinged and even begin to merge. This is one of the most original contributions offered by Glass, but does not appear fully developed until some years later. Put another way, the composer uses conflict within the score without forcing a resolution—specifically when it does not appear overdetermined as it does in the vocal section of "A Gentleman's Honor."

In following suit with minimal art, the early Philip Glass was apparently against any reference to subjectivity in music; it was more about the pragmatic structure. The problem of vocals had not entered in—not until *Einstein on the Beach*. With *The Photographer*, seven years later, the problem of emotional content in Glass's music was still unresolved. Yet, the tendency of moving more overtly toward the Romantic was clearly in place.

Glass's career since *The Photographer* has shown the composer's remarkable ability to transform the conflict, so profoundly felt within this work, into a more relaxed position. One may even talk of two distinct approaches in the music of Philip Glass: that which works best as a recording, and that which needs to be heard in the context of a performance. This is the crux of the conflict in *The Photographer*.

IV. Issues

After the Deluge: The Return of the Inner-Directed Artist

I first conceived this essay while attending an exhibition of paintings by the French-born artist Jacques Roch at Exit Art. What struck me about Roch's paintings was a quality of directness that had some link to André Breton's notion of psychic automatism. It was the quality that Breton himself once articulated in relation to the early paintings of Joan Miró. What is this quality? One might describe it as a kind of visual play on language, or, perhaps, the dissembling of language by way of visual play—the irrevocable linkage to the unconscious that emits a certain directness of sensibility, a certain memory that is buried deep beyond conscious, visible recognition. Roch's paintings left me with that impression. They were playful, but, at the same time, seriously involved in concretizing a vision or gesture that could have easily slipped from consciousness. With Roch's paintings, the brilliant color and pervasive gestural dots had a courageous resonance about them. Why these dots? Purely decorative? I think not, though I once considered it. The figures are naive in one sense, yet they are also myste-riously ecstatic and assured. I look at Roch the way I look at Miró from the mid-twenties or the way I read Isidore Ducasse at his most absurd—or, for that matter, the way I read Verlaine or Rimbaud. The gesture is not exactly an indelible one, but a sustaining effect, a dramatization of the absurd.

What was so refreshing about Jacques Roch? Why did these paintings give me pause at the end of the eighties? There is a certainty and a levity about these works that utterly transcend the heavy-handed trendiness, cynicism, and political correctness so endemic to au courant gallery shows during the eighties. This exemplary series of visual recognitions is about a journey between the frames of the conscious and uncon-scious, a journey not foreign to the voyagers of French symbolism, including the highly imaginative longings and descriptive phantasmagoria of Raymond Roussel. Roch is an original in spite of this obvious link to the surrealist past. He is an original at the demise of postmodernism's denial of originality. He does not admit or even profess originality, yet neither does he profess simulation or cynicism. Roch's paintings have a literary bent. By this I mean they evoke narrative sensations through the imagination more than they illustrate a preconceived idea. It is the kind of journey that opens the

Jacques Roch, The Oarsman, *1997. Courtesy Kim Foster Gallery.*

mind to the consideration of sensory input as a mode of cognition. It is a journey that—like the best poetry—is both intense and relaxed in its assemblage of parts. It is an art that resonates not with expression so much as with a necessity of being, of trying to purge the conscious world of its frightful and mundane detritus and to rejuvenate the mind as a sensory source of pleasure. Yes, why not? Roch's imagery evokes in me a sense of visual hedonism, a delight in the senses.

Nonetheless, I feel there is an issue here, or a network of issues, that reaches beyond the immediacy of visual hedonism. It is an issue of neglect in relation to mainstream art. Since the late seventies, the mainstream has been concerned with establishing a theoretical discourse about a simulationist point of view that is then illustrated with a consistent set of artists. I would point to the origins of this approach in the exhibition called *Pictures*, organized in 1977 by the critic Douglas Crimp for Artists Space, which was then under the direction of Helene Winer (who shortly thereafter formed the gallery Metro Pictures). The point of view was fundamentally a cynical one directed at the complete absence of originality in art, presumably inspired by the famous, often quoted essay by Walter Benjamin. According to Benjamin, what has replaced the "aura" of originality in works of art is the apparent plethora of manufactured images in the world, initiated by the invention of the camera. In many ways, Crimp's *Pictures* was a success. It was successful in launching a post-pop attitude about the use of "appropriated" images that further ensured an attitude of trendiness based on an encoded system of art world behavior that emphasized the function of social signs (semiotics), severe restraint in the exchange value of images, and a highly understated, yet obviously overdetermined, bourgeois careerism. It was an exhibition (and an essay later revised and published in *October* 8) that, in many ways, set the stage for the marketing of art in the eighties. It would be an exaggeration to say that this was the only factor that determined a shift away from the pluralism of the seventies (a rather positive aspect of the exhibition), but *Pictures* did crystallize a change from the lethargic reticence regarding theory as well as a weakening adherence to late formalism and postminimalism. It is also significant that the five artists included in *Pictures* went on to become significant art world figures in the eighties—Troy Brauntuch, Jack Goldstein, Sherrie Levine, Robert Longo, and Philip Smith. The mainstream gradually began to define itself in terms of an even greater emphasis on publicity, careerism, and overt cynicism. Art and popular culture had become virtually indistinguishable, as some art historians have claimed, thereby defining one of the basic hallmarks of postmodernism. In other words, the mainstream of the eighties was about postmodernism, and postmodernism was less concerned with the intimacy of an expressive form or idea and more given to the publicity of the artist as spectacle or to publicity in itself as a primary attribute of this new culture, this anesthetized culture—what one French sociologist termed "the hyperreal."

Now that "originality" was defunct, or at least on the wane, art was no longer about a series of endgame strategies, as once stated by critic Jack Burnham in relation to late modernism, but was merely a game—a careerist's game. One way of succeeding within the context of the game was to be adopted by a writer or a maga-

zine—preferably both—with the right art world credentials; one who would quote Benjamin, Adorno, and the five famous French poststructuralists, and thus reify or legitimate one's position in the mainstream. It soon became clear that this process of legitimation involved being in several group shows, curated by "guest" curators, at trendy, emerging galleries. It was important, however, that the group shows be presented at the *right* galleries; in other words, the galleries where the right artists, critics, and collectors hung out, so to speak. An important aspect of the new game was to find a writer, or an artist functioning as a writer, or a well-connected critic functioning as a theorist, in order to transmit the parameters of the newest trend by endorsing certain artists who fit the network of social signs and deal with those signs effectively in terms of their work. (There were very few "critics" in the eighties who were not functioning on a theoretical level; consequently, less attention was being focused on the actual art, with greater attention given to what I call "criticism by consensus"; that is, writing about art on the basis of trends, as a consequence of careerism.)

For example, Robert Longo and Sherrie Levine, two of the artists who emerged from Crimp's *Pictures* exhibition and who were both influenced by the earlier work of John Baldessari, became two of the trendiest artists of the past decade. Both artists went on to appropriate images and manufacture objects, often within the context of full-scale (and expensive) installations. The critical attention that has been lavished on these and other related artists (including essays by this writer) has been enormous. The problem is not so much with them—they have both on occasion produced substantial works. Furthermore, any objection would at this point be superfluous, if not meaningless. Given their influence on younger artists of the current generation, it would hardly matter what I or any other critic felt about the quality of their careers in general. The issue here is rather to define or redefine what has been lost in the mainstream since the contemporary art market during the 1980s accelerated beyond belief, beyond any single dealer's expectations. The fact is that this moment of acceleration is now history, and it belongs to the previous decade, not to the present one.

While publicity was the foundation of careerism in the eighties, and of course still is, other tendencies have emerged, or are in the process of emerging, that are worth examining. These tendencies, as opposed to *trends*, are interesting because they reveal a content that is both direct and subtle, and that occurs on more than a single conscious level. I am thinking of the works that, while not purposely naive or eccentric, use a process of image construction with reference to an intimate domain that is not averse to ideology, but, in fact, locates the ideological problem within a personal frame. These are not works that look alike or can be identified in terms of style—that old late-modernist hangover—but are works that are conceived on the basis of unselfconscious visual content.

These artists are not oblivious to the current mainstream of theoretical discourse, but they have developed, more or less, through a conscious eschewing of trends. Their intentions favor the discovery of an ontology that is not altogether removed from language. In fact, one of the common threads in these works is a connection to various forms of literary, poetic, or narrative sensibility. That is to say, the content of these works is inclined toward the literary, but their formal or ideological

positioning is not specifically linguistic. Their language is directed toward (internal) meaning rather than (external) function. Still, one might argue, and justifiably so, that even though these works are being discussed as independent of current trends, they may eventually be viewed as trendy. This argument is always more complex than it might appear initially, yet the possibility of works being viewed within a mainstream context is imminent.

As artists who deliberately eschewed the dominant attitudes of the eighties, Mira Schor and Susan Bee wished to establish their own alternative discussion. Based on the notion that too much significant art was being eliminated from serious criticism and that the mainstream had become too exclusionary, they decided to produce a periodical in support of their respective "outsider" positions. Their journal, entitled *M/E/A/N/I/N/G,* was founded as a vehicle to widen the parameters of criticism to include the "other" work—work that provoked ideas but was not illustrative or unidimensional in its purpose. Schor and Bee have completely divergent approaches to the image, yet they seem to concur on the importance of the relationship of the subject's "voice" (a euphemism for "eye"?) to the painting. Rather than impose a theoretical construct, Schor and Bee are interested in the provocation of issues as they emanate from the visual subject matter. What one feels in relation to the image or the surface (two different aspects of painting; indeed, two different approaches to painting) is a matter of how one examines the signs possessed by the work, not how one treats the work as a sign. Here lies another crucial distinction.

Whereas Schor focuses on the image as her representation in relation to the surface, Bee focuses on the surface as her representation in relation to the imagery. Schor's paintings resonate with the self-contained knowledge of a feminist speaking in her own voice, projecting her sense of intimacy outward, revealing the nakedness of her subject as essence without concealment in language. Bee's works are noncompositions in which the stickers children play with enter into and through the field to set up a kind of mock narrative, a pseudotropism, where the connecting element always feeds back on itself, making the surface the issue. Schor's paintings are a complete discourse on the body, the body as a transference toward representation, the complexion of body parts as elements of *disfiguration* in order to challenge the manner in which the body projects meaning. What is clear in these divergent approaches to painting is the subjective presence (Schor) in contrast to the personal absence (Bee); the longing for wholeness, in either case, is the completeness struggling for interpretive reconciliation as a narrative task.

Schor's paintings verge on surrealism. Bee focuses on irony as if to deflect the notion of commodity as an internal system of representation within painting. Bee, in contrast to a commodity artist such as Jeff Koons, uses kitsch as a conflicting element within her system of representation, not as an overt sign of bourgeois ridicule upscaled for the purpose of extending the mystique of narcissistic indulgence.

This paradigm of comparison between Schor and Bee correlates in a curious way to the paintings of two other artists, Pamela Wye and Germaine Brooks. Much of what has been said in relation to the former two could also apply to the latter. In Wye's paintings and drawings, there is an intense arbitration between an interior mental state

Mira Schor, Grey Breasts Of, *1992. Collection: Tom Knetchel. Photo: Ken Pelka Photography.*

and an exterior sequence of manifestations related to either botanical, marinelike, or imagined physiological forms. Wye, as with Schor and Bee, has a definite literary point of view; that is, the narrative connections within Wye's hallucinogenic forms recount a mental picture of an imaginative process suggestive of a kind of longing for existential freedom. Wye has the tendency to seek out internal states of being in such a way as to elevate their significance beyond the mundane—to exorcize the hallucinogenic forms from her internalization of the mundane and to give these forms transformative power. Wye reveals the process of her thinking as a sequence of intimate gestures; but these are resolved in terms of visual narrative. Wye is not trying to illustrate psychoanalysis as a theoretical construct, but rather to evoke a response through imagery that expresses direct internal conflict. Her art functions to reveal rather than to conceal. By allowing the insemination of the imagination to inspire its own thought process, Wye's visual narratives construct a sense of disjuncture within an intimate self that is quite the reverse of an art that relies heavily on the accepted vocabulary of external signs. In Wye's drawings, in particular, the pen-and-ink lines and watery blotches have a sense of physical presence not unrelated to Arshile Gorky; however, at the same time they possess the mental tenacity of Henri Michaux's mescaline drawings in which diffusion usurps concrete reality, yet without dissipating completely. The peculiar, growing buds,

Susan Bee, Buster 'n Sis, *1992. Collection: Susan David Bernstein and Daniel Kleinman.*

the dilapidated vines, the overabundant flora and fauna, the icons of a primitive cult—all these imagined signs lead back to nature in its primeval state or back to consciousness at its origins. Wye's images function as translucent tissue—at times vacant in its entropic nod toward the horrific, at times replete in its mesmerizing hyperphobic omniscience. Here the ego is as much a gender issue as it is a generalized condition of the immanent in confluence with a possible transcendent vision.

While Wye's work is concerned with the omnipresent vestiges of a relatively unremorseful sense of the real interpreted as dreamscape, Germaine Brooks constructs imagined portraits that emphasize the image as a blunt abstract figuration complete with certain congenial signs of naive representation. As Klaus Ottmann has pointed out in an important essay, "The Reinvention of Painting" (*Arts,* January 1989), the currency of postmodernism must get beyond simple cause-and-effect relationships. It is unfortunate when art dwells too specifically either on itself or on the appropriation of its history. Ottmann claims that art world discourse has become "too sophisticated and too self-conscious" and that "primitivism" or "amateurism" in painting would be better sources for a reawakening of artistic practice and energy. Brooks, according to Ottmann, is evolving a style that has emerged from "the world of the simple." Brooks is a painter whose images of people appear disarming in that they tell more about painting

Pamela Wye, The Big Wave, *1987. Courtesy Luise Ross Gallery.*

than they do about portraiture. Their simplicity is a ploy for a more intuitive sense of concrete abstraction.

It would seem that Brooks has developed an approach similar to that of the later Malevich. Just as the Russian painter implicitly tried to connect representation with the concrete, Brooks does much the same. Yet, at the same moment, one can feel pathos in her imagined portraits without the slightest degree of angst. They are carefully constructed as concrete essences encoded with eccentric details of clothing and facial expression, but they simultaneously evoke a level of emotional content through a method understood by many self-taught painters as well as some Renaissance masters. When Malevich discusses his black square on a white ground as producing the equivalence of feeling, he should be taken quite literally. Furthermore, the concept becomes all the more sophisticated in his later paintings, in which he has literally instilled the concrete within representation. With Brooks, the visual ploy is much closer to American folk art, but the aura is an iconic one; the image is felt as it becomes reified.

The attitude of painters such as Schor and Wye, in particular, clearly emanates from a feminist concern with the intrinsic vocabulary of a female subjective voice. One might consider the morphology of their images as having historical roots in contemporary American art, even though those roots have been, until recently, hidden beneath the mainstream of avant-garde developments ranging from abstract expressionism through early conceptual art. One painter that comes to mind from the fifties is the late San Francisco artist Jay DeFeo. DeFeo's paintings and works on paper (memorial shows were organized following her death in 1989 at the University Art Museum, Berkeley, and at Paule Anglim Gallery, San Francisco) have an interior quality that is unrelenting in its boldness of expression. This is to imply that images of the interior are not at all synonymous with a demure line or quiet image; in fact, DeFeo's work advanced a surrealist sensibility by pushing the image in front of the picture plane or

Germaine Brooks, Bell Had Something Special, *1995.*
Courtesy Tricia Collins Contemporary Art and The West Family Collection

meeting the gaze of the viewer directly with a representation of large eyes or circles within an organic context suggestive of a swirling vortex of energy. As shown at Nicole Klagsbrun in March 1992, along with four other artists aligned with California's beat generation of the fifties, DeFeo's frenetic and primitive imagery reveals a statement at odds with the mainstream. Whereas respectability hides the revelation of desire, DeFeo makes her passion explicit. She challenges the viewer in this way to look for the impulse as an energetic response to life, to emerge from the demure shadows of academic distancing and to allow desire to happen, to free it from the controls of representation. Like Louise Bourgeois, who worked in a surrealist manner during the abstract expressionist fifties in New York, DeFeo was interested in expressing erotic feeling and sexual energy. Less knowledgeable in psychoanalysis than Bourgeois, DeFeo's raw and direct assemblages offer another element to her rich vocabulary of images. Clearly, DeFeo's sensibility as an artist grew in reciprocity with other San Francisco artists, such as Bruce Conner, Wally Hedrick, and Wallace Berman—all of whom are associated with a kind of regionalism that is translated in terms of the beat image.

The show at Klagsbrun was remarkable for several reasons. It presented DeFeo, Conner, and Berman, along with George Herms and Jess, to a new generation of New York artists and critics who were, in some cases, completely unfamiliar with their work. Berman, of course, had had a touring retrospective in 1978 and was shown last year at the Louver Gallery, New York. For the most part, seeing these works was like seeing "post-appropriation" art from another vantage point. It is important to understand that this development was going on in Los Angeles and San Francisco more or less concurrently with the so-called neo-dada art of Rauschenberg and Johns in New York. One could make the argument that the image/grid format was invented not by Warhol, but by Berman, who used the grid in his highly intuitive cabalistic images printed on a Verifax machine (an early version of Xerox). Berman, in fact, worshiped the mundane in a much less cynical way than Warhol, and frequently used advertising imagery, combined with Hebrew letters, in his collages. In this regard, Berman was as much of a bridge to pop art as Rauschenberg. One could make a similar case for Conner, or, for that matter, Herms. One of the problems in revising this history, aside from the enormous investments in the New York version of it, is the fact that these artists are seen as regional. There is something problematic, however, in the definition of regionalism if one is to compare the work of these early American assemblage artists with that of painters such as Charles Burchfield, Grant Wood, and Thomas Hart Benton. How can an art movement—regardless of how loosely defined—be both regional and avant-garde? I would argue that the reason this history has been ignored is because it has never had a mainstream following; put another way, where there is no cynicism attached to history, there can be no trends. Fashion is a fluke. Often, the most obvious signs are chosen as "important" because they look like art. Whether they have any interest or stir any emotions beyond the superficial ideogram, the easily digestible sign, is another matter. In the eighties, this approach to art as a surreptitious indicator of value speculation became all-important. The mainstream was essential to the market. Now comes the task of sorting through the debris of signs in order to examine their references.

David Geiser, Blackthorn VII, *1994. Courtesy Kim Foster Gallery.*

In the New York art world, no one would ever talk about regionalism. Why? Because this is New York. What happens in New York is presumably in the mainstream. I would submit that there are artists working in New York who are serious artists—call them underground or avant-garde, whatever—but whose works appear to be regionalist. These artists are fully aware of the mainstream. They know what is trendy. It's not that they necessarily reject what is trendy. (For example, one of the artists I am writing about feels that Koons was an important artist for her.) The point is this: there are inner-directed artists and there are outer-directed artists. Inner-directed artists deal purposefully with what they have to say as artists. Outer-directed artists pay a lot of attention to what is in the mainstream and to what is acceptable, before they show. We are talking about careerism: making the right moves in the right places, and if the art catches the fancy of the right dealer or the right critic, then a career is born. Art simply becomes the vehicle for one's career, rather than the other way around.

Current work that has a purpose and a concept, that is not dependent on what other artists think or don't think, might be thought of as "tactile subjective." It is art that offers a subtle pleasure because there is something about it that feels resolved, even if that resolution is about fragmentation and disjuncture. I have seen many large paintings and countless watercolors and sketches by Chris Martin. The work is difficult, but there is a tactile sense about it. The surface obscures the gaze, yet the image holds. There is the sense of a process going on, a conceptual process that is inextricably linked to a material through visual cognition. Something is being learned, but what is being learned is never something that is proven. Martin's rivers of language wind in loops back and forth across the canvas. One reads the language as a poem; yet the process of reading becomes a visual one, a fixed sensation of language as it strives to represent. The new *Blackthorns* of painter David Geiser have a similar resonance. These are not paintings that deal with entropic form merely to offer a statement on decay. They are paintings about metamorphic time, the very temporality that makes them paintings. They are not emblematic or concrete; they are encrusted surfaces, striations that run vertically through space, reiterating the light of Newman's "zips" but in a more theatrical sense. They are paintings that vitalize and sensitize the surrounding space; they are calligraphic moments of ontological recognition; they stand for desire. There are other such new works I have seen: objects by Fred Tomaselli and Jesse Goode, both of whom use the assemblage technique in different ways, loading the content with literal devices: constellations, numbers, recycled junk, armatures; the literal becomes literary. New narratives emerge, narratives that reinterpret states of being in a tactile environment and that make a connection with the eye/mind—a conceptual tactility. Ideas are felt, not simply examined, through new approaches to formal structure. The concerns of the inner-directed artist, who resists the terms of public mediation, involve maintaining one's private distance within a larger discourse, not giving social distance a cynical edge.

The Spectrum of Object Representation

If the individual self is an illusion, it seems clear to me that the group is also an illusion; in that case everything is illusion, which is quite possible. And yet the illusion itself can have a certain truth or reality (since it can be defined or named) which must be taken into account, whether it be an illusion of self, of nation, of race, of other groups, of the world.

Eugène Ionesco, Fragments of a Journal

Much of the recent discourse about art is related to art's neutralization as seen in reference to mass-produced objects. This, of course, has its roots in Duchamp and later in minimal art. Concomitantly, there are references in other forms of pop standardization, specifically Warholian nonaesthetics and in the assemblages of Arman. The case being this: mass-produced objects are culturally determined manifestations of desire. They rehearse our most intimate fears, our nostalgia, and our need to escape. They represent cultural entropy as a denial of the handcrafted object. They function as signs of our psychic adherence to merchandise. They give us a sense of fragmentation or delusion in terms of who we think we are. This sense of fragmentation is rarely, if ever, apparent at the outset, at the moment of our projection. We purchase and we acquire these objects. Some of them we may need; others we don't. Many we think we need in order to pursue some long-term venture. We call these kinds of purchases capital expenditures. They are the fuel of our simulacra, the moral debasement predicted long ago by William Morris.

Mass-produced objects may stir lust and appear to restore the missing link to one's sense of self-identity. From a Warholian perspective, the issue of identity—that is, personal identity—is a superfluous one. Identity is a matter of constant slippages through a progression of signs. Objects from mass culture seem to possess some manner of affectation; but the affectation is never real. Nor is it ever absolute (unless it is a sign for vodka).[1]

Just as the labels of processed foods could be repeated with the same mean-

ingless diligence as the image of a movie star or the image of an instrument of social humiliation and degradation—such as an electric chair—so any "serious" work of art could be reduced to a similar status of object representation. In the Warholian mode, it doesn't matter whether the object is a common mass-produced casting of a Renaissance sculpture or a pair of cookie jars or lace curtains or an article of clothing worn by a favored movie personality. Standardization is simply omnipresent. Individual identity, as argued by Foucault, is neither present nor absent, but defunct.

For Warhol, self-identity was only a sales pitch—an idea to be manipulated—that would eventually succumb to the motives and the effects of merchandising. The yearnings of Sartre and other existentialist philosophers to evolve a sense of being in the world was a lost cause. The acquiescence of art to the larger mass cultural frame was the real issue. Contrary to existentialism, objects from the robotic arms of the postindustrial world would take their own course and would reveal their true insignificance as mere signs without referents to be shuffled about and reconstituted mindlessly by others. The basic frame of operation was not an ontological one, as with the existentialists, but a purely semiotic one. In the current state of the postmodern, signs achieve meaning through intertextuality. They operate entirely bereft of either the ontic or the ontological. They aspire toward a condition of the social, and if we are to accept Baudrillard's position, the social aspires toward the hyperreal—what a recent publication cites as having "ecstatic" consequences.[2]

This condition of the hyperreal is only possible within a highly advanced capital system. Objects function as entropic signs with very definite social and psychological effects (one might even say pathological effects). To talk about objects in this sense is to talk about the condition of the hyperreal—an accelerated and encyclical enterprise of culture—and how objects are represented. For objects in the consumerist sense are not only represented as signs in flotation (although this is one viable way they can be metaphorically represented), they can also be spoken of in terms of effects. One extreme is the Warholian mode of artistic productivism where effects are merely surreptitious and do not justify or include any meaningful form of existential recognition. Another extreme is the existential reality of things, their immanence as embodiments of human reality. Jim Dine's "tool paintings" might serve as a good example of the latter, to cite another artist occasionally associated with pop art.

In the spring of 1989, at Jay Gorney Modern Art, Haim Steinbach installed one of his major works in the basement gallery. The work consisted of two parts. On one wall he built a lengthy shelf and placed five elephant-foot stools at regular intervals. Each stool was made from an actual elephant foot—which has very thick, rigid epidermal layerings—with an actual zebra-skin cushion on top. Although somewhat standardized in their appearance, each stool had a distinct size and shape. They were uniform but not exact. They were industrialized artifacts.

On the opposite wall, facing the five elephant feet was a fairly large elephant skull. The skull was placed on a separate square-shaped shelf. Each of these components were purchased at an import store in New York up in the Nineties. The significance of this work as object representation is neither fully Warholian nor fully Duchampian. While it may be an admixture of the two, this would not entirely account for its

dramatic impact. Seeing this untitled work by Steinbach was a theatrical experience. If spectacle can still be considered a viable aspect of theater, one might presume that these "signs" of culture required some sense of audience participation—perhaps in the sense of a Kaprow environment. One entered into the space caught between archaeology and simulation. Where was the line between the two? In terms of theater it was like a Beckett play or an Ionesco—as in the latter case, where the language dissipates before the audience, where sense and syntax become confused, and where the demarcation and organization of information feels insecure, on fragile ground.

Why five feet instead of four? Four would be too predictable, too symmetrical. Also, with four elephant feet, one has to acknowledge the absence of a single mammalian source. Could these tough feet have been severed from five separate beasts? Yet, the perspective relationship to the elephant skull seen across the gallery—which held an absurd omniscient view of the five pedestals—declared a form of unity, an almost monotheistic view of the space. It is as if a single beast had been possessed with an extra appendage, more than a normal mammoth quadruped, a freak. This hyperreal space and spectacle might give the viewer a titillation of absurd humor, a puzzling paradox, equivocal and impossible.

In addition to the absurd, there is the social. With Steinbach, it is the problem of dealing with colonial origins and the colonialist regime associated with these trophies. The skull is a remnant, perhaps, of an archaeological dig or a finding on the jungle plain. Somehow it acquired value. It was crated along with numerous others and shipped to the States. Eventually, the item would be purchased and then placed in someone's den or rec room beside the billiard table. Does it then become a sign of subjugation and/or the conquering instinct? It is very complex, not easily decipherable. The fact that the skull was sold is not the same as if the beast were hunted down and killed by the collector. The feet function in much the same way, although their origins may have been more tribal and related to the conquering desires of chieftains who required fetishes. In Steinbach's installation there is an absurd equivocation on many levels. Where is the line between origins and simulation? What is the relationship between hunting and collecting? What is the mechanism of desire that produces a need for these signs? And where are they connected within the patriarchal regime?

Another work, *Scarsdale* (1987), a painting by Eric Fischl, was shown at the Mary Boone Gallery during approximately the same period of time as the Steinbach installation. It is a three-panel painting, but not a triptych. One panel hangs on the wall. An elderly women is dressed in a satiny wedding gown smoking a cigarette, leaning forward in a chair. In one of her hands, a gloved hand, the woman is holding a leash with a dachshund. The dachshund appears at the lower edge of the woman's gown, shown on a separate panel that is smaller than the one on the wall and leans against it while resting on the floor. A third panel is placed off to the side of the two others. It is a middle-sized panel and includes a tabby whom the woman is contemplating. This panel is also placed on the floor, resting against the wall, and is adjacent to the larger panel on the wall.

Fischl's style in this painting is not unrelated to John Singer Sargent. The relatively static pose of the aging woman is belied by the tense anxiety of her expres-

sion. This tension is augmented with the dachshund pulling at the leash. Her gown looks out of place. It is a gown for a younger woman. Also, the dark tones surrounding the brilliant white gown of the seated woman is clearly reminiscent of Sargent's style and era.

The woman's relationship to the two animals is most intriguing. The tabby confronts her, and she confronts it. "Tabby" is a word with three meanings: a pet cat, a silk gown, and an old widow. Here the sign functions in a tripartite manner. The dachshund stares in the other direction away from the woman.

The issue of object representation in this painting is established through its absence. What is represented is a person on the "edge of despair"—to use a quotable term from the fifties. Somehow, the sentiment appears completely simulated, unreal; yet the condition of despair also seems apparent. Engrossed in wealth—and perhaps another attempt at marriage—the woman contemplates an illusion of herself as absurdly articulated by the position of the tabby. The dachshund creates another simulated tension as a manifestation of internal expression. The pictorial fragmentation reinforces the disjuncture of these tensions. The two lower panels, each containing one of the household pets, operate as simplistic, if not as incredible, metaphors—a style of pictorial reading from another era, a bygone era of early modernist aesthetics.

This lack of credibility given to the pathos of the content is emphasized in the painting's literal and physical disjuncture. It is this sense of fragmentation that transforms the pseudocontent of the picture plane into a semiotic puzzle, a fake circumstance where existential reality is as foregone as modernist aesthetics, where despair is as meaningless as dogs and cats, where language can only exist in the absence of what is being represented. The painting is, after all, a collectible—a kind of souvenir that can only be comprehended through its semiotic code. To say that this form of despair is the "end of the road" in terms of mass culture would be to miss the view of the hyperreal. It is here we find the illusion of the self in the absence of object representation. Only the frustration is left.

Where Spectacle Meets Art: Klein's Magnificent Anthropometries

Yves Klein is one of those artists who, endowed with a desire to signify a spiritual state of awareness, felt himself deeply misunderstood during his lifetime. Given his legendary status in the recent history of art, it may seem difficult to fathom to what degree he felt misunderstood. Klein's work is celebrated for its sweeping elegance and grace, for its sophistication and allure, for its conceptualization of spiritual and material reality, and for its sheer visual power and impenetrability. One could make a comparison to the work of the painter van Gogh seventy years earlier. Both artists died young—both were in their thirties. The story of van Gogh is, of course, better known than that of Klein. This only suggests that protomodernism will find acceptance where the early progenitors of conceptual art often will not. Yet both Klein and van Gogh were, in their discrete ways, great artists, but great artists coming from two extreme points of view and therefore two vastly different criteria.

The 1997 exhibition of the Anthropometries by Yves Klein, completed between 1960 and 1961, at the Danese Gallery was an inspired exhibition. At the same time, it was a commercial one. (One cannot deny this bifurcation in the history of art, not as a judgment, but as a fact.) In this sense, one might see the Anthropometries of Klein as engaging the spectacle within the context of art. This is very different from making art into a spectacle as we have recently seen in the works of Longo, Koons, Barney, Serrano, Hirst, and the Chapman brothers. Klein was interested in signifying what he called "zones of immaterial pictorial sensibility." He wanted to produce images of a tactile substance that would signify the rejuvenation of the spiritual within secular existence; that is, the world of commerce. He saw himself as somewhere between *l'art ancien et les ultramodernes*. For Klein, the spiritual and the commercial worlds were not

Yves Klein, ANT 73, L'Étoile. *Estate of Yves Klein. Courtesy Danese Gallery, New York.*

distinct. As with the philosopher Georges Bataille, one had to account for the secular world, the world of excess—the commercial world—within the domain of the spiritual. This is a very different idea than denying the spiritual in favor of commerce and the media, where the ultimate result becomes a kind of self-conscious and deeply cynical joke—a type of stupidity rationalized under the rubric of postmodernism. It is this latter tendency that has informed so much uninformed conceptualism and "installation art," representing the glut of a pathetically forlorn absence rationalized in many American universities as the visual culture of today. In other words, this denial of the spiritual has been inverted as a kind of spectacle posing as art, a sickening pose where any possibility of a critical distance has been precluded. This was not the situation for Yves Klein, who in many ways struggled for just the opposite.

Klein has been recognized as an important artist, a preeminent artist with regard to the history of contemporary art. Like Ad Reinhardt, he represented the closure of one tendency and the opening of another. In the case of Reinhardt, it was "imageless icons" and the beginning of minimal art. With Klein, it was the end of the traditional representation of the figure and the beginning of a type of conceptual performance art. Klein returned art to the ritualized performance in which the activity of the artist/participant was essential to the community. It was both an atavistic impulse and an expressive response to the lethargy of "high art" so endemic to much of the stylism in the École de Paris after the Second World War.

In the exhibition at Danese, in addition to the marvelous paintings of female figures poised in the void—a concept that evolved from an admixture of Zen Buddhism and Rosicrucianism—there are photographs of Klein during the performance at the Galerie Internationale d'Art Contemporain in Paris from 1960. These black-and-white images lend the necessary counterpoint to the paintings in the main gallery. The sense of ritual, in which three nude women bathed in blue paint and impressed their bodies against the canvas, combined with a musical score by Klein, the *Monotone Symphony,* for string quartet. The ritualized making of monochrome blue paintings—otherwise known as IKB (International Klein Blue)—was accompanied by monotone music. There is a fashion-show aura about the performance, thereby bringing the spiritual and commercial realities into a unified focus, a spectacle within the larger context of art.

One photograph, in particular, is stunning. Klein stands poised in a tuxedo with his eyes partially closed in concentration. His hands are raised up at waist level with his fingers open. There is a moment of reflection signifying a hiatus in the activity, an interstice in which the magic of the ritual is about to occur. What brings modernism in touch with the conceptual aspect of art is held in this moment, in the language of this photograph. There is thought and there is action, and there is time and space between them. There is the intensity of emotion, refined as feeling, and the transference of the idea into a new pictorial reality. There is a new vision of what art can be. To see this image of Klein without cynicism is to get in touch with his intention—not as faked religiosity, but as a heightened sensory cognition on the nature of art.

The 1997 Whitney Biennial

What was so new and different about the 1997 Whitney Biennial? The photography was generally better. The film and single-channel video works were occasionally engaging. The painting was generally nonexistent. And except for the Louise Bourgeois room, the sculpture was almost missing. The conceptual work failed to understand its own process and tried to cover its arcane media nonsensibility with densely compacted and obscure rhetoric using dates or names and dates. Who cares? But the real death knell of this compendium of visual culture was that never-so-clear category of hybrid artwork known as "installation art."

Whether on the wall, on the floor and wall, or on tabletops, this genre—at least in its material manifestation—has never looked so indulgent and so out of touch. Whether Chris Burden or Jason Rhoades, the disquieting pretension and hyperreal glut exceeds the limits of emotional attraction on almost any level, ranging from adolescent irony to anti-aesthetic excess.

Several years ago, I came to the conclusion that for an installation to work, the quality of the idea somehow had to match the quantity of material, cost, and scale it was given. If the equivalence was not there—in other words, if the amount of material, money, and scale given to the work was out of sync with what the work actually had to offer—something was wrong. The work was either ill conceived or severely overdetermined. As a reflex, one might consider straightforward video installations as some kind of solution. You could avoid the material clutter and stick to the sensation of the image in a darkened room. Yet, the dematerialized counterpart to excessive materiality exists on the same structural level. The medium of video does not in itself make the reality of viewing an installation any more successful or capable of being received.

As for so-called painting, I honestly do not understand the rage over Lari Pittman's ultraconvolutionary cybercartoons or the cynical face-lift representations of Richard Phillips or the academicized (Pollock-inspired) doodles of the recent work by Sue Williams. All of these artists' works reveal the end of a legacy that began around 1978–79 when *Artforum* started devoting more attention to how the image of a painting

looked in print than what the quality or significance of the actual painting might be.

In the case of Richard Prince, the faux École de Paris abstractions with stumbling post-Freudian jokes captioned on the bottom—presumably "to take the mind to regions more verbal" (as Duchamp once said)—suggest a considerable conflict. Contrary to whatever the nonintention of the work might be, the real tension appears less a conflict between language and image than a longing to paint a painting that is more than a sign. This appears augmented by a gnawing, unbearable pressure incited from within the marketplace to sustain some vaguely deterministic Oedipal enigma where jokes continue to persist as a most acceptable social displacement.

There are some smaller, less attention-getting works worthy of some real viewing time. One can search out these rare jewels amid the omnipresent state-of-the-art detritus with hastening glee. Examples would include the inkblot drawings and prints by Bruce Conner, the silver prints of Aaron Rose, the "desert landscape" piece by Michael Ashkin, and the incredible galactic (though small in scale) paintings and related graphite works by Vija Celmins.

The effect of Celmins's work offers an overwhelming satisfaction, a reverberation of thought and mystery elevated to the level of profound feeling, an authentic searching vision. The politics of fashion is simply out of the picture. What replaces it in Celmins's work is a sensory cognition transmitted through the imagination, a private vision that speaks beyond it, a vision where experience is not a matter of cultural categories nor even a matter of privilege. Instead, Celmins reveals an intensity of meaning through the most abbreviated effects—a light beckoning a sea of stars, a magnitude of energy expressed as matter, a sign for humanity to watch and to understand in order to go beyond the economic limitations of exploitation and the naive smartness that seems to be the origin of conflict and incessant trouble and repeated tragedies. These works are more than craftlike or technical feats. The works by Celmins are a respite from the deluge of the grotesque that occupies a good portion of this exhibition.

This Whitney Biennial's noteworthy achievement may be in signaling the decline of "installation art" as a viable art form. This would be a blessing, and there is certainly plenty of evidence in this exhibition to make the case. Media and excess are two issues that have been overdone to the gills. We don't need another comment about what any intelligent person already knows: commercial television and now the commercial Internet have become fundamental sources for escapist violence, anti-erotic sexuality, and orgasmic purchasing power. What else is new? The result is the grotesque. And there is plenty of it around. The galleries are consumed with it. If only a few of the practitioners who are so fond of the grotesque would sit down for a moment and study—really study—why first-rate artists like Louise Bourgeois and David Lynch make it happen in a way that is truly moving, the art world would be rejuvenated. You have to know something to make something happen, and knowledge is much more than the accumulation of codes and information.

Perhaps there should be a study guide instead of a gallery guide, a manual for how to differentiate between art and the empty plethora of visual culture that exists as a mindless sequence of political solipsism. Now that the imagination has withered

from the vine, we have the endless seduction, the incessant and unyielding givenness of cathode-ray light and mega-RAMs surrounding the planet. Of course, you find indications of these depletions throughout the museum.

Generally speaking, the Whitney Biennial has become a no-win situation. This has been true for more than two decades, and I don't see it changing radically for the better. As I have said before, the Whitney Biennial is not an exhibition that is curated so much as it is organized. All the right ingredients have to be present, and these ingredients are becoming more complex year by year. To say that it is an institutionally driven exhibition would be a serious understatement.

West Chelsea:
An Experiment
in Attitudes
and Architecture

When did it all begin? Was it the move of the Dia Art Foundation from
SoHo to West Twenty-second Street in the late eighties? Was it the inspiration of
the Paula Cooper Gallery, formerly a pioneer in SoHo in the late sixties? Was it the
influence of a series of feature articles that appeared in places like the *New York Times*
and *ARTnews* on the "death" of SoHo? My own theory is that the gold rush to West
Chelsea was an exclusionary idea; that is, to give the galleries an aura of exclusivity, a
mini–art world apart from the fray. It represented the separation of the artists, who live
in the east (Williamsburg), from the commercial support structure in the west (West
Chelsea). This breach is quite different from the concept of SoHo thirty years ago
where the galleries followed the artists in order to integrate themselves with the new
burgeoning scene.

The development of West Chelsea galleries began with the development of
West Twenty-second Street by Dia and the Rainer Museum in the late eighties. Then
Matthew Marks moved down the block in the early nineties. Other galleries filled
the spaces in between. The phenomenon began to spread south to West Twenty-first,
then West Twentieth. Eventually, galleries started appearing on the north side of West
Twenty-third and as far north as West Twenty-sixth. The Greene Naftali Gallery was
one of the first. Others have rapidly followed, including Barbara Gladstone, Metro
Pictures, and yet another space for Matthew Marks. All this activity has happened
within the two years between 1995 and 1997.

The trend caught on like wildfire. But it was not surprising. The art world
needed a change. Art stocks were down, and West Chelsea looked like a panacea. SoHo
was presumed dead, a place from another era. Gallerists were packing their bags and
going northwest. Ecstatic cries of *Eureka!* could be heard for miles—well beyond Fifty-

seventh street. By claiming exclusivity in West Chelsea, the art market could revive itself. The search was on to find the gold. Or was it fool's gold? No one bothered to ask.

When I inquired with one gallery as to why it was moving from its well-established SoHo space, I got the response, "Victoria's Secret has moved to Broadway!" As if that was supposed to indicate the ultimate demise of downtown art. One might easily argue the opposite. So-called visual culture has, in fact, been enhanced by the presence of the Queen!

The problems with West Chelsea are multifold, and anyone who has actually suffered the trek over there understands them well. Transportation is a major problem, particularly in the winter. There is one diner on the corner that bulges at the seams on Saturday afternoons or after openings (weather permitting) with both food and service that leaves something to be desired. There are no little shops or coffee places or comfortable bars to relax in within the network of galleries—many of which are hard to find—in buildings that seem perpetually in the process of renovation. Some buildings have elevator problems (remember the old days, waiting for an elevator at 568 Broadway!) or elevator operators that are never available. The streets, with the exception of West Twenty-second, are quite noisy and filled with fumes from open bays dispensing chemicals of one kind or another. There are no adequate sidewalks.

This new art district is unfortunately divided by West Twenty-third Street, a major thoroughfare that interrupts both physically and psychologically the flow of movement from one gallery to another. One of the fundamental problems with West Chelsea as the location of a new gallery scene is the absence of a pleasurable experience. Just as pleasure is an important drive behind art, even in its most abject manifestations, it is also a drive that motivates people who want to see art—a point that was overlooked in the mad rush for real estate.

And why do people still come to SoHo in droves? Because, relatively speaking, it is still pleasurable. People like those little shops, the restaurants, the boutiques, the commercial print galleries spliced in between the more focused activity of viewing and negotiating deals on works of art. They like the easy access to galleries and, regardless of what people say, they seem to enjoy the exhibitions, even if they are provocative.

SoHo is easy to get to by numerous subway lines. There are three important museums and three alternative spaces on Broadway between Houston and Grand Streets. One can get good food, good service, and good coffee, or one can buy a salad for three or four bucks, and sit on a stoop—and no one will care. It has a democratic rather than an exclusive, foreboding, angst-driven feeling. One deals with the schlock along with the sophistication. There's plenty of each to go around. There are interesting galleries in lower SoHo with a variety of exhibitions—some good, some mediocre, some bad, and some controversial. Furthermore, everyone knows that people who can afford to buy art also like to buy other things—fur coats, jewelry, chic wardrobes. And they like good, but reasonably priced, restaurants.

As for the question of rent, the great expectation that West Chelsea is a sanctuary—a veritable haven—where rent is half or a third the price for three times the space is not exactly the ultimate reality. These spaces are going to get expensive, and it is already starting to happen. Is it a wonder that the gallerists are starting to feel the

pinch? There are a lot of attitudes floating around West Chelsea that suggest that the place is not all it was cracked up to be. But time will tell. Maybe this funky new art district will transform itself and become a kinder, gentler place—a place where the art is truly good, and which does not need the spectacle, the fashion show, the media hype, or obnoxious behavior from uninformed gallery personnel to get attention.

Just as artists are mistakenly hypervulnerable to what the media and the market has to offer them, West Chelsea offers itself as a manifestation of all that is trendy in art yet often lacking in substance. It is all about the shell and not the content. It is all about taking a blind consensus seriously and relinquishing one's right to resist the pressure of what others are doing. Culture is not made through consensus or imposition. It is made through ideas that are strongly felt, undeniable feelings where one acknowledges the course of history in relation to the present. I am not convinced West Chelsea has this potential; but, it may. And if it does, then the exclusionary attitudes will have to change.

In the better interest of the new West Chelsea residents—many of whom I know and respect—I can only wish them success. It is still too soon to know what will happen, but let's hope things improve and that West Chelsea becomes more user friendly—that the attitudes become as attractive as the architecture. On the other hand, it is the art that will remain the ultimate challenge, and this means more significant quality and fewer fashion-oriented spectacles.

The Hugo Boss Prize 1996

Taking the A train to Brooklyn one morning last week afforded me the opportunity to see lots of casual wear—oversize jeans, baseball caps, hooded sweatshirts, warm-up jackets, XXL T-shirts—all with a full array of prestigious designer labels, including Perry Ellis, Calvin Klein, and Hugo Boss. The quality of the attire was not stylish, at least not from a Wall Street perspective, nor did it appear particularly well made (at least compared to Tommy Hilfiger who specializes in this kind of attire). So I began to ask: What was the purpose of these gargantuan logotypes emblazoned so tastelessly across the front of XXL T-shirts and other related sports attire?

The answer to my question came in the late afternoon upon my return from Brooklyn. At Fulton Street I changed from the A train to the Number 5 Express going uptown. There I noticed a distinct difference in the clothing being worn by the passenger clientele. Instead of casual sports attire, there were blue pinstripes under heavy woolen topcoats and gray-breasted business suits all coming from the financial district in lower Manhattan. This official-looking crew of quasi entrepreneurs were, in fact, wearing the attire that—dare I say?—the folks on the A train were advertising.

The official-looking crew on the Number 5 Express represented what in semiotics might be called an implicit order of signs, while the folks on the A train were wearing signs of a more explicit order. This is to suggest that the system of fashion is based on a currency of agreement exclusive of taste, and that there is a certain unconscious reciprocity that is needed within the social structure in order for the system to exist. The means of promotion in the fashion industry occurs through a highly sophisticated set of signifiers that function in direct relation to some of the more sensitive aspects of our social psychology. But, of course, the fashion system, like any other system, wants to survive, and, therefore, is interested in its own self-preservation.

By the time this article appears, the $50,000 representing the *prestigious* Hugo Boss Prize will have been awarded to one of the six artists promoted in the press release some weeks ago as "The Short List," and currently exhibiting their work on the top floor of the downtown Guggenheim.

Yasumasa Morimura

Morimura is a Kabuki-inspired photographer who uses digital manipulation to construct what in current theoretical discourse are called "transquerades" that show him impersonating Hollywood movie actresses. Some observers have noted that Morimura is Japan's answer to Cindy Sherman. If you miss the Guggenheim display, you can see some of the same large-scale prints at the concurrent Luhring Augustine show, or vice versa.

Cai Guo Qiang

He is probably the most interesting artist nominated, which means he is unlikely to get the award. His enormous room-size installation is called *Cry Dragon/Cry Wolf: The Ark of Genghis Khan* (1996). Qiang has installed an ascension of bloated sheep skins, moving from floor to ceiling, using a set of three old Toyota car engines to suggest their transcendental propulsion into space. Undoubtedly, there is an important, culturally specific set of symbols here—a language with which I am not familiar—even so, the impact of the work is undeniable in its emotional presence.

Stan Douglas

I have seen this artist's video installations before, and they have a lot to do with politics, history and the ideology of culture. The work seems intensely theoretical and, some would say, visual. At the Guggenheim, Douglas is presenting a video work called *Nutka* (1996), in which overlays of image and text deal with man's intervention into nature. He has another room of photographs related to the video.

Matthew Barney

Having seen the video/film *Cremaster I,* it was impossible not to recognize the related photographs, objects, and drawings in "self-lubricating" frames. Recognized in Germany, I am told, as the most popular American avant-garde artist, Barney has devised an ingenious way to extend his metaphors through multiples related to his famous film. *Cremaster I,* is convincing to the extent that it projects a fixation of some type, a choreographed scatology, suggesting primal play with all its technological trappings, and stealthily symbolic, perhaps, as a clever arrangement of newly discovered feces. Everything looks rigidly clean, and things keep dropping out of small (or ever-widening) apertures. I had never considered the displacement of a football as a turd before encountering the work of this artist. Some, however, interpret his work as a discourse on androgynous sex.

Janine Antoni

An artist known for cast busts made of chocolate and soap, Antoni has been weaving the silk from her nighties into a distended "blanket" of much coarser material. She has been working on this "concept" periodically over the past three years, sleeping in various prestigious museums in Europe and the United States in order to record her REMs (rapid eye movements) on an electroencephalograph in order to transpose these rhythms as the graphic design for the blanket.

Laurie Anderson

This famous recording artist has four ambitious electronic installations of various scales—all from 1996 (one being a remake of an original from 1975). The biggest of the four is something called *Dancing in the Moonlight with Her Wigwam Hair.* It is an electronic, black-and-white installation with lots of pulsating movements, symbols, and signs, typical of her work over the years: humorous, charming, yet also coy, smart, and cynical. Her music suggests a holding pattern, as in the airplane that circles on a diagonal armature, with occasional bits of white dust falling over it, representing snow, one would gather. The message is a negative one, a sad one, a distanced expression seemingly mythically entranced with the effects of media and how media has determined who we are in spite of who we think we are. Again, it's ambitious in form, but repetitive in content.

But what is the point of the prize? Why is it necessary to name it for Hugo Boss, despite the fact that the funding for the prize is donated by the company? It would seem to have something to do with the promotion of the fashion industry through contemporary art and, concomitantly, the promotion of art through fashion. It would seem to be about maintaining the status quo of the marketplace, of keeping certain artists within an exclusive range by creating an aura of exclusivity. It is a prize that binds art to fashion as if to suggest that there is no distinction between the two. It is about the quick register, the electronic imprint, the logo that repeats, and then disappears.

If contemporary artists continue to use the fashion industry as their model—both formally and conceptually—as they have been doing under the aegis of such misleading terms as "neo-conceptualism," they will eventually cease to have any status of their own. If art becomes stultified through the programming of change according to supply and demand, and if artists refuse to take a position that enhances intimate feelings in relation to ideas as communicated through a context, then we have lost something essential to understanding the richness of living in a truly multicultural world. Instead of pairing visual art and the fashion industry, perhaps we should become naive again—naive enough to consider that art exists, that it has the potential to empower and liberate human consciousness; and through this deliberate and purpose-

ful naïveté, to say that instead of programmed obsolescence and business as usual, and the ultimate boredom of a universe of logotypes and empty signs, we have "art" as a signifier of a better world—as a utopian sign that fosters the release of positive energy at a time when we so desperately need it.

Does the Trace Remain? The Situation of the "International" Artist Today

The decade of the eighties was one in which the art world shifted dramatically from that of cultural elitism to a type of multinationalism. This shift was evident not only in the New York art world but elsewhere, especially in Europe and Asia. In New York, the artists were moving toward concerns of marginality, such as sexual preference, gender, and racial identity. In retrospect, it is in some ways peculiar that more concern was not given to the socioeconomic distinctions that existed in the art world, particularly among artists. For example, the issue of artists emerging through the ranks of social privilege is rarely, if ever, discussed in art world symposia in the United States. On the other hand, in Europe, the situation at the outset of the eighties was quite different. A certain type of cultural identity started to become evident, particularly among expressionist painters. Gradually, as the eighties progressed, cultural identity became less an issue as more mediated styles of object representation—"commodity art"—became apparent. By the end of the decade, images of simulation and appropriation had spread to such an extent that cultural regionalism (i.e., nationalism) appeared on the wane. Yet, these issues are not as simplistic as they might appear.

The situation of the internationally known artist today may not be one of cultural identity so much as it is a problem of distancing oneself strategically from the origins of cultural experience. During the eighties, artists became enmeshed in a postmodern discourse that established the notion of culture not in specific terms, but, rather, as a homogeneous phenomenon. To make art was to enter into another kind of

experience of language whereby the parameters of culture operated on the level of a *meta*language. As a result of this metalinguistic conformity within the art world system, there was a tendency to either overlook or underestimate the cultural experience of the artist as having a specific relationship to important political and social issues within the international context. Instead of an open dialogue among artists or between artists and various members of the international art world, there was a denial that such a dialogue was relevant or more important than how one's image was maneuvered within the marketplace. This unfortunate trend persisted in giving us the postmodern concept of a new *un*originality in art—that art was not related to origins. In fact, art was exempt from origins. There was the persistent notion that nothing could be made that had not already been made. Indeed, culture itself had become an irrelevant notion in that the traces were being vaporized by way of an infinite chain of simulacra.

This created a certain distancing effect among artists from various cultures outside the United States and Europe, an effect that was particularly problematic for artists from the so-called Third World. In such a condition, artists from countries in South America, Eastern Europe, or South Africa had little access to the market unless they came from "privileged" means or were connected to those who were. This only increased, if not doubled, the effect among those artists who were not from privileged situations. In order to accept one's image of "otherness," a certain denial of one's cultural memory and attribute was required. It was a denial that was conveniently suited to the market.

The issue became one of survival in an increasingly conformist art world. In order to be considered legitimate in the art world—that is, the international market—it was often necessary to forfeit one's inherent cultural background and personal experience, particularly if one was outside the established norm of cultural production, in order to "fit" with the current art world image. One might say that the discourse in contemporary art that had begun more or less at midcentury had degenerated, by the late eighties, into an image. Thus, it became somewhat imperative for artists with any serious intent of entering the "international" market to establish a kind of cyberspatial nonidentity. This was not only true for artists but also for critics and curators who aspired to the same socioeconomic status. Regardless of the players, it became a matter of forfeiting delicate topical or political issues that constituted any obfuscation of one's market potential.

Gradually, the discourse of the marketplace (not to be confused with aesthetics), being largely an Americanization of French poststructural theory, was appropriated in such a way as to become indistinguishable from the socioeconomic apparatus that provided the fuel for artistic consumption and investment. If an artist wanted to be relevant in postmodern New York, it became increasingly necessary to adopt a strategy that would accommodate the needs of that apparatus. This could mean that differences within the established code of the art world would meet with an equally subtle dismissal. To be a "good" artist meant that one had to subscribe to the current of this new "internationalism"—an international market/discourse that would ironically exist as a corporate image in relation to one's inherent cultural position.

This pseudointernational corporate aura had come to replace the European

nationalistic fervor of the late seventies and early eighties as evidenced in the expressionist revivalism at that time. The international metalanguage of the late eighties was a kind of placebo, a surrogate for originality in the form of a populist discourse based on homogeneity. It was a sense of homogeneity that allowed any artist—no matter the cultural origin—to become part of the international network. The fervor of nationalism in the art world of the late seventies had certain limitations, not to mention a certain level of apprehension about what was in store for the marketplace after simulation had replaced originality. This became the trendy new mode of cultural production. By the mid-eighties, the strategy for artistic success depended largely on one's ability to further deny any tactile relationship to the object in favor of cynical (often mistaken as "conceptual") distancing, and, therefore, to deny any attempt at authenticity in favor of the standardized logotype.

Much of the denial that encompassed the art world at this time was augmented by the East Village phenomenon in the United States and by the backing of certain West German galleries by wealthy bankers. This permitted the seeds of provincialism, disguised as "internationalism," to be quickly sown, only to be harvested within months of the same season through outrageous speculation. These tendencies were, of course, embraced by the major auction houses as a sign of unprecedented growth in the contemporary art market—a "growth" that could not last. There is no way to statistically analyze what is qualitative within culture; statistics and quality ride on separate tracks. To speculate on statistics in art—that is, conformist agreement—is neither smart nor intelligent.

Even so, the desperation implied in this "growth" factor put pressure on foreign artists living in New York to conform to what the market was telling them through the trade magazines. The magazines function as vehicles for these marketing expectations; that is, for what is "hot" and trendy; in essence, for the new "internationalism." This ironic denial of cultural identity (though culture can never really be denied, only overdetermined) was contingent upon the failure of the new corporate audience to significantly accept cultural difference. This failure occurred despite the appropriation of theory in various journals and trade magazines that purported to do otherwise.

For those serious artists outside the system it was a matter of tightening one's grip, so to speak, on the expectations that were made apparent through the complicity of art dealers, collectors, and, finally, curators and critics. They were all talking fast. The market was thriving in the mid-eighties, and there were few signs of relinquishment. The foreign artist in New York, if previously "unknown," either had to have a strong market before arriving or there was little hope of finding one beyond the network of alternative spaces and small college art galleries; that is, unless the artist's adaptation of culturally specific qualities was made explicit. A real intercultural dialogue seemed less important than theories of culture. They were, by no means, the same thing. The art world system, as Baudrillard once explained, was its own system like any other socioeconomic system.

To work within that system had virtually nothing to do with making a statement representative of one's cultural experience. Art had been cut off from culture.

"Difference" was seen as a matter of recoding the system based on the somewhat limited issues of sexual preference and gender. "Difference" was primarily recognized in these terms, in spite of Edward Said's position on the "other" and Lyotard's discussion of "naming." These terms were used for expediency, but had little effect in changing the inner dynamics of the marketing system. (This situation has subsequently improved for better or for worse with the instigation of Deitch Projects in lower SoHo after 1995.) Many immigrant artists in New York found difficulty expressing themselves within the art world system. Although immensely capable of doing so, few had a voice or an opportunity to really become "international." The critic Lucy Lippard alluded to this dilemma in several essays over the previous decade.

Now, during the nineties, there is an opportunity to restore some semblance of an intercultural dialogue through art; because only through the recognition of a dialectical and diacritical relationship between art and culture can we restore the concept of significance in art. At the end of the eighties, it appeared that art world cynicism had run its course; but clearly this is not the case. Cynical collectors still find entertainment in buying cynical art; and there are plenty of artists to provide them with the goods that they require. The game lingers on; it will take another decade at least before the nausea is felt. Whereas the failure in the art market at the end of the eighties suggested a turn for the better, things have not, in fact, gotten better.

The illusion of West Chelsea has temporally helped the art market back to its feet. The stock market is good, and, relatively speaking, so is the art market. They exactly parallel one another. Even so, now is an appropriate time to reconsider the terms for a truly international art where artists with various points of view can find an audience, where artists are not expected to deny their rite of passage from one culture to another, but to allow the trace of meaning to persist within a larger discourse that is, in fact, a real intercultural dialogue. Again, the point is not to deny a market for art; the point is to raise the level of expectation and quality that a healthy market needs to sustain itself over time, and which by sustaining itself over time will unequivocally improve the quality of our cultural lives. This is a vague initiative. It is about individuals standing apart from the seduction of the crowd and making a claim for what is good, what is truly beneficial to sustain art as a vital force; it is, in fact, a resistance to the nonculture of corporate globalization.

The Anti-Aesthetic, Careerism, and Art Schools

The anti-aesthetic that began in the late seventies enabled a blatant marketing procedure to expand in the eighties and to continue into the nineties, virtually without challenge from institutions of higher art education. The problem is not only a matter of how we got there—by way of a dormant, if not soporific, approach to art education—but how we might consider improving the situation at the beginning of the next century.

The anti-aesthetic, frequently associated with postmodernism in the visual arts, is not a style so much as a method of critique. And it is not criticism in the strict sense, but a theoretical approach to culture. If postmodernism is about the appropriation of styles, then we have to consider this tendency in terms of a pastiche; that is, a kind of bricolage that brings together various styles of modernism into a new grab bag, a modus operandi held in suspension. Given the removal of aesthetics from the domain of its structure, one might say that artists, both younger and older, who entered into this game were fundamentally seduced by the opportunities of the marketplace—what I have already referred to as "cultural Reaganomics."

It is relatively easy to dismiss "originality" and "quality" as operative terms in the discourse of anti-aesthetic postmodernism. These terms simply had no place in an era of high transition, dominated by a vapid network of cultural and subcultural interests, all heavily politicized, without a sense of resolve, and without a sense of volition as to any possibility of a new direction in the language of art. (I would contrast this position, made possible by cultural Reaganomics, with the energetic advances made in American art during the late sixties and early seventies in which the question of art as language gained a significant foothold in the art world.)

The two most recent decades have been a period in our culture where criticism has ceased to function as operable in relation to works of art. Experience, in aesthetic terms, has gone out the window, so to speak—or at least beyond the frame. During the eighties, what was in at the moment was also what was "hot." And what was "hot" at any moment had to have the support of a discourse as if to prove that language—stated in the most overt way—could support a politically minded visual

culture. This was the general course of events in the eighties. Criticism as it related to the experience and analysis of art in specific terms was thrown out, and generalized theories of culture found their place at the center of a new academia. But these were theories appropriated from the French—Derrida, Foucault, Lacan, Barthes, Baudrillard, Lyotard, etc.—and occasionally the German—Benjamin, Adorno, Horkheimer—schools.

In the eighties, art schools and university art departments generally produced overinformed and undereducated students. One model for this unfortunate turn in higher art education was the California Institute of the Arts, particularly at the outset of the seventies when something called a "post-studio" program was implemented. The pretense of this loosely defined approach to art education was to feed students the right kind of information with the implied guarantee that with it they could make their careers. Forget about art history—or, for that matter, forget about history itself! Forget about foreign languages or anything to do with a serious study of philosophy or aesthetics! How many students, for example, or professors for that matter, in art academia have actually read any portion of Kant's *Critique of Pure Reason* or Croce's *Aesthetic*?

Instead, this loosely knit post-studio paradigm was all about "theory"; that is, reading *Artforum* and, of course, *October* with the sole incentive that by being informed, one might position oneself more correctly in the art world. By positioning oneself more correctly one might be able to declare which artists were "good artists" and which artists were not. Put another way, art academia was fostering a competitive attitude more than it was nurturing a serious open-minded search for a meaningful discourse through art. M.F.A. programs were functioning on the same level as the M.B.A.—survival of the fittest!

The absence of criteria by way of any sophisticated or truly intellectual approach to methodology was simply not an issue. The process seemed rather to be about disclaiming art that did not conform to the CalArts consensus—thus promoting a kind of American middle-class cynicism that, of course, was symptomatic of cultural Reaganomics. Unfortunately, by the late seventies the program was hopelessly entrenched in a type of theoretical distancing and careerism that precluded the intervention of new ideas beyond the predictable restraints of a contrived art program that existed on the level of a technical trade school.

Not to belabor the point, but, ironically, there were some first-rate artist/teachers who taught at CalArts—John Baldessari, Michael Asher, Jeremy Gilbert-Rolfe, and Douglas Huebler. The problem was with the stated goals of the institution as reflected in the curriculum; namely, to produce career-minded artists and media strategists on the model of Andy Warhol (as if Warhol's career could ever be successfully imitated). The results were to bring anti-aesthetic postmodernism into the visual arts with a vengeance.

The educational agenda at CalArts was complicated given its sponsorship by Walt Disney Studios. Clearly, its model for careerism was the technical trade school, which, as Gropius revealed at the Bauhaus, is antithetical to art education. In a curious way, the Whitney program in New York was the East Coast version of the same ap-

proach. Instead of Disney, however, the Whitney Museum of American Art was, by the late seventies, coming increasingly under the influence of its board of trustees. The implications of this influence are enormous and cannot be dealt with here. Even so, it is not difficult to find a parallel with the agenda of Disney at CalArts, given specific concerns for an aesthetic that conformed to the principles of the establishment. This might be characterized as two discrete forms of cynicism, both stemming from a mediated view of culture that was accepted rather than pragmatically challenged through critical discourse.

While the Whitney program may have seen itself in opposite terms—that is, as challenging the status quo of art—it was in fact feeding into the mainstream by transforming marginality and the concerns of abject experience into a newly institutionalized deconstruction of art language. Once art academia falls into this kind of conformist impulse, it is difficult to retain any accurate idea of self-reflection that is equally possessed by an energetic output or by any clearsighted notion of production. It is here that the battle lines were drawn and the conflict was sustained: modernism versus postmodernism. Rather than finding some basis of dialogue as a response to the common threat of media conditioning so rampant in American society during the eighties, the camps were established as polarities of the art-educational spectrum.

Entering the breach came "visual culture," the institutionalization of this new marginality that virtually usurped any problematic with regard to how to develop an expanded aesthetics that might function as a more positive means toward understanding the present in relation to the past. In some sense, the best and most honest alternative during this decade would have been to combine aesthetics and studio training in art schools with a curriculum devoted to media demystification. In this way, artists could have benefited from a semiotic analysis of cultural signs without being threatened by the loss of their social-scientific pursuits.

This last point may be worth considering as we approach the art academia of the twenty-first century. If postmodernism is to have any positive, lasting effect in this moment of high transition within our global culture, it might be understood in the following way: it is not contingent on an anti-aesthetic or the concerns of abject reality; rather, it is concerned with the suspension of opposites without resolution. This might have applications that are both aesthetic and political. But the fact remains that educators have to decide in some definitive way whether the experience of art is worth preserving in our culture without succumbing to a reactionary form of cultural nostalgia. If this decision can be affirmatively made, then the hard work will begin as to how to structure the curriculum to include the development of an expanded aesthetic point of view that includes the cultural issues of the last two decades without denouncing the possibility that one can still feel something in relation to the world of the imagination.

Notes

The End of the Art World

Originally published in *Art Criticism* 11, no. 1 (spring 1996). This essay is based on a talk given in the graduate school of the Museum of Fine Arts, Boston, on December 13, 1994. The initial idea evolved from a short statement that I prepared for *M/E/A/N/ I/N/G* 125 (spring 1994) at the invitation of Mira Schor and Susan Bee. The first completed version of the article was presented at the Museo del Bellas Artes in Buenos Aires at the invitation of Jorge Glusberg (November 1995). Subsequently, it was delivered at the University of Wales, Cardiff; the Artists Museum, Lodz (Poland); Bezalel Academy of Art, Jerusalem; Hansung University, Seoul; and the New York Studio School. Translations of the text have been published by the Artists Museum, Lodz (1996); Hansung University Graduate School of the Arts, Seoul (1997); and the Centro Cultural Rojas at the University of Buenos Aires (1998).

The Delta of Modernism

This paper was first presented at the College Art Association meeting in San Francisco, February 28, 1981, on a panel entitled "The Role of Theory in Art-Making." Originally published in *Re-Dact*, ed. Peter Frank (New York: Willis, Locker, and Owens, 1984). Revised and reprinted in *Esthetics Contemporary*, 2d ed., ed. Richard Kostelanetz (Buffalo, N.Y.: Prometheus Books, 1989). A Spanish translation appeared in *Revista Esthetica*, CAYC, Buenos Aires (fall 1991).

1. I am referring to two essays in particular: Greenberg, "Modernist Painting," *Art and Literature*, 1963 and Greenberg, "Post-Painterly Abstract," Los Angeles County, Museum of Fine Art, 1963. The first of these was apparently written three years prior to its publication, and has since been reprinted in Battcock, *The New Art*, 1966 (revised 1973), and in these pages.
2. These reviews and essays would include Mr. Greenberg's writings for *The Partisan Review*, for which he served as an associate editor during the late forties, and later for *Art News*, and eventually his book, *Art and Culture* (Beacon, 1961).

3. This is historical and theoretical conjecture. I am trying to suggest that Greenberg's and Rosenberg's writings in art criticism hold profoundly different points of view at the source.
4. James M. Coleman, *Deltas: Processes of Deposition and Models for Exploration* (1976).
5. See Robert Smithson, "A Sedimentation of the Mind" in Nancy Holt, ed., *The Writings of Robert Smithson* (NYU Press, 1979).
6. Pincus-Witten, *Post-Minimalism* (New York: Out of London Press, 1978).
7. Jack Burnham, *Great Western Salt Works: Essays on the Meaning of Post-Formalist Art* (New York: Braziller, 1974).
8. Douglas Davis, "Post Post-Art," *Village Voice* (June 25, 1979); sequels appeared in issues on August 13, 1979 and December 17, 1979. A fourth installment on photography appeared late, April 1–7, 1981.

The Status of Kitsch
An earlier version of this essay was published in *Art Press*, no. 217 (October 1996).
1. Clement Greenberg, "Avant-Garde and Kitsch" in *Art and Culture* (Boston: Beacon Press, 1961), 3–21. This is a somewhat altered version of the original.
2. John O'Brian, "Introduction" in *Clement Greenberg: The Collected Essays and Criticism. Volume I, Perceptions and Judgments, 1939–1944* (Chicago: University of Chicago Press, 1986).
3. Interview with Clement Greenberg in *Andy Warhol.* Film directed by Lena Jokel, Blackwell Distribution, 1974.
4. Robert C. Morgan, "Signs in Flotation," *The New Art Examiner* 22, no. 8 (April 1995).
5. Two important sources used in formulating my position on kitsch include: Guy Debord, "*La societe du spectacle*" (Paris: Editions Buchet-Chastel, 1967), English translation published as *Society of the Spectacle* (Detroit: Black and Red, 1970), and Jacques Derrida, "*Spectres de Marx*" (Paris: Editions Galilee, 1993), English translation by Peggy Kamuf (London: Routledge, 1994).
6. As an example, I refer the reader to Jean-Christophe Ammann, "Jeff Koons: A Case Study," *Parkett* 19 (1989): 56–59.
7. "It's Time for a New Vision of Contemporary Art Spaces," Jeffery Deitch interviewed by Giancarlo Politi in *Flash Art News.* Quoted from the exhibition catalogue for *In Full Bloom* (New York: One Night Stand Gallery, 1996).
8. Although it is a well-known fact that, in the formal sense, British pop preceded American pop art by seven years, the impact on the market was made by the latter.
9. Comment by Leon Kraushar in "You Bought It. Now Live with It: The Country's Leading Collectors of Pop Art Enthusiastically Fill Their Homes with It," *Life* (16 July 1965): 59. Quoted in Irving Sandler, *American Art of the Sixties* (New York: Harper and Row, 1988), 133–34.

Signs in Flotation
An earlier version of this essay was published in *The New Art Examiner* 22, no. 8 (April 1995).

The Plight of Art Criticism
An earlier version of this essay was first published in *Annals of Scholarship* 10, nos. 3/4 (1993) as "Introduction" and "Art Criticism Today: Forum or Repression?" It was reprinted in English and in Korean translation as *The Plight of Art Criticism* (Korea: Hansung University Graduate School of the Arts, Department of Painting, 1997).

1. The spectrum of this equivocation goes from the au courant position of editors at *Artforum* to the more conservative column of Hilton Kramer in the *New York Observer*. In the case of the three major glossies in New York—*ARTnews*, *Artforum*, and *Art in America*—art reviews have gotten increasingly slick in their sophistication and orientation, but rarely, if ever, does a forthright "negative" review appear unless the general consensus outside the purview of the magazine is made clear. I would challenge the reader to find a major exception to the mostly neutral, "well-balanced" reviews that have appeared since the economic decline of the art market. This policy is not isolated to New York art magazines but applies elsewhere in European and Asian art magazines as well.

2. French poststructuralism, in English translation, has had a widespread appeal among art critics, particularly in the late eighties. The term "deconstruction" is generally applied to the writings of Jacques Derrida. See, for example, *Speech and Phenomena* (Evanston, Ill.: Northwestern University, 1973).

3. Benjamin H. D. Buchloh, "The Andy Warhol Line" in *The Work of Andy Warhol*, ed. Gary Garrels (Seattle: Bay Press, 1989), 55.

4. For an analysis of the connection between postmodernism and cynicism see Peter Sloterdijk, "Critique of Cynical Reason" in *Theory and History of Literature, Volume 40*, trans. Michael Eldred, with a foreword by Andreas Huyssen (Minneapolis: University of Minnesota Press, 1987).

5. See John Dewey, *Art as Experience* (New York: Capricorn Books, 1931).

6. This term is borrowed from a discussion between Marcel Duchamp and Pierre Cabanne in *Dialogues with Marcel Duchamp* (New York: Viking, 1971). I am using it here to suggest that the critic functions very much in relation to art as the artist may function in relation to culture.

7. As an example, one of the editorial policies adopted by *ARTnews*, reputed to have the widest circulation in the United States of the three major art glossies, was to put a photograph of the artist on the cover and then run an article inside with "human interest" appeal. This policy would suggest the use of entertainment or spectacle for promotional appeal.

8. Julian Street was the name, I believe, of the critic who wrote a review of the much publicized *New York Armory Show* where Duchamp's painting, along with three of his other works, was first exhibited in the United States. It was eventually purchased by the collector and poet Walter Arensberg who later became a benefactor and close friend of Duchamp.

9. Again, *ARTnews* has run several issues in the last few years devoted to statements by collectors, curators, museum directors, blue-chip artists, and other "important" art world people. These statements, of course, are purely journalistic reportage.

10. Stanley Ulanoff, *Advertising in America* (New York: Hastings House, 1977), 14–15.

11. As a New York art critic, over the years I have had countless conversations with other writers and critics whose work I respect, most of whom have concurred that occasionally certain comments and ideas have been manipulated, even distorted, in order to fit the policy format of the magazine. Editors, of course, will generally say that the reason for the changes or deletions or rejections is purely editorial and based on considerations of being "newsworthy," and have nothing to do with conflicts related to advertising contracts.

12. The popular media goes for art that presents itself as spectacle. Take, for example, the extraordinary media coverage given to an artist like Jeff Koons or the French performance artist Orlan who has plastic surgery done on her body regularly for television viewing or, for that matter, the late Haitian artist Jean-Michel Basquiat who died tragically in 1987 of a drug overdose. The list goes on, but little of it has anything to do with either art or criticism.

13. See David Carrier, *Artwriting* (Amherst: University of Massachusetts, 1987).

A Sign of Beauty

This essay is based on a paper delivered at the Seoul National University, Korea, November 21, 1997. It was originally published in *Uncontrollable Beauty: Toward a New Aesthetics,* eds. Bill Beckley with David Shapiro (New York: Allworth Press, 1998).

The Boredom of Cézanne

Originally published in *NY SoHo Arts* 2 (September 1996).

The Enduring Art of the Sixties

Originally published in the exhibition catalogue, *The Art of the Sixties: Selections from the Collections of Leo Castelli and Ileana Sonnabend,* Sam Hunter, curator (Easthampton, N.Y.: Guild Hall, 1991).

1. Robert Rauschenberg, statement in *Sixteen Americans,* ed. Dorothy C. Miller (New York: The Museum of Modern Art, 1959), 59.

2. Calvin Tomkins, *The Bride and the Bachelors* (New York: The Viking Press, 1969), 236.

3. Irving Sandler, *American Art of the 1960s* (New York: Harper and Row, 1988), 63.

4. Harold Rosenberg, *The De-Definition of Art* (New York: Collier Books, 1972), 2.

5. Ibid.

6. Clement Greenberg, "Modernist Painting" in *The New Art,* ed. Gregory Battcock, rev. ed. (New York: Simon and Schuster, 1968), 208.

7. Max Kozloff, "Jasper Johns," *The Nation* (December 7, 1963) reprinted in *Renderings* (New York: Simon and Schuster, 1968), 208.

8. Leo Steinberg, "Contemporary Art and the Plight of Its Public," *Harper's* (1962) reprinted in Battcock, *New Art,* 223.

9. Sandler, *American Art,* 66.

10. E. C. Goossen, "Distillation," Stable Gallery (September 1966) reprinted in *Minimal Art,* ed. Gregory Battcock (New York: Dutton, 1968), 61.

11. Donald Judd, "Specific Objects," *Arts Yearbook* 8 (1965).

12. Donald Judd, statement in Bruce Glaser, "Questions to Stella and Judd," *ARTnews* (September 1966) reprinted in Battcock, *Minimal Art,* 161.

13. Lucy R. Lippard, *Pop Art* (London: Thames and Hudson, 1966), 82–84.

14. Max Kosloff, "Pop Culture, Metaphysical Disgust, and the New Vulgarians," *Art International* (March 1962) reprinted in *Renderings,* 216–22.

15. Lawrence Alloway, "The Development of British Pop" in Lippard, *Pop,* 27.

16. Hal Foster, "The Crux of Minimalism" in *Individuals: A Selected History of Contemporary Art, 1945–1986,* ed. Howard Singerman (New York: Abbeville, 1986) in conjunction with the exhibition at the Museum of Contemporary Art, Los Angeles (December 10, 1986–January 10, 1988), 178–80.

17. Benjamin H. D. Buchloh, "The Andy Warhol Line" in *The Work of Andy Warhol,* ed. Gary Garrels (Seattle: Bay Press, 1989), 52–69.

18. Michael Fried, "Art and Objecthood," *Artforum* (1967) reprinted in Battcock, *Minimal Art,* 116–47.

19. Ibid., 142–46.

20. Lucy Lippard, "The Dilemma," *Arts* (November 1970) reprinted in *The New Art* Gregory Battcock, ed. (New York: Dutton, 1973), 147–48.

21. Lucy Lippard, *Pop Art,* 14–16.

22. Kirk Varnedoe and Adam Gopnik, *High and Low: Modern Art and Popular Culture* (New York: Museum of Modern Art, 1990) in conjunction with the exhibition (October 7, 1990–January 15, 1991), 335.

23. Lucy Lippard (with John Chandler), "The Dematerialization of Art," *Art International* XII, no. 2 (February 1968) reprinted in Lippard's *Changing: Essays in Art Criticism* (New York: Dutton, 1971), 255–76.

24. Robert C. Morgan, "Eccentric Abstraction and Postminimalism," *Flash Art,* no. 144 (January–February 1989).

25. Robert C. Morgan, "A Methodology for American Conceptualism" in *Art conceptuel formes Conceptuelles,* ed. Christian Schlatter (Paris: Galerie 1900–2000, 1990), 556–69.

Antiformalist Art of the Seventies

An earlier version of this essay was published in the exhibition catalogue, *Concept-Decoratif* (New York: Nahan Contemporary [in collaboration with Holly Solomon Gallery], 1989).

1. Lucy R. Lippard, "Sol LeWitt: Nonvisual Structures," in *Changing Essays in Art Criticism* (New York: Dutton, 1971), 160.
2. Ludwig Wittgenstein, *Tractatus Logico-Philosophicus,* trans. D. F. Pears and B. F. McGuinness (1922; reprint, London: Routledge and Kegan Paul, 1961), 8.
3. James Joyce, *A Portrait of the Artist as a Young Man* (1916; reprint, New York: Viking, 1964), 8.
4. Harold Rosenberg, "Art and Words" in *The De-Definition of Art* (New York: Colliers Books, 1972), 59.

Eccentric Abstraction and Postminimalism

An earlier version of this essay was published in *Flash Art,* no. 144 (January–February 1989).

1. Lucy R. Lippard, "Eccentric Abstraction," *Art International* X, no. 9 (November 1966).
2. Reprinted in Donald Judd, *Complete Writings, 1959–1975* (Halifax and New York: Press of the Nova Scotia College of Art and Design and New York University Press, 1975), 181–89.
3. Interview with Lucy Lippard, University of Texas at Arlington (April 16, 1988).
4. Robert Pincus-Witten, *Postminimalism into Maximalism: American Art, 1966–1986* (Ann Arbor: UMI Press, 1987), 1–6.
5. See Jane Livingston and Marcia Tucker, *Bruce Nauman: Work from 1965 to 1972* (New York: Los Angeles County Museum of Art and Praeger, 1973).
6. Lippard, "Eccentric Abstraction."
7. Claes Oldenburg's "soft sculpture" was one of the major impulses in this shift away from formal reductiveness at that time.
8. Interview with Joseph Helman, New York (May 24, 1988).
9. Pincus-Witten, *Postminimalism,* 101–16.
10. Interview with John Duff (May 26, 1988).

American Sculpture and the Search for a Referent

An earlier version of this essay was published in *Arts* (November 1987).

1. An excellent interview with Chamberlain is included in *John Chamberlain: A Catalogue Raisonné of the Sculpture, 1954–1985,* ed. Julie Sylvester (New York: Hudson Hills Press and the Museum of Contemporary Art, Los Angeles, 1986), 8–25.
2. Samuel Beckett, *Waiting for Godot* (New York: Grove Press, 1954), 52.
3. Cheryl A. Brutvan, "Joel Fisher" in *Structure to Resemblance* (exhibition catalogue), ed. Michael Auping (Buffalo: Albright-Knox Art Gallery, 1987), 29.
4. Ludwig Wittgenstein, *Tractatus Logico-Philosophicus,* trans. D. F. Pears and B. F. McGuinness (1922; reprint, London: Routledge and Kegan Paul, 1961), 26.
5. Samuel Beckett, *Endgame* (New York: Grove Press, 1958).
6. Beckett, *Waiting for Godot,* 52.

Art Outside the Museum

Originally published in *The Age of Modernism: Art in the Twentieth Century,* ed. Christos M. Joachimides and Norman Rosenthal (Ostfildern-Ruit: Verlag Gerd Hatje, 1997) on the occasion of the exhibition held at the Martin-Gropius-Bau, Berlin, May 7–July 27, 1997.

1. L. Moholy-Nagy, "Space-Time Problems" in *Vision in Motion,* ed. Sibyl Moholy-Nagy (Chicago: Theobold, 1946). Reprinted in *Esthetics Contemporary,* ed. Richard Kostelanetz (Buffalo, New York: Prometheus, 1989), 69–74.

2. See, for example, Gilles Deleuze and Felix Guattari, *Anti-Oedipus: Capitalism and Schizophrenia,* trans. Robert Hurley, Mark Seem, and Helen R. Lane (Minneapolis: University of Minnesota Press, 1983).

3. For a more in-depth investigation of these issues, see my essay "Signs in Flotation," originally published in *The New Art Examiner* 22, no. 8 (April 1995) and revised for this volume.

4. Roselee Goldberg, *Performance Art: From Futurism to the Present,* rev. ed. (New York: Harry N. Abrams, 1988), 40–43.

5. I am clearly leaning on Jean Baudrillard's theory of simulacra here, a pervasive theme in much of his recent work that is most ostensibly represented in *Simulations,* trans. P. Foss, P. Patton, and P. Beitchman (New York: Semiotexte/Foreign Agents Series, 1983).

6. See John Cage, *Silence* (Middlebury, Conn.: Wesleyan University Press, 1961).

7. Allan Kaprow, *Untitled Essay and Other Works* (1958; New York: Something Else Press/A Great Bear Pamphlet, 1967), 2–5.

8. Simon Anderson, "Fluxus Publicus" in the exhibition catalogue *In the Spirit of Fluxus,* eds. Elizabeth Armstrong and Joan Rothfuss (Minneapolis: Walker Art Center, 1993), 38–61.

9. Robert C. Morgan, "The Fluxus Ensemble" in *Commentaries on the New Media Arts* (Pasadena, Calif.: Umbrella Associates, 1992), 1–5. Originally published as "the Fluxus Phenomenon," *Lund Art Press* 2, no. 2 (1992): 125–128.

10. Henry Flynt, "Concept Art" (1961) in *An Anthology of Chance Operations,* eds. La Monte Young and Jackson Mac Low (New York: Heiner Freidrich, 1963), unpaginated.

11. Ibid.

12. "Excerpts from a Correspondence, 1981–83" (Andrea Miller-Keller and Sol LeWitt) in *Sol LeWitt Wall Drawings, 1968–1984* (Amsterdam and Hartford, Conn.: Stedelijk Museum, Stedelijk Can Abbemuseum Eindhoven, and the Wadsworth Atheneum), 21.

13. Flynt's disavowal of fluxus began in a protest (with La Monte Young) during the *Ubi Fluxus/ibi Motus, 1990–1962* exhibition at the time of the 1990 Venice Biennale (at Gudecca). In Flynt's 1993 press release for his show at the Emily Harvey Gallery in New York, there is no mention of fluxus, only "concept art."

14. Sol LeWitt, "Paragraphs on Conceptual Art," *Artforum* (summer 1967). Reprinted in the exhibition catalogue *Sol LeWitt,* ed. Alicia Legg (New York: Museum of Modern Art, 1978), 166–67.

15. Ibid.
16. Marcel Duchamp, "Apropos of Readymades" in Kostelanetz, *Esthetics Contemporary,* 13–24. Reprinted from *Art and Artists* 1/4 (July 1966).
17. Octavio Paz, "The Ready-Made" in *Marcel Duchamp in Perspective,* ed. Joseph Masheck (Englewood Cliffs, N.J.: Prentice-Hall, 1975), 88.
18. Joseph Kosuth, "Art After Philosophy, Part I" in *Art After Philosophy and After* (Cambridge, Mass: The MIT Press, 1991), 13–24. First published in *Studio International* 178, no. 915 (October 1969): 134–37.
19. Robert Smithson, "The Spiral Jetty" in *The Writings of Robert Smithson,* ed. Nancy Holt (New York: New York University Press, 1979), 109–16. First appeared in Gyorgy Kepes, ed. *Arts of the Environment,* 1972.
20. Robert C. Morgan, "Who Was Joseph Beuys?" in *Art into Ideas: Essays on Conceptual Art* (Cambridge, UK: Cambridge University Press, 1996), 150–61.

Nancy Grossman: *Opus Volcanus*
Originally published in *Sculpture* 17, no. 6 (July 1995).

1. I refer to an exhibition and curatorial essay by Townsend Wolfe entitled *Powerful Expressions* (National Academy of Design, New York, 1996–97) in which Nancy Grossman was prominently included.
2. This and other quotations in the essay attributed to Nancy Grossman were taken from a telephone interview with the artist, February 18, 1998.
3. Arlene Raven, *Nancy Grossman,* catalogue for an exhibition of the same title curated by Judy Collischan (Hillwood Art Museum, C.W. Post Campus, Long Island University, Brookville, N.Y., September 27–November 10, 1991), 78.
4. Ibid., 38. When the family moved from New York City to Oneonta in 1945, two of her mother's sisters followed along with their respective families. Nancy grew up with eight adults and as one of sixteen children. Grossman's father was a devout Jew, while her mother enforced Roman Catholicism on the children, thus creating a conflict.
5. Ibid., 108.
6. Jeremy Gilbert-Rolfe, "Beauty and the Contemporary Sublime" in *Uncontrollable Beauty,* ed. Bill Beckley with David Shapiro (New York: Allworth Press, 1998), 40.
7. There is an earlier sculptural figure of a male torso, also wrapped in leather, that is the single exception to the rule. On the other hand, many of the male figures in the drawings could be interpreted as equivocating between sexual identities.
8. In "Fragments of a Journal in Hell," Artaud states: "I hunger less for food than some kind of elementary consciousness." Jack Hirshman, ed., *Artaud Anthology,* 2d. ed., trans. Mary Beach and Lawrence Ferlinghetti (San Francisco: City Lights, 1965), 40.
9. Raven, *Nancy Grossman,* 98.
10. Interview from the film *Marcel Duchamp: In His Own Words,* edited and produced by Lewis Jacobs, 1976.

11. Raven, *Nancy Grossman,* 102.
12. The affinity between Grossman's heads and science-fiction film would be a fascinating topic to pursue, especially in the light of the current academic rage for visual culture. In addition to Cameron's *Alien* (director of the original film), I would suggest that the character Darth Vader in the George Lucas *Star Wars* trilogy has an affinity with Grossman's work. On the other hand, Grossman might have to share the source of the Vader image with the face on Boccioni's *Continuity of Forms in Motion* (1912), otherwise known as the Walking Man, in the collection of the Museum of Modern Art, New York.
13. I recall this statement by Fromm as it was cited in a book published in 1965, *Teacher,* by New Zealand educator Silvia Ashton-Warner. In the book, Ashton-Warner discusses her rationale in teaching unacculturated Maori children.

Sang Nam Lee: *Minus and Plus*
Originally published in the exhibition catalogue, *Sang Nam Lee* (New York: B4A Gallery, 1993).

The Fundamental Theology of Gilbert and George
Originally published in *Review* 2, no. 16 (May 15, 1997).

Carolee Schneemann: The Politics of Eroticism
Another version of this essay was published in *Art Journal* 56, no. 4, Performance Art Issue (winter 1997).

Bruce Conner: Engraving Collages and Films
An earlier version of this essay was published in *New York Arts,* no. 12 (July 1997).

Rauschenberg: Supply Side Art and Canoeing
An earlier version of this essay was published in *Review* 3, no. 6 (December 1, 1997).

Nancy Graves: Translucency
Originally published in the catalogue for the traveling exhibition, *Nancy Graves: Recent Works* (Baltimore, Md.: Fine Arts Gallery, University of Maryland, 1993).

Bill Viola's Simulated Transfiguration
An earlier version of this review was published in *Review* 2, no. 9 (February 1, 1997).

Kevin Clarke: Signs of Loss and Intimacy
Originally published in *Review* 3, no. 7 (December 15, 1997).

Philip Glass: *The Photographer*
Originally published in *Writings on Glass: Essays, Interviews, Criticism,* ed. Richard Kostelanetz and Robert Flemming (New York: Schirmer Books, 1997). The essay was written in 1984 and revised in 1996.

After the Deluge: The Return of the Inner-Directed Artist
This essay first appeared in *Arts* (March 1992). It was reprinted in my book *Essays on Art in the Nineties* (New York: Red Bass, 1993).

The Spectrum of Object Representation
Originally published in *Arts* (October 1988).
1. This refers to a well-known ad designed by Warhol.
2. See Jean Baudrillard, *The Ecstasy of Communication* (New York: Semiotexte, Foreign Agents, 1988), 11–27.
3. Steinbach related a story that the original elephant skull that he had seen and wanted to purchase was bought by pop singer Michael Jackson the previous day.

Where Spectacle Meets Art: Klein's Magnificent Anthropometries
An earlier version of this review was published in *Review* 3, no. 4 (November 1, 1997).

The 1997 Whitney Biennial
An earlier version of this review was published in *Review* 2, no. 13 (April 1, 1997).

West Chelsea: An Experiment in Attitudes and Architecture
Originally published in *Review* 2, no. 19 (July/August 1997).

The Hugo Boss Prize 1996
Originally published in *Review* 2, no. 7 (December 15, 1996).

Does the Trace Remain? The Situation of the "International" Artist Today
This essay is a revised and expanded version of a paper, using the same title, that I presented at the School of Visual Arts in New York City on November 20, 1990. It was

again presented at the AICA panel at the College Art Association meeting in Washington, D.C., on February 22, 1991. This version was later reprinted in my book *Essays on Art in the Nineties* (New York: Red Bass, 1993).

The Anti-Aesthetic, Careerism, and Art Schools
Originally published in *New Observations,* no. 118 (spring 1998), Lucio Pozzi and Bradley Rubenstein, guest editors.

Index

 Books from Allworth Press

Uncontrollable Beauty: Towards a New Aesthetics
edited by Bill Beckley with David Shapiro (hardcover, 6 × 9, 448 pages, $24.95)

Imaginary Portraits
by Walter Pater, Introduction by Bill Beckley (softcover, 6 × 9, 240 pages, $18.95)

Lectures on Art
by John Ruskin, Introduction by Bill Beckley (softcover, 6 × 9, 264 pages, $18.95)

The Laws of Fésole: Principles of Drawing and Painting from the Tuscan Masters
by John Ruskin, Introduction by Bill Beckley (softcover, 6 × 9, 224 pages, $18.95)

The Artist-Gallery Partnership: A Practical Guide to Consigning Art, Revised Edition
by Tad Crawford and Susan Mellon (softcover, 6 × 9, 216 pages, $16.95)

Design Literacy: Understanding Graphic Design
by Steven Heller and Karen Pomeroy (softcover, 6¾ × 10, 288 pages, $19.95)

Design Dialogues
by Steven Heller and Elinor Pettit (softcover, 6¾ × 10, 272 pages, $18.95)

The Education of a Graphic Designer
edited by Steven Heller (softcover, 6¾ × 10, 256 pages, $18.95)

Artists Communities
by the Alliance of Artists' Communities (softcover, 6¾ × 10, 224 pages, $16.95)

Looking Closer: Critical Writings on Graphic Design
edited by Michael Bierut, William Drenttel, Steven Heller, and DK Holland
(softcover, 6¾ × 10, 256 pages, $18.95)

Looking Closer 2: Critical Writings on Graphic Design
edited by Michael Bierut, William Drenttel, Steven Heller, and DK Holland
(softcover, 6¾ × 10, 288 pages, $18.95)

Please write to request our free catalog. To order by credit card, call 1-800-491-2808 or send a check or money order to Allworth Press, 10 East 23rd Street, Suite 210, New York, NY 10010. Include $5 for shipping and handling for the first book ordered and $1 for each additional book. Ten dollars plus $1 for each additional book if ordering from Canada. New York State residents must add sales tax.

If you would like to see our complete catalog on the World Wide Web, you can find us at *www.allworth.com.*